Sumida River. East
Tokyo is a vibrant
shopping area.

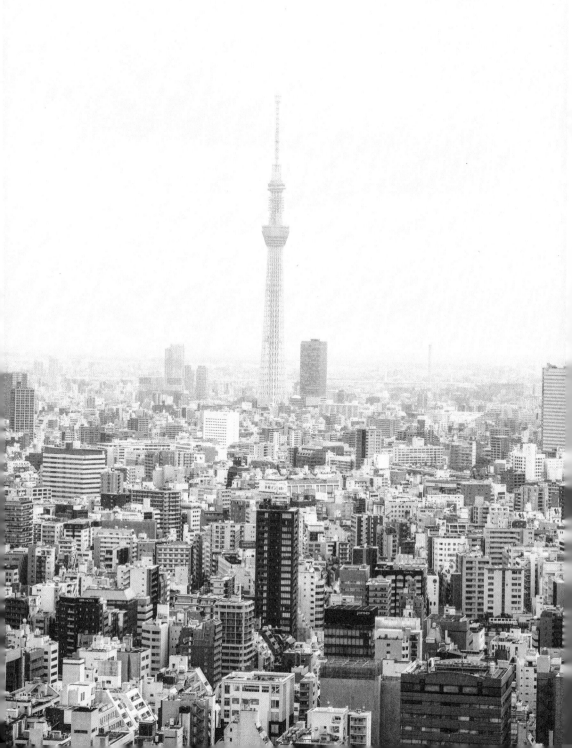

Introduction

"If you look at the streets in Tokyo, you will instantly get a sense of Japanese fashion trends."

—Yoshiyo Abe, designer, Petite Robe Noire

Tokyo has been a major source of high fashion for decades, and the city's presence on the world fashion stage seems to be more prominent each year. Following in the footsteps of Japanese fashion icons, such as Rei Kawakubo at Comme des Garçons, Yohji Yamamoto, Issey Miyake, Junya Watanabe, Jun Takahashi, Chitose Abe, and Hiromichi Ochiai, new, up-and-coming Japanese designers continue to gain recognition both from the fashion establishment and among their devoted fans from around the world.

While you can catch a glimpse of Mount Fuji from the upper floors of tall buildings throughout the city, it's nearly impossible to see the end of the urban sprawl that radiates from the shores of Tokyo Bay all the way to the outer sub-urbs and beyond. Walking through the streets here and watching people go by, it seems that the possibilities for indi-vidual style are equally infinite. Despite Tokyo's large scale, however, the streets and neighborhoods retain individual character, with style to match.

Experiencing Tokyo can be overwhelm-ing for first-time visitors, but those who spend time here can't help but feel inspired by the creative dynamism and open, carefree approach to style on show amid the vibrant energy of the city—the endless landscape of tall buildings, flashing neon lights, and packed pedestrian crossings. Because people tend to observe traffic lights, there is a delicious anticipation just before the lights change and every-one moves together. There is also the surprising sight of hundreds of people boarding the crowded trains during the morning rush hour—sometimes forcibly crammed into the cars by gloved attendants. Observing so many people just going about their daily lives, visitors to Tokyo often remark on how great everyone looks, how well-dressed, stylish, and put together they

OPPOSITE Traffic stops entirely and pedestrians surge into the intersection from all sides at Tokyo's famous "scramble crossing" in Shibuya, a vibrant shopping area known for its large department stores.

"People in Tokyo have a particularly strong desire to be fashionable."

—Shoichi Aoki, editor in chief, *STREET* magazine

"You'll never get bored looking at the streets of Tokyo. It's a perfect city for people watching."

—Naho Okamoto, founder and designer, SIRI SIRI

seem, whether it's in a suit or uniform for work, a school uniform, or a simple outfit for running errands. What's sometimes even more surprising is the range of styles that can be seen on any given street corner.

Your guides through this complex style mecca are two Tokyoites who have built successful careers in the fashion industry. Our author, Yoko Yagi, is a freelance fashion editor, writer, and a graduate of Tokyo's renowned Bunka Fashion College, who has worked as a fashion editor for the magazine *Soen* (Bunka Publishing), which has been showcasing Japan's most stylish women for more than eighty years. Through her work as a freelance fashion writer, fashion consultant, and marketing director, companies routinely seek Yagi's advice on brand development. Our photographer, Tohru Yuasa, also a graduate of Bunka Fashion College, majored in styling for his degree before pursuing photography as a career after graduation. Yuasa's sense

"What is important in fashion is whether you can be yourself or not."

—Mariko Hayashi, designer, jonnlynx

of craft (he shoots using increasingly hard-to-find film in his spare time) and stylist's eye for fashion and composition are evident in the shots you'll see throughout the book.

Our goal is to showcase a range of individual styles through photographs and interviews with Japanese fashion designers, editors, artists, photographers, and fashion influencers. Each of the individuals featured possess an instinct for original style and an independent, bold approach to fashion that allows them to wear the clothes that help them express their points of view.

In the pages that follow, we'll hear from stylish individuals and learn what makes their approach unique and what their thoughts are on Tokyo fashion in general. We'll take you on a treasure hunt through some of Tokyo's best vintage stores, and hope you'll be inspired by the ways in which Tokyo's most stylish people incorporate vintage into their own looks. We'll also explore the often misunderstood style concept of *kawaii* (which means "pretty," "adorable," or "cute") by talking to fashion designers, shop owners, and other influential personalities who elevate Japan's renowned "cute" culture to a more witty and sophisticated level. Their stores and clothes might seem soft and girly on the outside, but their razor-sharp take on *kawaii* has had a major influence on Tokyo street fashion and the designers and fashion labels defining Japanese style today.

We'll move from superfeminine florals and frills to more androgynous, boundary-pushing looks, which Japanese designers have been producing for a generation and the rest of the world seems to be only just waking

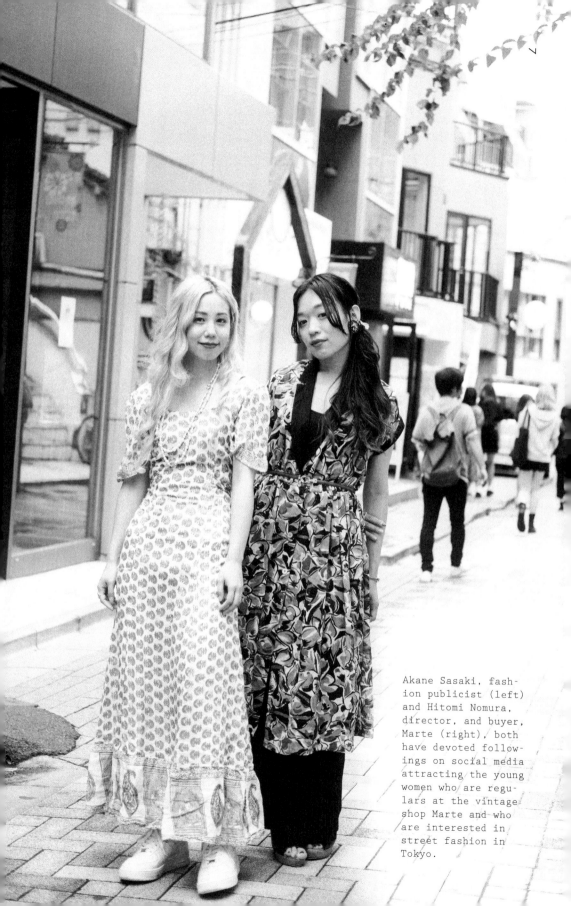

Akane Sasaki, fashion publicist (left) and Hitomi Nomura, director, and buyer, Marte (right), both have devoted followings on social media attracting the young women who are regulars at the vintage shop Marte and who are interested in street fashion in Tokyo.

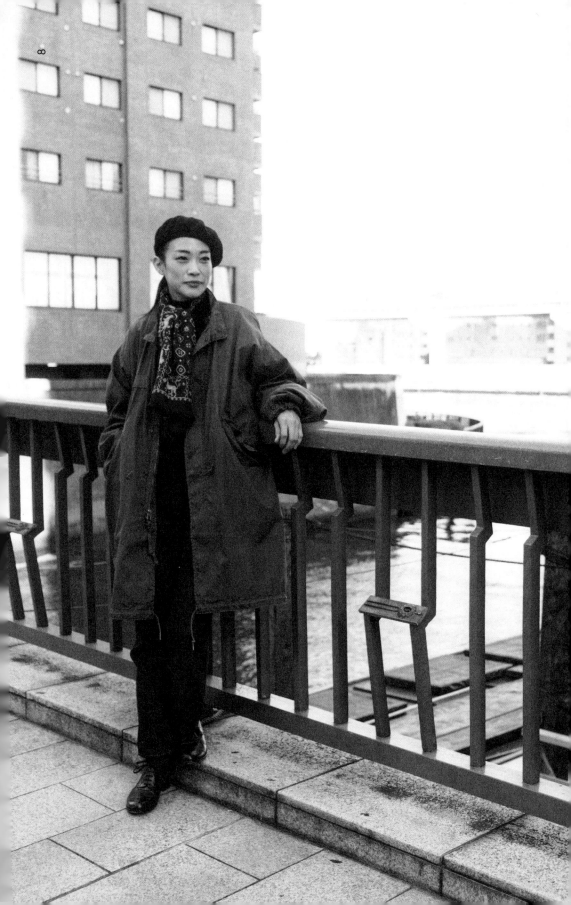

"Fashion literacy is high in Tokyo."

—Hirofumi Kurino, senior adviser for creative direction, United Arrows

up to. It's fairly common for women to wear men's clothing and be called stylish, and Japanese designers like Yohji Yamamoto and Rei Kawakubo at Comme des Garçons (which, of course, literally translates to "like the boys") have been pioneering genderless styles for more than forty years. But the ways that the designers, fashion brands, boutiques, and other influencers of street fashion featured in this book conceive of gender and gender-free clothing these days are truly revolutionary and are sure to play an important role in the years to come, as gender-free styles become more central to global fashion movements.

Then we'll take a closer look at concept stores and select shops—Japan's unique multilabel stores, each with its own curated concept and approach to styling—which have had tremendous influence on street fashion in Tokyo since their beginnings in the late 1980s. And since a book about Tokyo, a city famous for its world-class restaurants, wouldn't be complete without a look at the food scene, we'll explore the

connection between fashion and food, to discover how food is a fundamental part of a completely stylish life.

If you are searching for sources of inspiration for your own style, pay close attention to the feature on hair, makeup, and nail art, as worn by some of Tokyo's coolest people, and the profiles of up-and-coming brands that are influencing street style in Tokyo, many of which are shoppable overseas. And if you do make it to Tokyo, we've also included a detailed list of spots in our Tokyo Guide that attract some of the most devoted fans—or "maniacs," as they're called here—including recommended boutiques stocking the latest brands and some of the world's best sources for vintage finds, along with our picks for the best areas for people watching, shopping, eating, and drinking that the city has to offer.

Whether you are a frequent visitor to Tokyo or you're encountering the city and its stylish residents for the first time in the pages of this book, we hope you'll get the impression of Tokyo as not just a city where anything goes, but also one that inspires you with its constant creative energy, as a place where true experimentation is possible.

We want to celebrate the way stylish Tokyoites take inspiration from around the world, always keeping an eye out for new and exciting influences wherever they might be found as they mix different elements together in each outfit they wear. We also hope you will adopt a very Tokyo attitude of indulging—completely guilt-free—in the beautiful clothes, delicious food, and unique treasures you can find throughout this vibrant, one-of-a-kind city.

OPPOSITE Masami Sato, staff member of the popular select shop Anatomica, is wearing a US Army-style military overcoat next to the Sumida River in Asakusabashi where the shop is located. The jacket worn underneath, along with jeans, and matching shoes are all original products by Anatomica. The men's scarf is Drake's.

Tokyo is divided into twenty-three wards. Here we focus in on the neighborhoods that are home to some of the best spots for observing street style and for shopping. See the Tokyo Guide (page 205) for more detailed information.

● SHIBUYA

One of the most popular shopping and entertainment districts of Tokyo, with large department stores, cosmetics retailers, and more. Perhaps best known for its neon lights and "scramble crossing" in front of JR Shibuya Station, which sees thousands of people crossing in all directions with each light change.

● HARAJUKU

The center of Japanese youth culture, subculture, and street styles famous for its weekend gatherings of people dressed up in incredible outfits in a wide range of styles, as well as the variety of clothing stores, candy stores, fast-food restaurants, and so on that line the district's main road, Takeshita Street.

● OMOTESANDO

Harajuku's grand older sister, a tree-lined avenue sometimes called Tokyo's Champs-Élysées, full of high-end designer flagship stores and boutiques.

● AOYAMA & NISHI-AZABU

Exclusive, wealthy, sophisticated adjacent residential neighborhoods. Aoyama is famous for its excellent bookstores, stylish boutiques, exquisite cafés and restaurants. Nishi-Azabu is known for its nightlife.

● AZABU-JUBAN

Azabu-Juban is a residential area with a small village vibe in the middle of the big city. It's packed with cozy neighborhood cafés and bars frequented by the locals and intrepid travelers venturing away from more crowded and touristy Roppongi.

● ROPPONGI

A bustling shopping and nightlife district popular with foreign tourists, which is full of interesting restaurants and clubs. Tokyo Midtown and Roppongi Hills shopping centers offer high-end luxury fashion alongside fast-fashion names like Zara.

● EBISU

A beautiful, high-end residential and commercial neighborhood, featuring office buildings, luxury homes, shopping malls, and restaurants centered around Yebisu Garden Place, a popular date site and home of the

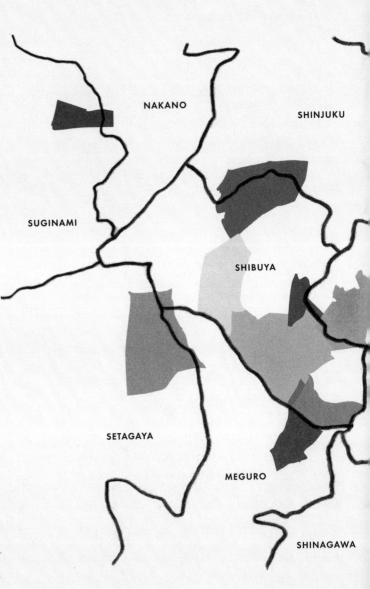

NAKANO

SHINJUKU

SUGINAMI

SHIBUYA

SETAGAYA

MEGURO

SHINAGAWA

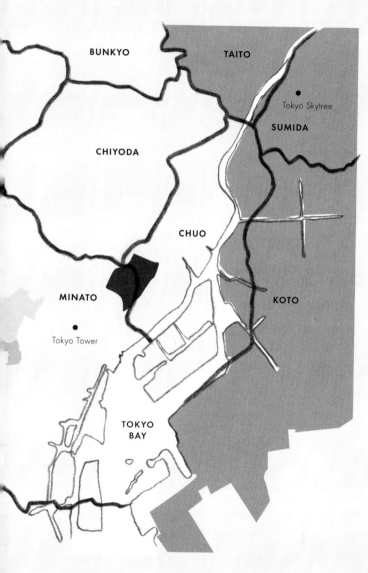

NAKAMEGURO
Many of Tokyo's best vintage shops, restaurants, and laid-back cafés can be found in this bohemian shopping and residential area, centered around the cherry-blossom-lined Meguro River.

YOYOGI-UEHARA & YOYOGI-HACHIMAN
Close to Yoyogi Park, these extremely stylish adjacent neighborhoods, where fashion seems to fill the atmosphere, not just in the cosmopolitan mix of great restaurants and cafes, but also in the many different styles on the streets. It's becoming known as a birthplace for new concept stores.

SHIMOKITAZAWA
KOENJI
Known for excellent vintage shops, independent bookstores, cheap bars, and cafés, frequented by students from nearby universities.

SHINJUKU
Famous for its skyscrapers, electronics stores, and major department stores, as well as the world's largest train station. Kabukicho is one of the liveliest nightlife districts in Tokyo.

GINZA
A stately, high-end shopping district full of world-famous fashion, cosmetics, and jewelry brands, along with Japan's major department stores. Nearby Kyobashi is one of the oldest commercial districts in Tokyo, and includes the world's first department store, Mitsukoshi, and other small shops selling Japanese food, traditional handcrafts, and more.

EAST TOKYO
Dominated by Tokyo Skytree tower, this area has a more "downtown" Old Tokyo feel about it. Lower rents encouraged many of the first select shops in Japan to open here in this favorite area for artists looking for cheap studio space, alongside traditional mom-and-pop shops and old-style Japanese inns and restaurants.

Tokyo Metropolitan Museum of Photography, the Museum of Yebisu Beer, an extraordinary annual Christmas light display, and the Yebisu Marché, a French-inspired farmers' market.

DAIKANYAMA
A cosmopolitan fashion district close to Shibuya, with many foreign embassies, art galleries, and bookstores, including the famous Tsutaya bookstore Daikanyama T-Site.

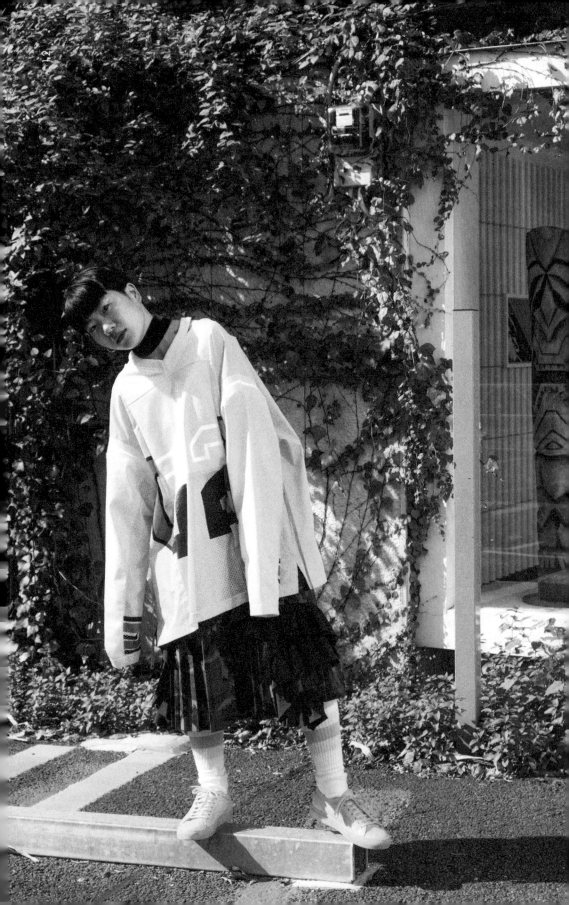

Chapter 1

What Is Tokyo Street Style?

"Tokyo fashion is directed by outsiders, the people in the streets."

—Rei Shito, street-fashion photographer

On the streets of Tokyo, visitors can't help but notice the eclectic range of fashion styles on display. But what is perhaps most striking is the playful, open attitude. Tokyo-based fashion journalist and blogger Misha Janette (see page 65) has lived in Japan for more than ten years. She tells us a story about a friend visiting Tokyo for the first time that encapsulates this open-minded attitude: "A while ago, a friend of mine came over from Berlin to Japan and said, 'I feel at home in Tokyo.' He is super tall with a shaggy beard and tends to stand out in a crowd. So, when he goes abroad, he often gets stared at, which makes him uncomfortable. In Tokyo, people might glance his way,

but nothing more. That's why he feels at ease here. People in Tokyo absolutely don't give others strange looks, and this applies not only to foreigners but also to anyone dressed in an eccentric fashion. It's been more than a decade since I started living in Tokyo, but my friend's story reminded me how different fashion in Tokyo is."

But why is it so different? Like the city itself, street fashion in Tokyo is a kind of beautiful chaos, always churning and moving, but with an energetic, flexible, and generous spirit that seems to drive us forward, always toward the next stage, the next thing, the next trend, the next experiment, while honoring past traditions. In this chapter, we hear from key figures in Tokyo fashion, who have witnessed the origins and the transitions of Tokyo style firsthand and who continue leading it into the future. We present a range of comments on Tokyo style as a starting-off point, highlighting some general characteristics, before exploring major street-fashion movements in greater detail in the chapters to follow.

TOKYO AS FASHION INSPIRATION

Mike Abelson, designer and founder of Postalco, is a longtime resident of Tokyo

OPPOSITE Outside Facetasm in Harajuku, noted staff member Chang combines bright yellow sports gear with a tiered, ruffled, camouflage print skirt, pieces from the spring/summer 2017 collection.

"There are so many styles intermingling [in Tokyo], everything from conservative to avant-garde."

—Naho Okamoto,
founder and designer,
SIRI SIRI

who revels in the mix of old and new: "I love that there is simultaneously new technology and tradition side by side. There is technology like supercomputers or high-speed trains. At the same time, there is a continuation of the traditional crafts like urushi lacquerware, indigo dyeing, and fabric weaving. I love the way these traditional and contemporary needs are blended." In creating his designs for bags and other leather accessories, Abelson often visits factories and construction sites in Japan and marvels at the attention to detail on display even in a large industrial setting: "Construction workers' clothing can be so well designed—the shape and colors are really fresh. During a recent sweltering summer, it was interesting to see jackets with electric fans built in for ventilation. They puff up the jacket in an interesting way, changing the shape of the body. At the same time, the fans help with the serious problem of overheating." Well-made uniforms and workers' clothing play an important role in Tokyo street fashion, inspiring designers, shop owners, and consumers alike.

Adrian Hogan, an Australian illustrator who is also a longtime resident of Tokyo, appreciates the high level of fashion awareness and skill among people here: "Both women and men are highly conscious of fashion. They are sensitive to trends, care about hair and makeup, and even with inexpensive clothing they have the skills to coordinate fashionably . . . and the same person can change his or her style dramatically. Maybe it's the cosplay tradition, but thinking of it that way, Tokyo people are so rich in flexibility. They add playfulness freely, and skillfully take in cultures of Japan and foreign countries. I think that kind of attitude is reflected in their fashion very well." United Arrows cofounder and senior adviser for creative direction Hirofumi Kurino agrees. Kurino joined the multi label select shop Beams in the late 1970s. "From a global viewpoint, Tokyo is actually a very special place. No other city exists with such diversified street-style fashion." Even an abbreviated summary of some of the different street-fashion trends of the past few decades suggests how rich the culture is (see page 16).

OPPOSITE United Arrows cofounder and senior adviser for creative direction Hirofumi Kurino is an influential figure not only in fashion worldwide but also in music, film, design, and fine art. His keen eye for world affairs and the political economy has garnered attention for Japan's fashion industry both nationally and internationally. In addition to his role at United Arrows and his contributions as a fashion journalist, Kurino also serves as a graduation competition judge in fashion at the Royal Academy of Fine Arts Antwerp and as a judge for the LVMH Prize for Young Designers.

Takenoko-Zoku

Pink House

Kogal

The most influential fashion trends of the past several decades are listed chronologically below, along with a short list of defining characteristics. Some, such as the hippie, miniskirts, skinny jeans, or fast fashion trends, mirror the fashion of Europe and North America at the time; others are uniquely Japanese.

--- 1960s–1980s ---

Miniskirts
The brands Mary Quant, courrèges, and others precipitated a miniskirt boom all over the world, but it was when British-born model and actress Twiggy came to Tokyo in 1967 that the trend took hold and gained momentum throughout Japan.

Ivy League/Preppie
Varsity letter jackets, slim sheath dresses or miniskirts, sweater sets, pearls, V-neck sweaters, cable knits, knee socks, and so on.

Hippie
Long hair and bell-bottom jeans (also called "trumpet trousers" or "pantalons") worn by both men and women, oversize hats, billowing sleeves, embroidered shirts, dresses in natural materials, and dragonfly glasses.

New Tra (New Traditional)
A classic style worn by upper-class female students based on designs by Louis Vuitton and Gucci. A bag from an instantly recognizable overseas luxury brand was an essential accessory.

--- 1980s ---

Takenoko-Zoku (Bamboo Shoots)
Dance group trend from the mid-1970s to the early 1980s named for a popular boutique, Boutique Takenoko, on Takeshita Street in Harajuku. Participants would wear brightly colored costumes, often featuring harem suits, and dance to boom-box disco music in the pedestrian zone of Harajuku.

Karasu-Zoku (The Crows)
All-black, usually layered, billowing clothing and long overcoats paired with black flats or heavy black boots. This look was inspired by high-end designs by Rei Kawakubo at Comme des Garçons and Yohji Yamamoto. The trend made wearing black, which was traditionally associated with mourning, into a fashion statement.

Bodycon (Body Conscious)
Wild, permed "sauvage" hair and sexy, form-fitting minidresses to go dancing in at clubs and discos that showed off the shape of the body gained popularity among women in Tokyo from the mid-1980s to the early 1990s.

DC Brands (Designer & Character Brands)
Wearing coordinated designer-brand clothing from Japanese fashion designers from head to toe. The DC brand Pink House made its world debut at this time. Country-style floral motifs were popular among women.

--- Late 1980s–1990s ---
Mixing styles and brands gained popularity with the rise of select shops.

Shibu-Caji (Shibuya Casual)
Derived from American casual styles worn by college students in the US, men and women coordinated jeans, loafers, and dark blue blazers.

French Casual
As the name suggests, a French-inspired style featuring cropped cigarette pants, Breton stripes, berets, and so on. Made popular by brands such as agnès b., chic styling with only a few key pieces became popular.

Urahara (Ura-Harajuku/ Backstreet Harajuku Tribe)
Brands such as Undercover, A Bathing Ape, Porter, and others who had set up stores in the back streets of Harajuku ("ura" means "back" in Japanese) were huge hits among young men who identified with the minimalist, functional street fashions they offered. For women, "boys' style" swept the streets with

Decora

Lolita

Mori Girl

oversize T-shirts paired with colorful skinny jeans. The "sneaker hunting" phenomenon, in which people wearing rare, popular models of Nike Air Max sneakers would actually be robbed of their shoes, took off around this time.

Kogal (School Girl)
A trend based on meticulously arranged school girl uniforms with supershort miniskirts, long sweaters, and long, loose, white bunched socks worn like leg warmers with dark loafers. Kogals would dye their hair brown, get deep salon tans, and wear white eye makeup to go out shopping at 109 (a fashion building in Shibuya). Kogal style eventually evolved into Yamaba Gal style, whose ghostlike white hair and makeup is meant to look like something out of a ghost story.

------ 2000s-2010s ------

Sub-Kal Kei (Subculture Girls)
Styles born out of subculture and music, including anime. Factions of this movement includes Cosplay, Decora, and Lolita styles.

------ Decora ------

A Harajuku street-fashion craze that involved a large number of brightly colored accessories (bows, clips, pins, Band-Aids, ribbons, stickers) all worn at once and attached to low ponytails and bangs. These

accessories would "decorate" and even obscure the face and clothes (usually dark or neon-colored hooded sweatshirts paired with ballet tutus). Originally documented by Shoichi Aoki in the street-fashion magazine *FRUiTs* in the late 1990s through the early 2000s.

------ Lolita ------

Harajuku fashion style with many subgroups, including Gothic, Kodano, and so on, characterized by an exaggerated girlish style of clothing with fitted waists; short, full skirts; petticoats; pinafores; and aprons, worn with curled, colored hair and doll-like makeup.

Skinny Jeans
Styles inspired by J-pop stars, foreign celebrities, and models, based on low-rise skinny jeans worn with elastic-heel ballet flats, became hugely popular. Around this time, denim designed and manufactured in Japan gained recognition and popularity.

Fast Fashion
Styling with cheap, mass-produced, on-trend clothes from overseas brands such as H&M, Zara, Forever21, and others became popular, along with "high-low" blended styling that accessorized clothes from these brands with a luxury designer bag.

Mori Girl (Forest Girl)
A nostalgically feminine, pretty, earthy trend, meant to evoke a "girl who runs through the forest" and characterized by natural, floaty fabrics, floral prints, long skirts and dresses, and long curled hair adorned with flowers.

New Standard
Simple, back-to-basics style, popularized by brands like Muji, involving matching sweater sets, Levi's jeans and white T-shirts, flat-front chinos, and Converse sneakers.

Urban Outdoor
Inspired by a mountaineering and hiking boom among young men and women beginning around 2010, this style involved wearing outdoor sportswear such as camping gear, fleeces, cargo pants, and hiking boots in the city. Down linings and vests were particularly popular among men and women of all ages across Japan.

Nineties Revival & MA-1 Flight Jackets
Military-inspired urban gear, based on fighter-pilot-style jackets (also called *blouson* in Japan) and worn with jeans or dresses became iconic elements in the 1990s-revival style, in which old silhouettes were deformed, expanded, or destroyed to create new looks, and wearing vintage clothing with new clothes became popular.

"We always have been exceedingly ingenious when it comes to clothes. It is almost like it is in our DNA. The reason behind this, I believe, is an admiration for international influences and styles. That is why so many original fashion styles were created."

—Kumiko Takano, editor in chief, *ACROSS* magazine

THE ORIGINS OF STREET STYLE IN TOKYO

In August 1980, a Japanese magazine and research institute called *ACROSS* began investigating youth fashion culture in Shibuya, Harajuku, and Shinjuku, three areas of Tokyo known for their vibrant youth fashion scenes. The magazine used a method called *"teitenkansoku"* or "fixed-point observation." They wanted to record changing fashion trends over time by focusing on the clothing worn by regular people on the streets in these areas. Once a month, *ACROSS* editors would go out on location, set up a camera, and photograph and interview people who passed by.

Kumiko Takano is the editor in chief of *ACROSS*. She also serves as an expert adviser to the Japan Fashion Color Association. After first joining PARCO as an editor in 1992, Takano was appointed editor in chief in 2000. PARCO, the storied Japanese retail chain, was the first store to carry designs from Comme des Garçons and Yohji Yamamoto and

has been shaping Japanese fashion through its selections and its publications for generations. We ask Takano for her thoughts about the major developments in Tokyo street style over the years, and how those changes are still relevant today. "Looking back at Tokyo's street-style fashion from the beginning of *teitenkansoku*, we see that from the early 1980s, 'designer and character' brands, shortened to 'DC' in Japanese, were in their prime," Takano explains.

Not long after *ACROSS* began stopping people on the streets, the big trend in Tokyo was a unified, coordinated style, usually with clothes from a single designer. "Comme des Garçons and Yohji Yamamoto were first on the list," Takano says, talking about the most popular DC brands, "and unifying attire from head to toe under a single brand name was the most popular style back then. People wanted to share the creative aspirations of the designer by wearing brand-name clothing and they had a strong desire to embody the overall style being suggested by the designer."

MIXED STYLE

By the early 1990s, according to Hirofumi Kurino, "people learned how fun it was to play with mix-and-match fashions." Hirofumi Kurino, who began working in the fashion industry in 1977, is one of the original founders of select shops in Japan. As such, he had a major influence on the development of mixed styles. After joining the multilabel select shop Beams early in his career, Kurino and some of his colleagues at Beams started another multilabel store, United Arrows, in 1989. Kurino tells us that when the first select shops, such as Beams and United Arrows, were established they "became a major topic

of conversation because these companies showed you *what to wear* and *how to combine clothing* in order to create a proposed style rather than just selling you some clothes. In other words, the mission of multilabel stores is to suggest an overall style rather than just to simply offer up merchandise."

This shift in focus from brands to individual styling marks the beginnings of street-style culture, according to Kurino and Takano. Takano further attributes the movement toward styling rather than single-brand coordination to the children of the baby boomers beginning to take on a leading role in fashion: Rather than taking fashion inspiration from designers showcasing new styles on the runway or in fashion magazines, it became possible for anyone to experiment with different ways of wearing their own clothes and to go out on the streets of Harajuku or Shibuya to show off their styling creations.

One of the earliest styling techniques was layering, as people mixed and matched their DC brand clothes with more obscure brands or basics. Street-style culture developed, according to Takano, because "fashion styles were increasingly deconstructed and reformed." In other words, people began to notice each other on the streets and take inspiration from the ways in which their fellow street stylists would interpret trends. As fashion became more egalitarian, more grassroots in terms of how new styles were created, select shops, led by pioneers such as Beams and United Arrows, were established to cater to the new demand for personal style that mixed brands, shapes, textures, etc., rather than the hyper-coordinated stylings determined by a single brand.

Takano tells us that experimentation with size and proportion in styling was also increasingly visible during the nineties, and this styling technique is still popular today. "For example, take sneakers. People began wearing larger sneakers on purpose and the trend took off. But this was not just a simple fashion statement. By adding volume to the feet, the legs appear more slender." She says that people also tried to change the shape of their heads through styling. "People began to wear knitted hats and then took in the back of the hat, or attached something to the back of the head to add volume." Takano suggests that playing with proportions like this is inspired by interactions with fashion overseas. "When it comes to our figures, Japanese people seem to look to body types of Americans and Europeans for comparison. So, I think that in order to create something approaching what many considered an 'ideal figure,' like Western fashion models, fashion coordination and styling techniques were developed that made use of various textiles, patterns, and methods of layering."

"Street-fashion photography is almost an invention of Japanese people."

—Hirofumi Kurino, senior adviser for creative direction, United Arrows

Freedom & Precision: The Driving Forces Behind Tokyo's Fashion

Contributed by Hanami Isogimi

Staffer Chang's fearless outfit is in keeping with Facetasm designer Hiromichi Ochiai's bold, experimental ethos.

Even in the midst of accelerating globalization and easy access to fashion information around the world, designers based in Tokyo maintain an originality that is unlike anywhere else. Their penchant for combining disparate elements is made possible by two things: a free spirit and precise attention to detail. These traits are in the DNA of Tokyo fashion, which has in turn influenced the rest of the world. Today we are seeing an increasing number of hybrid styles appearing in international collections. But this free-spirited yet precise approach to fashion was born and cultivated on the streets of Tokyo.

Designers here don't hesitate to combine concepts or items that were originally antithetical. This sort of distortion is fun and interesting for Tokyo's street-style enthusiasts and is one of the most distinctive characteristics of Japanese fashion. One good example of how designers and fashion consumers revel in mixed, hybrid fashion is the popularity of the brand Facetasm. As the standard-bearer of mixed fashion, Hiromichi Ochiai of Facetasm is one of the most sought-after designers in Japan. Street- and high-fashion, casual and elegant, his style fuses elements that contradict one other. Facetasm has become popular across Japan and the

brand's presence overseas has been expanding recently.

Ochiai has often said that, being Japanese, he doesn't feel taboos and constraints when it comes to designing clothes. He says he is free—that is, free from social and cultural expectations about how to dress, free from rules about what clothing is, free from conventional cuts, fabrics, gender classifications, and so on. Through this freedom, Ochiai believes he is able to express multifaceted beauty in his designs.

In addition, the everyday style in Tokyo reflects a precise attention to detail. For instance, foreign visitors to Japan often notice people carrying small square hand towels or handkerchiefs. These are used for blotting the face on hot days, or for drying hands after washing them, even if hand dryers are available. This seems like a small, ordinary detail, and no one thinks twice about carrying one. But in fact, it is a kind of small, personal luxury in public bathrooms, on public transportation, and in other public places to have a good-quality, soft hand towel to use. High-end products, such as Imabari towels, made in Japan with the finest cotton and craftsmanship, or towels made by luxury fashion brands are common, but the towel doesn't have to be expensive to feel luxurious. It is this appreciation of and demand for small, personal luxuries of high quality that is a characteristic that many people in Tokyo, and indeed the rest of Japan, share. In terms of fashion, Japanese designers are extremely attuned to this demand, and so there is an emphasis on "made in Japan" quality and painstaking craftsmanship and construction.

We can see this attention to detail in brands like N.Hoolywood and Hyke, which are created by designers who are well versed in vintage clothing. These designers create clothes that, at a glance, look very simple, even though their cutting and material selections are distinctive. Design at beautiful people (page 228) also expresses this view. The brand's clothes are distinguished by their patterns, which are carefully developed to include subtle expressions of wit and humor. Although true fans enjoy discovering these in-jokes inscribed within the designs, many people who wear beautiful people clothes simply enjoy feeling the care and attention that so obviously goes into creating them, which, of course, they have come to expect from Tokyo designers.

Fashion journalist Hanami Isogimi first came across the street-photography magazine FRUiTS *as a child and grew up with a passion for Harajuku street-style fashion. After graduating from university in 2006, Isogimi joined the largest Japanese fashion industry newspaper,* Senken Shimbun/The Senken, *and covers a wide range of fashion-related events and topics, including Fashion Week both in Tokyo and internationally.*

A FASHION OBSESSION

Despite the popularity of mixed styles, one holdover from the DC brand boom in the 1980s is that there are many fashion-sensitive people in Tokyo who, when they feel an affinity with a designer's philosophy, will make sure to buy clothes from that brand, even if the clothes are expensive or impractical. These people are known affectionately as "fashion maniacs" (see page 205 for more about "maniac" fashion and the brands they love). Brand enthusiasts invest in a favorite designer's clothing as if they are buying artwork. As we'll see in the following chapters, these maniacs, through their support of fledgling brands and fashion businesses, are making it possible for new designers and curators of select shops and concept stores to establish their brands and focus on design and innovation.

Kumiko Takano links the insatiable desire for fashion—and also the fragmentation of fashion into an ever-expanding array of style options—to the rise of fast fashion in the early 2000s, most notably through overseas brands like Zara, H&M, and Forever21 opening up in Japan. "Although the power of consumers in Japan was strong [in the nineties], fast fashion from manufacturers responding to the needs of today's highly discerning fashion consumers has rapidly increased." While DC brands may have dictated style to their followers a generation earlier, fast fashion brands have taken a more responsive, consumer-driven approach to producing their designs.

Although many stylish people enjoy the immediate, on-trend availability of fast fashion brands, others are pursuing different aspects of fashion and style as a way to differentiate themselves. Since Japanese consumers expect brands to produce fashion (and everything else) with a high level of quality and style, as Hanami Isogimi mentioned earlier (see pages 20–21), it's hardly surprising that many discerning consumers would focus on finding high-quality vintage pieces, while others value traditional Japanese craftsmanship or are extremely particular about the materials and source of the clothes they wear. Still others look for a total lifestyle concept. Behind all of these pursuits is the desire for Japanese quality and the attention to detail that Isogimi discusses. Here, we'll look at a number of influential brands that provide the highest levels of design and quality, shaping street style in the process.

"MADE IN JAPAN" CRAFTSMANSHIP

Petite Robe Noire designer, Yoshiyo Abe, is often credited with bringing costume jewelry to the street styles worn by women in Tokyo. Before she launched a website selling vintage costume jewelry and later established her own jewelry brand Petite Robe Noire in 2009, costume jewelry was not something that women commonly included when styling their looks. The brand changed how women thought about costume jewelry to the extent that now it is a regular staple of both classic, elegant looks and sportier styles, playing on the deliberate mismatch between the jewelry and the clothes.

"It really makes sense to me to create jewelry by working in close proximity to all of the craftspeople and manufacturers involved in producing of my pieces," she tells us when we meet at the Petite Robe Noire atelier. "And Tokyo has

Inside the Nishi-Azabu store,
SIRI SIRI's contemporary jewelry is on
display. The distinctive designs,
created by Naho Okamoto (above) are
made using glass and rattan through
traditional Japanese techniques.
Okamoto's pairing of a black Muji
T-shirt with white JIL SANDER pants is
an elegantly simple way to showcase
her chic jewelry designs.

24

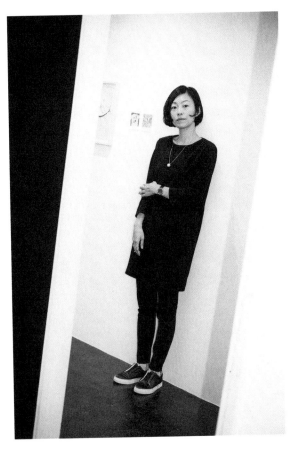

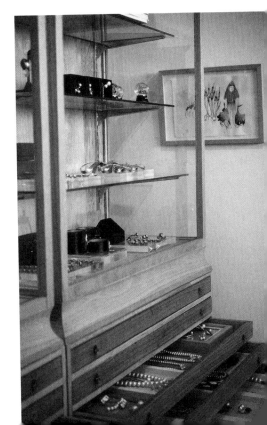

"We aim to pursue designs with originality to create something that is more than just 'made in Japan.'"

—Hiromichi Ochiai, designer, Facetasm

the kind of creative environment that is conducive to such collaborations. I want to keep pursuing the highest levels of craftsmanship, which is only possible here."

Another jewelry designer, SIRI SIRI designer Naho Okamoto, echoes this sentiment when talking about the creative possibilities here in Tokyo. "The more I go abroad, the more I am impressed with the level of freedom in Tokyo and the richness of the ways for expressing yourself. I want to keep creating jewelry as fashion in such environment—designs with the intensity of artworks, but that can also be used in everyday life." Okamoto combines traditional Japanese techniques such as *Edo kiriko* (glassware) and Buddhist altar fixtures with contemporary designs, working with skilled craftspeople to create SIRI SIRI jewelry.

OPPOSITE Inside the Petite Robe Noire showroom and atelier are designs that feature Yoshiyo Abe's signature luminous cotton "pearls," which are made by compressing cotton into beads and polishing them until they shine.

Many Tokyo clothing designers also prioritize both the provenance and processes by which the materials and fabrics they use are produced. For instance, Ryo Kashiwazaki, designer of the genderless brand Hender Scheme (see page 162), tells us, "We value wit and humor in our designs, and strive to create clothes with solid craftsmanship."

As fundamental as traditional Japanese methods and quality craftsmanship are to designers such as Abe, Okamoto, and Kashiwazaki, there also needs to be something more to create something truly unique. Tokyo's most influential designers are, naturally, also obsessed with originality and finding new combinations in their designs.

Designer Hiromichi Ochiai of Facetasm is known for his skill at sublimating his wide-ranging knowledge of music, film, and art in an original way to create surprising, sophisticated clothes. Facetasm's avant-garde designs blend street casual and luxury effortlessly and always top any list of Tokyo's fashion musts. When we meet Ochiai at the Facetasm store in Harajuku, we talk about his influences. "When I was a teenager in 1990s Tokyo, there were many fashionable adults who wore many different fashion genres. I paid close attention to street culture in which the world's fashions were mixed into Tokyo's original style. I think that my own creations reflect the influence that particular time has had on me."

The mixed styles and cross-genre influences from his youth are evident in the complex patterns and original textiles Ochiai's designs are known for. "While making the most of the Japanese people's excellent attention to detail," Ochiai says, "we aim

"**Because the Japanese have come into contact since childhood with various fashions that are not bound to a single country and culture, I think that the potential to create something new is high.**"

—Yoshikazu Yamagata, designer, writtenafterwards

to pursue designs with originality to create something that is more than just 'made in Japan.'" For Ochiai, the quality of manufacturing, and the brand's customers' demand for it, are a given. Building on that firm foundation of quality craftsmanship, Ochiai focuses on creating new possibilities for original designs without feeling constrained by cultural taboos surrounding Western-style clothes. This is a common refrain from the designers we spoke to and also directors of select shops and vintage stores, many of whom said they felt at liberty to collect, dismantle, and recombine various influences. With the whole world to choose from and a very Tokyo "why not?" attitude, Japanese designers and store directors, along with the people who wear their clothes and shop in their stores, have created some of the most original and eclectic collections in the world.

Designer Yoshikazu Yamagata of the brand writtenafterwards has been called a maverick by the Japanese fashion media for his avant-garde creations, which are more like works of mixed-media art than clothing: disposable outfits for a single wear made of scrap materials like paper and plastics, headgear with motifs featuring rakes and globes, and other surreal experimentations. Yamagata's designs are not so much to be worn in real life as to be displayed as art with the goal of evoking some kind of horror or fantasy. His clothes often have asymmetrical, organic silhouettes in vivid, hallucinatory colors and patterns, sometimes even with appendages growing out of them—a third or fourth arm or leg, one much longer than the other or pointing in odd directions, for example. As a designer, Yamagata is also not constrained by social trends and conventional wisdom. But what makes Yamagata's creations special is how he links his designs to contemporary world culture and current events as well as to popular legends such as Japanese *yokai* monsters, hermits, and other fantasy archetypes. He is a designer who has maintained a rebellious spirit while at the same time keeping a close watch on what is current in fashion.

We asked Yamagata what makes style in Tokyo unique: "Because the Japanese have come into contact since childhood with various fashions that are not bound to a single country and culture, I think that the potential to create something new is high compared with people overseas. Recently, the ability to adopt outside influences—not only in everyday style but also in costuming and cosplay—has created so many variations in Japanese street style that you could say it's the best in the world."

After graduating from Central Saint Martins, Yamagata worked under

At Kanda Myojin Shrine in the Sotokanda area, close to the brand's atelier, staff member of writtenafterwards Kazue Nukui is wearing a red organdy blouse with embroidery, a palette-shaped clutch by writtenafterwards, and a skirt from the London brand Molly Goddard.

John Galliano, whose own outrageous designs and modes of expression inspired Yamagata as a young designer. Yamagata is also a regular collaborator with the designer Mikio Sakabe with whom he published a book, *Fashion wa maho* (Fashion is Magical). Yamagata and Sakabe conceive of fashion as always evolving and ephemeral; it is like magic that appears and disappears in an instant, which is the central concept behind Yamagata's unorthodox designs. (Sakabe's own style is inspired by pop art and *kawaii* influences.)

But it was Yamagata's designs for Comme des Garçons spring/summer 2014 that truly established his brand as a major force on the Tokyo street scene, among both Japan's fashion media and his now-devoted fans. Talking about the experience of working with Rei Kawakubo, there is a sense of wonder and awe, the kind that a fashion student might have for a revered instructor: "I'll never forget the charming expression on Rei Kawakubo's face when she thanked me after we finished creating the collection."

Yamagata's constant innovation and rebellious spirit made him a natural protégé of Kawakubo, but also a role model for aspiring fashion designers. He tells us that, from working with Kawakubo, he learned "the ability to produce creations from abstract words. I also developed a more serious work ethic and attitude towards my designs." Yamagata has since taken the discipline and knowledge he gained from the collaboration with Kawakubo to mentor other younger designers.

Together with Sakabe, Yamagata opened the fashion school coconogacco. Under their tutelage, many of the

"One of the reasons for publishing street-fashion photography is that by pursuing fashion we might end up revealing fundamental human traits."

—Shoichi Aoki, editor in chief, *STREET* magazine

school's students were awarded prizes in the International Talent Support (ITS) fashion contest sponsored by Diesel. The success of writtenafterwards inspired him to spend a lot of time nurturing new talent through workshops, exhibitions, and fashion events to encourage them to develop their creative instincts and to go their own way, while also paying attention to what's going on around them and taking inspiration from the wide variety of styles that can be seen on Tokyo's streets.

FASHION AND IDENTITY

Having options—even when the number of options seems overwhelming—has made the street style we know today possible. Kumiko Takano from *ACROSS* recounts: "One day in 2008, a girl I spoke to while we were doing *teiten-kansoku* told me that 'fashion is like lunch.' That really surprised me. But she explained that she thinks about fashion each day in the same way that she does when she decides what to eat at lunch: today will be Japanese food, tomorrow is Chinese, the next day Italian, and so on. When you think about it, it's not really surprising or strange at all. If you were to search for street-style looks on

the internet you could easily decide on Shibuya casual for today, Kogal style for tomorrow, and then Ura-Harajuku style and so on. Young people who think this way are on the rise."

"On the other hand," Takano continues, "a different girl told me that 'fashion is a search for identity,' and that is something I think I will remember for a long time." While trying out a wide selection of style options does have its merits, most people we spoke to would agree that when you see someone with a clear sense of their own style, the effect is unmistakable. Mike Abelson says, "Popular trends come and go. But sometimes walking down the street, I'll see someone who has his or her own distinct but really good sense of style. They might seem aware of what is happening at the moment but at the same time, they're outside of the standard. I feel like there are quite a few people like that here in Tokyo."

Fashion as identity, as a way to reveal something essential about a person's nature, is an idea that Shoichi Aoki, founder and editor in chief of *STREET* magazine, has spent his career pursuing. "One of the reasons for publishing street-fashion photography is that by pursuing fashion we might end up revealing fundamental human traits," Aoki explains. Taking a remarkably neutral approach to fashion photography, Aoki has tried to capture styles as they develop in the streets in order to make a permanent record of something that is always changing.

EVER-CHANGING, EVERLASTING STREET STYLE

Just as specific trends come and go, the popularity of "street style" as a fashion story or a sub-genre of fashion photography waxes and wanes depending on the season, who is out and about, and what's trending on social media. When we spoke with Scott Schuman, of *The Sartorialist* fame, he was optimistic: "People ask me if street style is dead. I don't think it will ever die because people will always love looking at people."

We couldn't agree more. Walking down Omotesando's famous treelined boulevard and seeing everyone dressed up with obvious intention in so many different styles, it's hard not to get caught up in the performance. Our motivation for creating this book, for photographing and interviewing people whose influence can be seen in magazines, advertising, exhibitions, and other venues throughout Tokyo, is contribute to the conversation and create a lasting record of a significant cultural movement.

Style practiced in Tokyo has a relevance that extends far beyond the city limits. The themes we've introduced in this chapter and continue to explore throughout the book—finding inspiration everywhere, combining pieces in unique ways, paying careful attention to craftsmanship, passionately pursuing great style as an expression of self—are shaping fashion worldwide. They are compelling concepts no matter where you live.

In a printed book, we have to admit that the latest trends will always be beyond the format. But as we'll see in the next chapter, what makes someone stylish transcends trends and the season's collections.

Q&A
Shoichi Aoki

Editor in chief, *STREET* magazine

Shoichi Aoki is the editor in chief of STREET magazine, the first magazine of its kind to catalog street fashion. Aoki's pioneering approach to capturing the styles worn by young people on the streets has influenced the genre of fashion photography and fashion more generally ever since STREET was first published in 1985. As director of LENS Inc., the publisher of STREET and FRUiTS (currently closed), Aoki has also published numerous photographic collaborations with national and international fashion brands including Maison Margiela, Facetasm, Mastermind, and others. We caught up with him in Harajuku (where else?) to find out more about how street-fashion photography as we know it got started.

STREET is a pioneering street-photography magazine. What was it like when it first launched back in 1985?

Styles in Tokyo back then were the so-called designer and character [DC] brands, led by Comme des Garçons, Yohji Yamamoto, and Issey Miyake. All fashions were influenced by these leading fashion designers. There was a trend where if you were not wearing clothing from the above-mentioned brands, you were not fashionable. I didn't like this idea, so I created *STREET* as a way of bringing the liberated street-style fashion that I saw on young people in Paris to Tokyo.

When STREET was first published, there weren't any other magazines dealing with street photography, were there?

No, there weren't. Among those photographers shooting fashion shows during Fashion Week in London or Paris, I was the only one taking photographs *outside* the venue. I think everyone thought I was weird.

During a prolonged stay in Paris, I found that the street-fashion styles worn by young men and women there were quite new and fascinating. The experience triggered something in me and I began to think about where such fashion originated.

Humans have been drawing pictures using clay and plant-based pigments since prehistoric times, as in the Lascaux cave paintings. I thought humans may have expressed themselves by applying such paints to their bodies, too, and if so, that this painting could be seen as a form of early fashion. However, it seems like

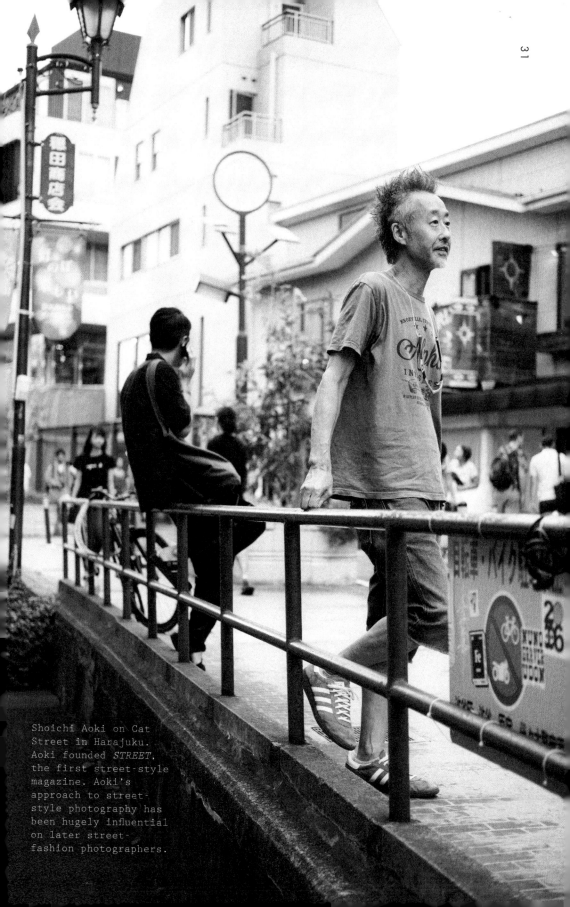

Shoichi Aoki on Cat Street in Harajuku. Aoki founded *STREET*, the first street-style magazine. Aoki's approach to street-style photography has been hugely influential on later street-fashion photographers.

fashion is considered to be less significant than music and the other fine arts in our society. I think fashion is a fundamental human activity, but why does fashion always seem to be treated as inferior when compared with other forms of art? In addition, other forms of art—music, painting, literature—are well documented and records remain, while fashion is rarely documented and tends to disappear. I thought this was so wasteful and decided to investigate this question of why people think less of fashion than other forms of artistic and cultural expression.

STREET was started with the intention of introducing liberated fashion styles to Tokyo while compiling records of street-style fashion. This mission hasn't changed since its inception. We do this to document street-style fashion history. That is why we have consistently had very few advertisements. We have simply been taking pictures of fashionable people who we found by chance on the streets.

Aside from Fashion Week, in the mid-1980s to the mid-1990s, you went to flea markets, Portobello Market in London for example, and took photographs of various people there. Is there a particular reason why you didn't take photographs in Tokyo?

As I mentioned before, if you weren't wearing clothing from a specific brand name in Tokyo, then you weren't considered fashionable. This trend persisted for nearly ten years after STREET was first published, so I wasn't interested in Tokyo back then. However, my office was in Harajuku and I can tell you that I was still observing Tokyo's streets. The popularity of DC brands had declined, and by the mid-1990s Vivienne Westwood and Christopher Nemeth were brought over to Japan. Then Milk started to introduce cute, punkish designs, and all of a sudden, in 1996, young people wearing the mix-and-match-style looks from these brands began to appear in the pedestrian zones of Harajuku. I thought to myself, "Now here is something different."

Even though not much originality had developed yet, I felt the coming of a new tide. So I gradually began to take photographs in Tokyo and expose everyone to Tokyo's new fashion in *STREET*. Then young people who were obviously styling themselves in their own very original ways began appearing. For example, we saw those who cut up brand-name clothes in order to create their own look. I could see gradual changes in youth street-style fashion. I thought, "We have to get serious about this!" So in 1997 we started to publish *FRUiTS*, a magazine that exclusively dealt with the introduction of street-style fashion in Tokyo.

Every issue of FRUiTS featured intriguing people. Some even were scouted by talent and modeling agencies.

Yes, Kyary Pamyu Pamyu, now a world-famous J-pop artist, was one of those models. Our method of photographing models who were standing up straight and not smiling became the standard for a series of street-photography magazines that were subsequently published. We also nurtured some talented photographers on our editorial staff, including Rei Shito.

What was the editorial process like at FRUiTS?

Similar to *STREET*, it began from an academic vantage point. One of its purposes was to collect records. As far as the photography is concerned, we tried to remember to take pictures as if we were creating "specimens." That is why we used to say, "Stand as you normally would," to those who were about to be photographed. I also think that including the background was quite important. I habitually warned our editorial

"Fashion is a fundamental human activity."

—Shoichi Aoki, editor in chief, *STREET* magazine

staff going out to take photos for the first time, "Take pictures precisely as if you were shooting exhibits at an art museum, be sure to include the background, and do not reflect your personality in those photographs." I should mention that back then cool kids didn't smile when we pointed the camera at them anyway, so it was natural for them. Maybe it was just that sort of time.

You have said that Tokyo's street style is less inspired today. Was there a noticeable turning point?

It was about five years after *FRUiTS* was first published. During those five years, the pedestrian zone along Omotesando was closed down. [Without that dynamic setting] our photographs all looked similar and, as a result, Tokyo's fashion no longer appealed to me. In London, fashionable people and stores were concentrated from Neal Street down to Covent Garden, and I used to go there to take pictures. I think that fashion will mature and evolve in a place like the flea markets in Portobello and Camden where there is a plaza or pedestrian zone. In order for street style in Tokyo to regain its energy, I think it is necessary to bring back the pedestrian zone along Omotesando in Harajuku.

Chapter 2

Tokyo's Street-Fashion Leaders

"The rule for good street style is not to make any rules."

—Rei Shito, street-fashion photographer

In this chapter, we introduce some of the leading figures in Tokyo's street fashion, who tell us about how they found their own individual style. We discuss how they experiment with street trends and what they admire in others. Nearly all of them said that what they found most attractive in other people was confidence in one's own taste and wearing what you like without worrying about what other people think. And each of the women featured happen to possess this fearless approach to fashion. They know their bodies and their lifestyles and choose clothes that work with both. They all love clothes and relish different possibilities for styling, whether it's mixing vintage with pieces from emerging designers, or combining high- and low-end fashion, adding fun and unexpected details to standard pieces, or experimenting with men's and gender-free styles. Whatever their personal style, the thing they have in common is the carefree attitude that allows them to experiment with new ideas and trends while remaining true to their own natural styles and senses of self.

We hope you'll enjoy seeing what Tokyo's most stylish people are doing and wearing and be inspired by the approach these women take to street fashion, in order to bring a bit of Tokyo into your own attitude toward clothes.

OPPOSITE To create a playful, somewhat boxy, girlish style with vivid colors, model and blogger Shen Tanaka pairs a high-impact Miu Miu jacket with a Zara knit.

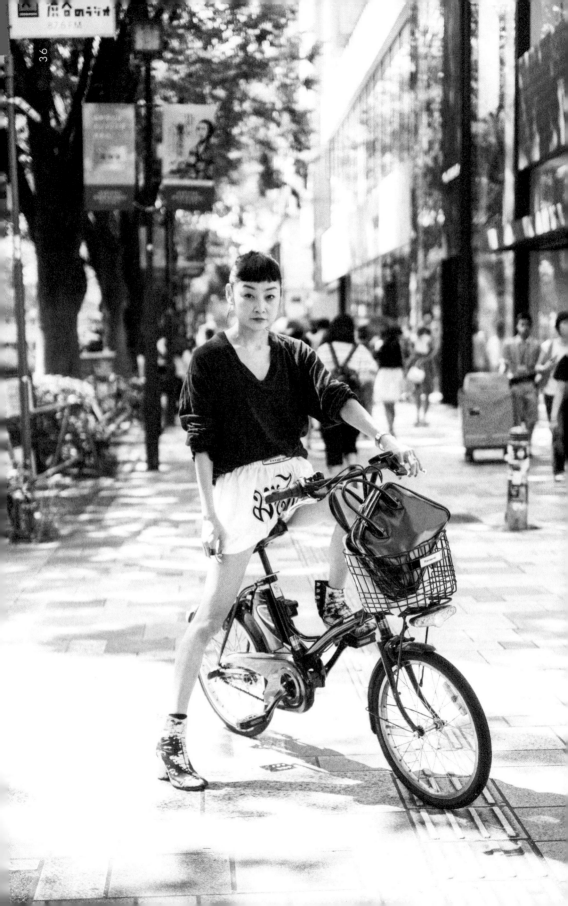

Rei Shito

Street-fashion photographer
and fashion journalist

"My sense of style comes from the streets."

—Rei Shito

Rei Shito is a Tokyo-based fashion photographer and journalist. She is usually found on her bicycle with her Fujifilm camera in her bag looking for new styles on the streets, which she posts on her street-style blog, *STYLE from TOKYO*. When she is not in hip Tokyo fashion areas like Harajuku, Roppongi, or Aoyama, she is traveling the world, shooting stylish people attending fashion events or just going about their lives. She is one of the hardest-working street photographers out there, and is a favorite street-fashion subject, too. She regularly appears on photographer Scott Schuman's *Sartorialist* blog and in Phil Oh's street-style reports on Vogue.com. When we caught up with her—on her bicycle out shooting street style, as usual—we ask Shito where she found inspiration for her unique style.

"I think my sense of style comes from the streets. What I learned there not only changed the style of fashion that I liked, but it also changed me." Growing up in rural Ishikawa prefecture, Shito loved fashion and, like many high school students, simply wore what everyone else was wearing. "I don't think I was very fashionable, though," she says, "because it was in the countryside and the amount of information about fashion, and the number of shops, were very limited compared with Tokyo. Plus, I hadn't decided on what I wanted to do in the future at all." We were immediately struck by how Shito mentions needing a clear purpose for the future as a precondition for being able to select fashionable styles. One of the prerequisites for good style that many of the women we spoke to mentioned is a defined sense of self. If you don't know what you like, or what you want to do, the thinking goes, you can't know what suits you best.

Shito decided to go to university in Tokyo, where, she said, the people around her inspired and nurtured her interest in fashion. "A friend of mine at university, Hideaki Sato, adored fashion. He later became a designer and established his own brand called Tokyo Ripper [though it's no longer in business]. Sato taught me about vintage clothing and about Martin Margiela, whom he really respects." Sato also encouraged her to occasionally participate in the storied Sen-i

fashion club, which was established in 1949 by a group of students, mostly from Tokyo's elite Waseda University. The club has turned out many popular fashion designers, including Kunihiko Morinaga of Anrealage and Keisuke Kanda who has an eponymous brand. Through Sen-i (which means "fabric"), Rei was discovered for modeling work. Among these high-IQ fashion enthusiasts and designers, she tells us, "I gradually came to realize how deep and interesting fashion is."

"Around the same time, Shoichi Aoki [the renowned street photographer and magazine editor] would often approach me and we would get to talking and do some photo shoots, too. One day, he called me over and handed me a single-lens reflex camera and said, 'Go and take some pictures.' I was like, 'What?' I'd never used that type of camera before and it was such an unexpected request . . . Anyway, with lots of question marks, I did as I was told and started to take pictures in the streets with the camera. I never once thought it would turn out to be my career."

We ask Aoki why he handed Rei Shito the camera: "Looking at Shito, a college student and also a model at the same time, she seemed to be lost in thought about what she wanted to do in the future. I thought that learning to use a camera could help her in her career as a model and in her own future."

Embarking on a career working as a street photographer, a change of course that led to a five-year stint in STREET's editorial office, Shito cultivated her own sense of fashion working behind the camera. But it was a fateful encounter with yet another renowned street-fashion photogra-

pher at New York Fashion Week that launched her to international fame.

While on assignment for STREET magazine, Rei was photographed by Scott Schuman, photographer and founder of The Sartorialist. She didn't realize what this chance meeting would lead to until after she returned to Japan and her friends told her she had appeared on the well-known street-style blog. "I didn't know that Scott was famous when he took my picture," she tells us. "I checked The Sartorialist and found over three hundred comments on my picture, and what's more, readers around the world who didn't even know each other were discussing it in the comments and communicating with each other. With printed materials, you can't do that."

Shito explains that around that time she was feeling uneasy that street photos were coming out in printed magazines such as STREET a month or two after they were taken. "Because the street styles in Tokyo change so fast, coming one after another, the styles in printed magazines for sale on a newsstand already seemed old to me. I thought that

OPPOSITE This smock blouse from the Japanese brand Banzai (which Shito's friend designed) is worn back to front to show off Rei's beautiful back. The velvet jumpsuit is from styling/, a Japanese brand. Shito deliberately chooses to wear a larger men's size of Converse sneakers. And the velvet ribbon wrapped around her head? "I bought it at a craft shop called Toa. I'm a regular there." Her enamel bag is a collaboration between Rei Shito and Isetan Mitsukoshi's private brand, Number Twenty-One.

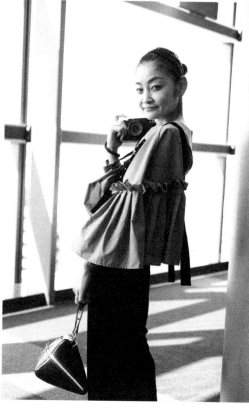

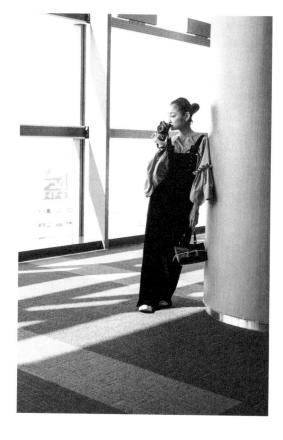

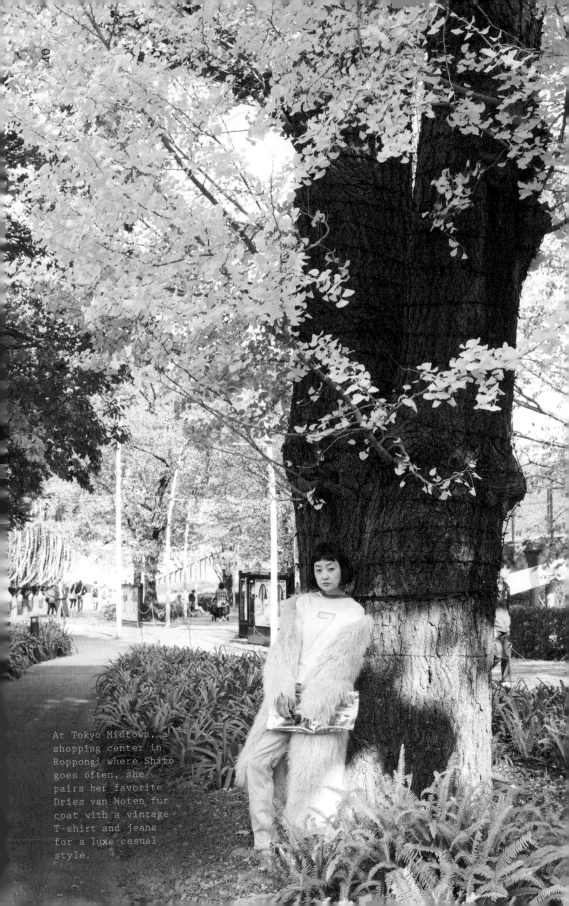

At Tokyo Midtown, a
shopping center in
Roppongi where Shito
goes often, she
pairs her favorite
Dries van Noten fur
coat with a vintage
T-shirt and jeans
for a luxe-casual
style.

"Rei consistently puts together things in a really unique, interesting way. It always looks like her, but it's also always different."

—Scott Schuman, photographer, founder of *The Sartorialist*

introducing styles on the internet, like *The Sartorialist* was doing, was faster and more suited to capturing Tokyo street style. So, I decided to go on my own and make a new start by launching my own website, *STYLE from TOKYO*."

After launching in 2008, *STYLE from TOKYO* soon became a popular source for street-fashion information. The site showcases fashion not only in Tokyo, but also the many places Shito regularly visits, including Paris, New York, London, Singapore, Moscow, and so on. From street fashion to runway shows of luxury fashion houses, Shito captures a wide range of fashion. We ask her whether her travels and global perspective help her to see Tokyo street style in a new light.

"It's definitely special. I think that the Tokyo streets are the center of trend transmission and they have an uncontrollable power. The power of kids on the streets, especially, is great; their styling shows their will to create the next trends really well. In particular, hair and makeup in Tokyo are the most independent in the world!" (See page 69 for more on hair and makeup.) With such power comes some side effects, according to Shito. "In an effort to refine their looks, maybe too much, in friendly rivalries on the

streets, kids here end up being somewhat 'strange' unintentionally." Gothic or Lolita looks in Harajuku are some of the most well-known styles in street fashion in Tokyo, but they are the extreme examples of a spirit of experimentation and freedom in styling. "But," Shito continues, "that strangeness actually turns out to be something new and good. Hair and makeup styles are becoming Galápagos-ized, but in a good way."

By "Galápagos-ized," Shito means the highly specific, peculiar originality that characterizes what most people outside of Japan associate with Tokyo street style. Think bright colors, wigs, chunky platforms, long hair extensions, and so on. These looks seem more "cosplay" than "fashion" and actually are considered subcultures rather than street-fashion by people here in Tokyo. The term was originally used in a pejorative sense to describe flip phones that were designed so specifically for the Japanese market that they could not be used in other languages or countries.

But for Shito, being Galápagos-ized is actually a dynamic, energizing force in fashion whose effects are felt in international shows and in couture especially. "There must be many foreign designers inspired by the hair and makeup of Tokyo girls," Shito says. "I feel that when I watch runway shows. And since many of the people experimenting with these looks are very good at self-promotion on social media like Instagram nowadays, I'm really looking forward to see how street styles evolve from now on."

We ask her what kinds of people on the streets catch her attention. "I notice people whose styling is so free, people who don't conform to conventions. I am always impressed with people who

can incorporate anything into their own styles, like someone pairing girly vintage wear with a boyfriend's big Converse sneakers, or wearing a ballet tutu and putting on a leather jacket over it, or even putting a dress around the neck instead of wearing a scarf, or making the length of a long skirt shorter by blousing it around the waist . . . with so many ideas, styling has no boundaries. The styles suggested by brand designers are not the only correct answers, and anyone can arrange things as they like—since I began to think that way myself, my own style began to change, too."

As for her preferred styles, Shito's one rule is to be open to anything. "At one time," she says, "I was really interested in a free layered style, in which anything was allowed, and that might have changed my view as a street photographer as well. Also, the staff at *STREET*'s editorial office were all people enjoying fashion freely, so I was really stimulated by them and following their lead. I make it a point to create a rule for my own styling: Fashion should have freedom, because from freedom comes more new discoveries. From cheap 100-yen stuff to designer pieces that costs a few hundred thousand yen, I like looking at a diverse range of things and mixing them together."

As we might have guessed from her oversize Thai boxing shorts and vintage boy's tee, Shito says gender categories and typical sizing don't concern her. "I don't look at clothes in terms of gender categories, so I don't really care about sizes. I can adjust them myself by flipping or pinching. I learned these things from vintage," which we'll discuss in more detail on pages 81–113. Vintage clothes, she says, are "basically one-off items, so I have to pick things I like and

"I notice people whose styling is so free, people who don't conform to conventions."

—Rei Shito

make them match my size. And I'm the kind of person who keeps favorite things forever. Like, the child-size flannel shirt I bought when I was in junior high or the bag I bought at DEPT [see page 84], the first vintage shop I visited in Tokyo when I was in high school—I still use them today." And her closet? "Oh, it's amazing, just so full of things. I probably won't ever be a minimalist."

The next person we'll speak to, Shen Tanaka, also embraces an eclectic range of styles and is far more maximalist than minimalist.

OPPOSITE Shito often takes street snaps around the famed shopping boulevard Omotesando, and can be spotted riding her electric bicycle (a definite must on Tokyo's sloping streets). Rei keeps everything she needs for street-fashion shots in this Number Twenty-One bag, which she also collaborated on (one of Isetan Mitsukoshi's private brands). The bag holds more than you might expect in its gorgeous floral and leopard-print interior.

Here she is wearing glitter instead of earrings for a glam-rock touch. Her Thai boxer shorts are a vintage find, which make a striking contrast to her Maison Margiela tabi boots. The Maison Margiela knuckle ring and playful barrette are witty details.

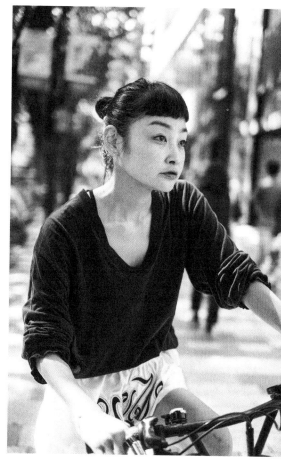

Shen Tanaka

Model and founder of the blog
HINT/OF/COLOR

"Miuccia Prada is my idol. If she were to disappear, I would be lost in fashion."

—Shen Tanaka

Shen Tanaka is a model, illustrator, and founder of the blog *HINT/OF/COLOR*. She studied dressmaking at both the Fashion Institute of Technology (FIT) in New York and Bunka Fashion College in Tokyo. After graduating, she worked for a clothing manufacturer. With her thorough understanding of both fashion and the construction of clothing, Tanaka is good at figuring out her own style and incorporating a wide range of viewpoints. She mixes souvenirs, secondhand items, and fast-fashion pieces with her favorite brands like Prada and Miu Miu. And she always looks amazing.

"I first became interested in fashion as a child—there was a new girl at my school and she was so stylish! I always loved to draw pictures, and as I got older I dreamed of becoming a fashion designer. In high school, I saw photographs of the Prada collections taken by Steven Meisel and I was truly inspired by them. Ever since then, I have deeply admired Miuccia Prada not only for her superb talent, but also the way she keeps a

close eye on everything from the arts to sports, showing classic yet contemporary fashions while proactively using the latest technology. I adore Prada, but I might love Miu Miu even more because of how Miu Miu toes the line between women and girls. Miuccia Prada is my idol. If she were to disappear, I would be lost in fashion."

Miu Miu's experimental, impulsive brand philosophy is very at home in Tokyo. Miu Miu's try-anything ethos is what attracts Tanaka to the brand, and she is not alone. Of course, many women here adore the more sophisticated, considered Prada looks, but street-style influencers like Tanaka can be said to embody the more carefree "why not?" attitude that Miu Miu explores. It is a fun style that can seem somewhat unfinished and effortless.

OPPOSITE Each click of the camera shutter reveals a different side of Shen Tanaka. Her poses show the skill of a true professional. And she creates a look that is equally multifaceted, pairing her Miu Miu jacket with a Zara knit. She bought the shiny mermaid-green pleated skirt at a night market in Taiwan for about $3. Her lemon-yellow Converse are a rare 1990s model.

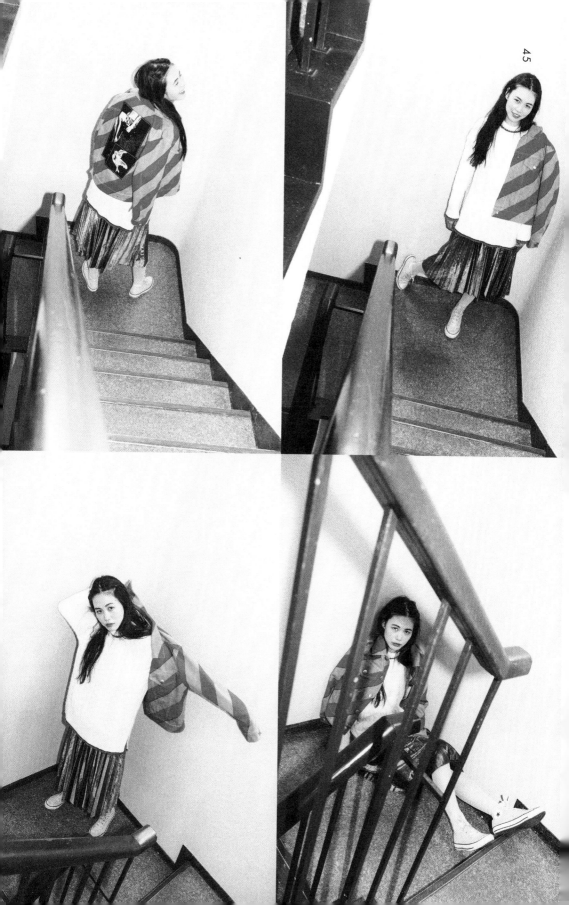

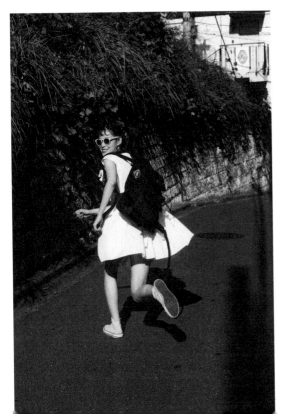
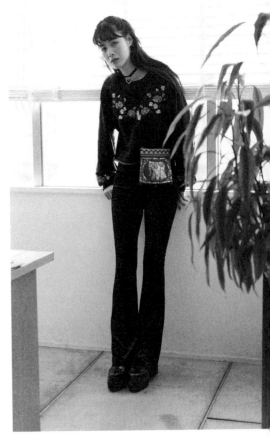

"The silhouette is key for fashion coordination. If I don't like things, even just the tiniest bit, I take things in or alter the shape of the collar myself."
—Shen Tanaka

Tanaka often buys clothes from Prada or Miu Miu at Prada's main store in Aoyama. "They will alter any clothes I buy to fit my body perfectly. Maybe it is because I've studied dressmaking, but, for me, the silhouette is key for fashion coordination. If I don't like things, even just the tiniest bit, I take things in or alter the shape of the collar myself." As any stylist will attest, the perfect fit is achieved only by taking needle and thread to customize the garment (or getting a trusted tailor or skilled friend to adjust the clothes to your body if you can't sew yourself). Tanaka sees her obsession with fit as a fault, but with such particularity comes a kind of freedom to adapt styles to suit your individual look. "Maybe it's because I love fashion so much that I'm so particular. I would really like to try out different styles without being so stubborn, and just relax while experimenting with new styles that suit me, but sometimes I can't help myself."

While a discerning eye for the perfect fit might handicap Tanaka's efforts to try new things, it is also an anchor that helps her stick to what she loves best and what looks best on her. Ayana Miyamoto, who we'll meet next, shares this confident, focused sense of self.

OPPOSITE LEFT AND TOP A crisp summer dress from Miu Miu with Monki sunglasses is worn with a backpack and sneakers to create a feminine but sporty feel.

OPPOSITE BOTTOM RIGHT Tanaka pairs a black base layer with an accent bag sporting an elephant motif that was purchased at a souvenir shop in Thailand. The top is from the Japanese brand Jouetie, known for its vintage-inspired cuts and feminine detailing; the velour pants are vintage; and the shoes are by AHS. The heart choker is from Wego, a budget-friendly Japanese brand inspired by vintage designs.

ABOVE One of Tanaka's colorful and witty illustrations on Instagram (@shen_tanaka).

Ayana Miyamoto

Model

With so much information on fashion available through magazines and social media, and so many shops and brands to choose from, Tokyo is a truly inspiring place for fashion, but also a place that can be overwhelming when it comes to identifying and pursuing your own style. In the midst of this deluge of information, model Ayana Miyamoto says that above all: "I always believe in my own fashion sense." But, that doesn't mean her style is fixed. She says, "I do seek new ideas from the street-fashion scene in Tokyo. I think it has a meaningful history and it is very real and unconventional."

We ask Miyamoto how she maintains an authentic approach to fashion that reflects her identity. "My grandmother used to be a seamstress so I have loved fashion ever since I was a small child. I create outfits according to my state of mind on that day without really being conscious of current trends. I occasionally incorporate vintage items that I inherited from my grandmother. Since I started modeling, I have had many opportunities to wear clothes that I wouldn't choose on my own, so my view of fashion has become more flexible. Being able to discover something new about myself is one of the real pleasures of being a model."

Ayana Miyamoto seems to be able to transform her look completely from shot to shot through her expressive face and instinct for clothes and how to wear them well. Maybe that's why she says her motto is "Be true to myself." Her outstanding off-duty wardrobe is also often cited by the Japanese fashion media.

Miyamoto was one of the first fashion people in Tokyo to take up social media. "Social media," she says, "appeals to me because I can casually transmit a distillation of myself." Miyamoto is constantly experimenting with multiple apps, prompting many of her nearly 100,000 Instagram followers (@catserval) to discuss her methods and wonder what she will try next. These "casual distillations" of herself on Instagram are fleeting experiments in street fashion—which appear and change like the many different clothes she has to wear for work—but they also show an eye for color, light, and most of all fun, inspired by the streets of Tokyo.

Grounding Miyamoto's sense of style is her grandmother's influence and her own love for and knowledge about how clothes are made. With this firm foundation, she is able to distill her look—and then transmit it to the rest of us—so that we, too, might take inspiration. We just need to keep our wits about us and, as Miyamoto says, be true to ourselves by holding on to something that grounds us, whether it's an early style influence, formal training in dressmaking or art and design, or, like our next contributor, our favorite music.

"Social media appeals to me because I can casually transmit a distillation of myself."

—Ayana Miyamoto

Miyamoto's looks are both rock 'n' roll and elegant. She is known for her exquisite color combinations, and here a vintage T-shirt is accented by a blue biker jacket and a pink bag.

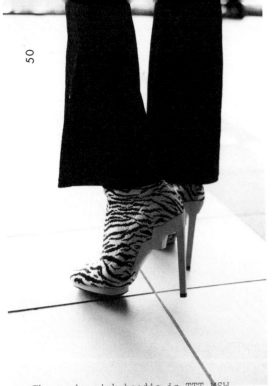

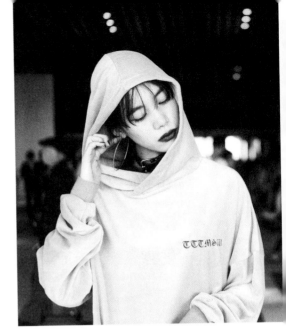

The smoky pink hoodie is TTT_MSW. The boot-cut pants are originals from NADIA, a multilabel-store in Tokyo. Wearing H&M x Kenzo pin-heel boots adds a little sexiness.

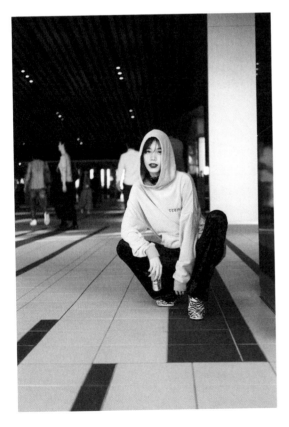

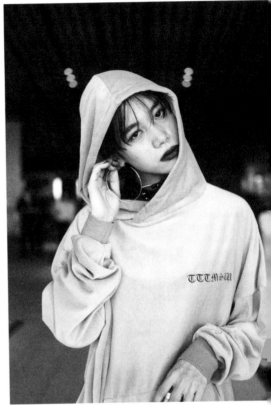

Miyamoto always catches the attention of street photographers with her unique outfits, like this one, which includes a T-shirt and bag by H&M x Kenzo, paired with sweatpants. The handmade choker adds an unexpected, romantic accent to her sporty style.

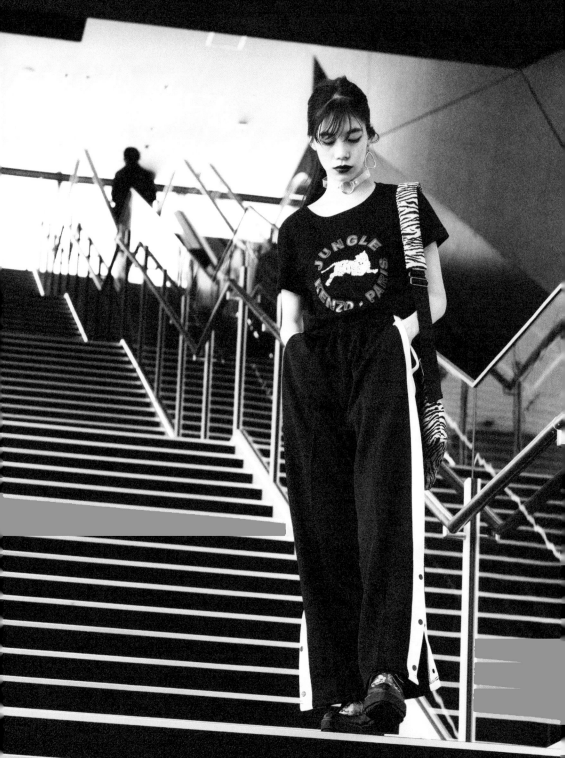

Akane Sasaki

Fashion publicist

"I try to incorporate elements of hip-hop into my style in subtle ways."

—Akane Sasaki

For Akane Sasaki, music is her way of keeping her style bearings. Sasaki has become extremely popular among young women in Japan, who follow her on social media, and is in demand with many of Tokyo's top fashion brands because of this social media presence (not to mention her distinctive fairylike looks and sharp fashion sense). When we ask her about her style, she says: "I love music by hip-hop artists like Kendrick Lamar, Pharrell Williams, and others. I try to incorporate elements of hip-hop into my style in subtle ways."

Since she started doing PR for the vintage store Marte (see page 105), Sasaki has begun adding vintage pieces, too. "Actually, I have never worn vintage or secondhand clothes before, so I'm looking forward to seeing how my style will change in the future. Lately, I have been wearing Chanel necklaces and earrings a lot, but the reason is that Pharrell Williams collaborated with the brand. Although I definitely try to incorporate elements of hip-hop," including, for example, wearing sneakers with everything and oversize sweatshirts with dresses, "nowadays, it seems like I am most comfortable in styles that fuse all of my fashion transitions rather than a single style."

"Since my mother preferred Ivy League/preppy styles when I was growing up, I often chose to dress that way, too. My grandmother also likes fashion and would often wear modern clothes by Japanese designers like Issey Miyake and Tsumori Chisato. I even used to borrow her clothes. Then, when I was in high school, I wanted to create a dreamlike world, so I used to dress in pretty styles that combined lace and various frilled pieces."

So how does street fashion influence her style? "You can wear whatever you want in Tokyo. When I went abroad to study in junior high school in New Zealand, I wore a miniskirt and I was criticized by my host family. I realized then that fashion viewpoints in Japan are very different from those overseas. I think that our attitudes about sexuality and age are very different." This open-minded attitude towards clothing reveals a playful, creative approach to fashion that is visible frequently on Tokyo street's—perhaps most often in the tendency to mix and match styles and genres. Fumika Uchida, our next contributor, excels at cleverly combining today's designer clothing with quality vintage.

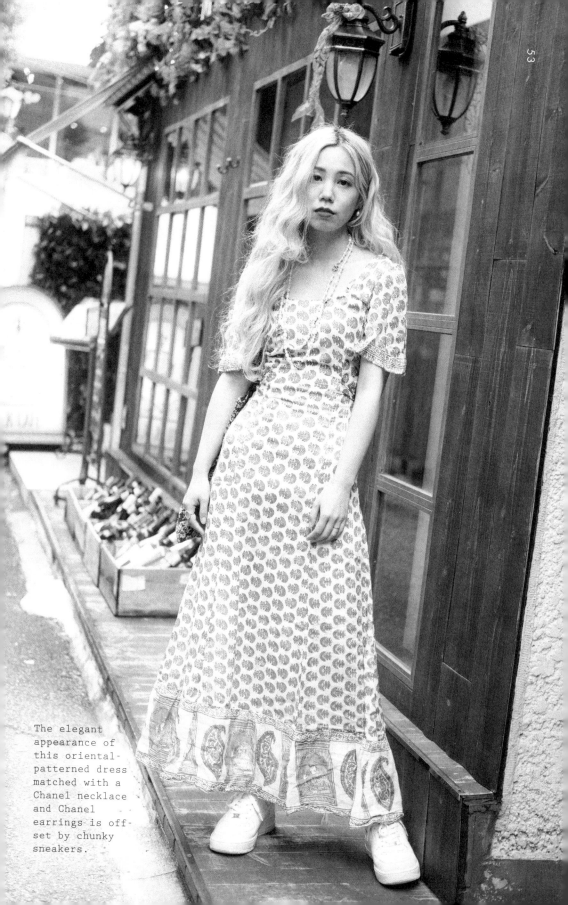

The elegant appearance of this oriental-patterned dress matched with a Chanel necklace and Chanel earrings is off-set by chunky sneakers.

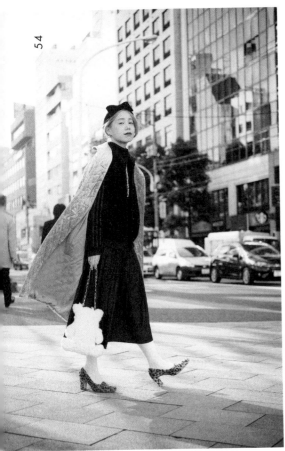

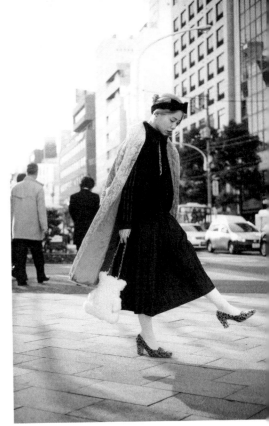
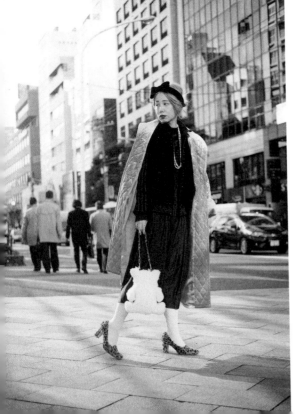
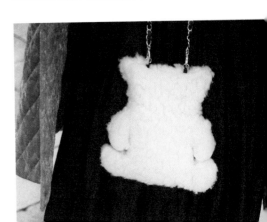

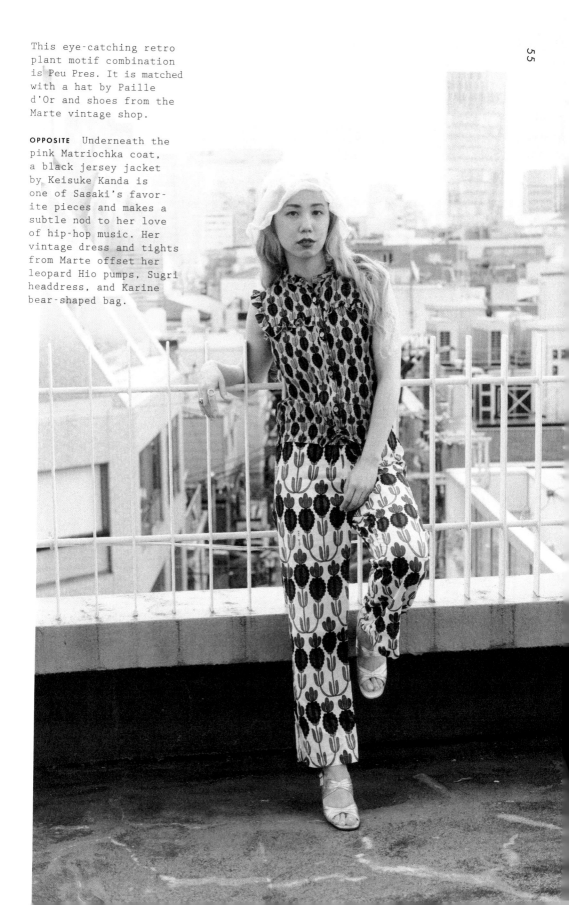

This eye-catching retro plant motif combination is Peu Pres. It is matched with a hat by Paille d'Or and shoes from the Marte vintage shop.

OPPOSITE Underneath the pink Matriochka coat, a black jersey jacket by Keisuke Kanda is one of Sasaki's favorite pieces and makes a subtle nod to her love of hip-hop music. Her vintage dress and tights from Marte offset her leopard Hio pumps, Sugri headdress, and Karine bear-shaped bag.

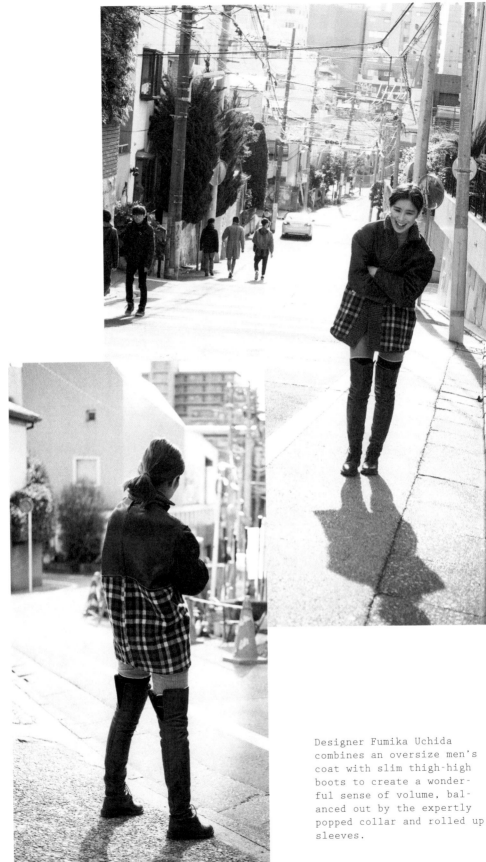

Designer Fumika Uchida
combines an oversize men's
coat with slim thigh-high
boots to create a wonder-
ful sense of volume, bal-
anced out by the expertly
popped collar and rolled up
sleeves.

Fumika Uchida

Designer, FUMIKA_UCHIDA

"Always being on the lookout for things and spending every day with an inquiring, challenging spirit is important when it comes to being fashionable."
—Fumika Uchida

Like many of Tokyo's style influencers and independent fashion designers, including her husband, Hitoshi Uchida, Fumika got her start working at Santamonica, the famed vintage store in Omotesando (page 97). While working there, she honed her eye for good vintage, but eventually she wanted to explore fashion in new ways, so she left the store to open JANTIQUES with Hitoshi (page 92). As an owner and buyer, Fumika has collected an amazing range of vintage from all over the world, and JANTIQUES is known for combining high-end luxury brands with good-quality vintage in-store.

It's not just her store that's known for this—it's characteristic of her own personal style. The clothes she designs and wears herself show a womanly yet handsome kind of beauty with a marked vintage-inspired flair. Her designs use fabrics traditionally used in menswear, including leather and tweed, and are often cut to emphasize a sense of volume in the silhouette. "Lately," she tells us, "I adore wearing clothes that make me feel sexy. Not erotic, but rather a kind of cool, handsome sex appeal. I think women who can create their own style, without dressing up too much or needing to do their hair and makeup, are really beautiful."

Fashion media outlets have taken notice, making Fumika a visible promoter of a core idea on the Tokyo street scene that fashionable women incorporate vintage items into their style.

For Tokyo women like Uchida, playing with new combinations of vintage and high-end fashion reflects a passion that is visible in other aspects of their lives, too. "I think that always being on the lookout for things and spending every day with an inquiring, challenging spirit is important when it comes to being fashionable. I admire women who possess an attitude like this. It makes them so attractive."

Our next contributor also has a passion for wearing pieces with history. Suilen Higashino looks to her Israeli heritage for fashion guidance as she incorporates heirloom and vintage jewelry into her everyday looks, taking inspiration, along with her sister, from their mother.

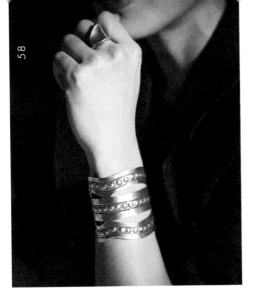

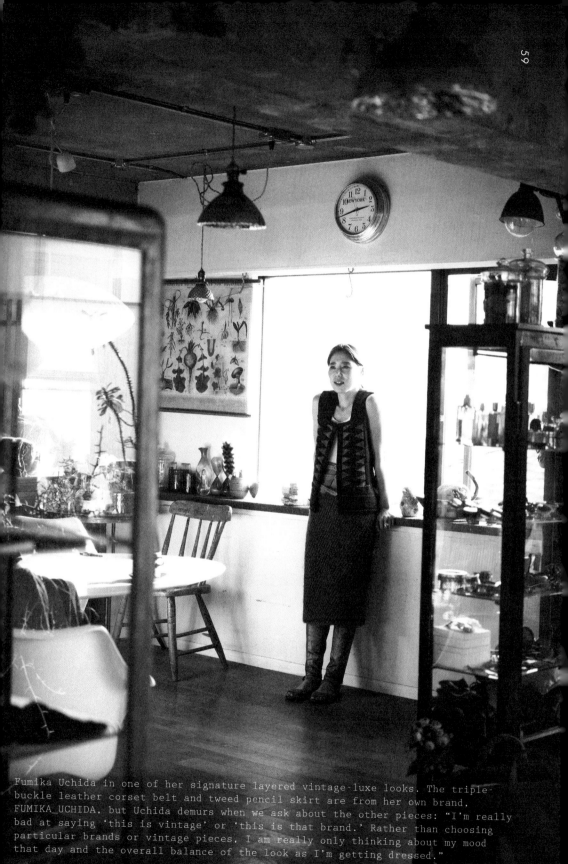

Fumika Uchida in one of her signature layered vintage-luxe looks. The triple-
buckle leather corset belt and tweed pencil skirt are from her own brand,
FUMIKA_UCHIDA, but Uchida demurs when we ask about the other pieces: "I'm really
bad at saying 'this is vintage' or 'this is that brand.' Rather than choosing
particular brands or vintage pieces, I am really only thinking about my mood
that day and the overall balance of the look as I'm getting dressed."

Suilen Higashino

Photographer and model

"Our choices in clothing and jewelry have been greatly influenced by our mother."

–Suilen Higashino

Suilen Higashino is a photographer known for her poetic, luminous style, who also regularly finds herself on the other side of the camera as a model. Through her work, she has become an influential style creator in Tokyo and beyond. When we sat down with the photographer Suilen Higashino, her sister, Kaya, and their mother, Rona, joined us. Meeting the three together, we were struck by how each woman's own style was distinct, yet they all seemed in tune with one another and had an undeniable fashionable quality. The daughters of a British-Israeli mother and Japanese father, Suilen and Kaya have a look that is somewhat bohemian and low-key but definitely considered.

Suilen explains, "Our choices in clothing and jewelry have been greatly influenced by our mother. We both think of jewelry as fun, as well as something important that is passed down from generation to generation in the family, rather than just being a part of fashion, and we have both been wearing various types of accessories since we were very

young. This inclination probably comes from our mother's Israeli culture. In Israel, even people who don't concern themselves with fashion care about jewelry and always make sure to wear some. As we get older, we enjoy adding jewelry to our collection—finding new pieces and inheriting others. As for clothes, we also learned to follow her example in cherishing our favorite pieces, and manage to repair or rework anything that gets damaged in our own way."

Rona has a distinctive aura about her, which is expressed in the clothes she wears. She puts this down to her experiences traveling throughout the world.

"Jewelry and scarves are essential to me and are basically a part of my body," Rona tells us. "I love secondhand clothes. I consider clothes to be a natural part of my life, an extension of myself, rather than just fashion. I am more concerned with finding ways to comfortably be myself, rather than being concerned with trends or brand names. At the same time, I really enjoy getting dressed every day." This genuine love of clothing as a mode of self-expression is something all three women share.

For them, jewelry in particular is a special, highly personal way to connect with and express their own culture and style. Our next contributor also aims to transmit culture through fashion—and her aspirations are global.

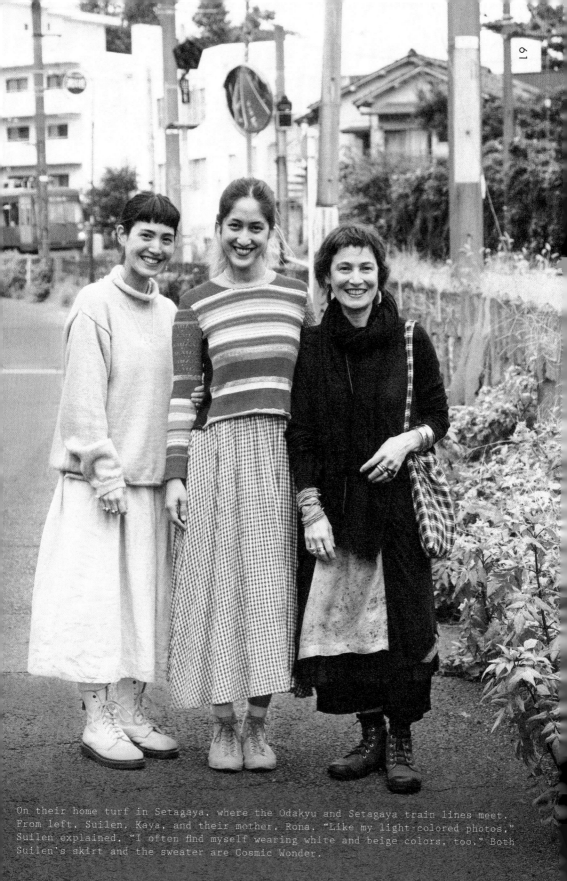

On their home turf in Setagaya, where the Odakyu and Setagaya train lines meet. From left, Suilen, Kaya, and their mother, Rona. "Like my light-colored photos," Suilen explained. "I often find myself wearing white and beige colors, too." Both Suilen's skirt and the sweater are Cosmic Wonder.

"I consider clothes
to be a natural part
of my life, an exten-
sion of myself,
rather than fashion."

—Rona Higashino, teacher

ABOVE Kaya is wearing a sweater
from a Japanese brand called Kosuke
Tsumura. "I have probably had it for
about ten years. The dress underneath
is secondhand. I have had this dress
for a long time, too, and can't even
remember when I got it."

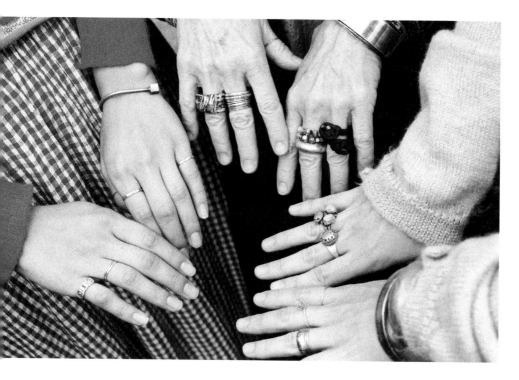

ABOVE All three women wear a number of rings and bangles, some of which have been made by friends in Israel or are family heirlooms. Others have been added to celebrate important milestones such as a marriage, a new baby, a new job, and so on.

OPPOSITE A closer look at Suilen's Dr. Martens x Y's boots reveals the stitches of white thread on the zippered part on the back. "Actually, the zipper broke and I took them into a repair shop. They told me the boots couldn't be repaired so I just sewed the zipper together. I stitched it together very roughly so I am actually embarrassed when people look closely." In the end, though, the stitches add a cool, slightly Gothic character to the boots.

RIGHT "My dress is dosa and my cardigan is Yohji Yamamoto. The long skirt under this dress is Comme des Garçons and my sneakers are Palladium, which I love." —Rona Higashino

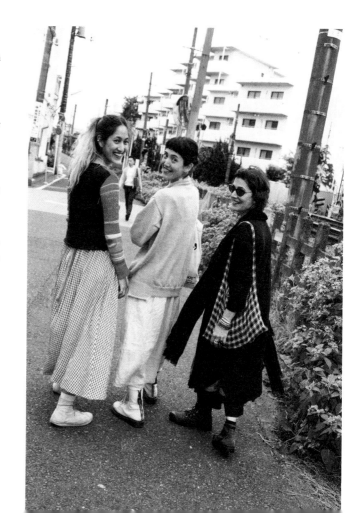

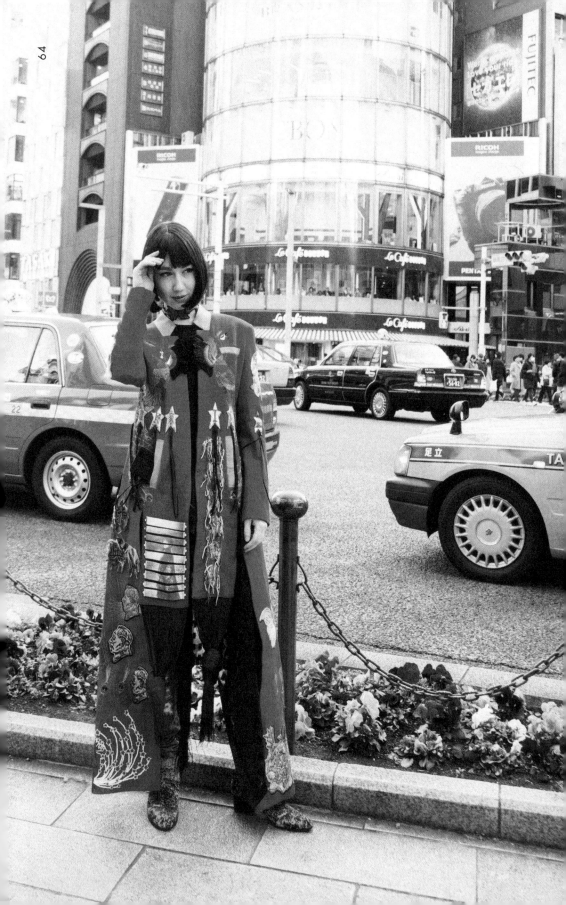

Misha Janette

Fashion journalist, fashion director,
and founder of the blog
Tokyo Fashion Diaries

"I want to connect countries through fashion."

—Misha Janette

Since first arriving in Tokyo more than ten years ago from the US, after being awarded a METI International Student Scholarship to study at Bunka Fashion College, Misha Janette has been a keen observer of Tokyo style developments. Through her work as a journalist for the *Japan Times* and a stylist and television host on Japanese fashion programs, she has become one of Tokyo's most influential fashion personalities. In 2013, she was named one of "The 500 People Shaping the Global Fashion Industry," along with Rei Kawakubo and Junya Watanabe.

We wondered what made her choose Japan in the first place. "I've always wanted to do something new and different, something only I can do," Misha explains. "So, I thought I could realize that goal more easily going to live in a country with a completely different culture, rather than staying in the US."

OPPOSITE Fashion journalist and founder of *Tokyo Fashion Diaries* Misha Janette wears Daisuke Tanaka on Ginza's Chuo Street.

Although she says she had a strong interest in Japanese aesthetics, Misha admits that she barely knew anything about Japanese fashion before she came to Tokyo. "But after I arrived, I was hooked. I discovered so many new and surprising things and I thought, 'The thing I want to share with people outside Japan is the fashion! I want to connect countries through fashion.' I began studying at Bunka Fashion College and became a journalist, a blogger, a stylist, a host on a Japanese TV program, and so on, each with a focus on fashion."

Misha regularly posts the latest updates from Tokyo's fashion world on her bilingual blog, *Tokyo Fashion Diaries*. As her social media feeds show, she also enjoys playing with proportions and different silhouettes in her own wardrobe, and this experimentation with different shapes and volumes often seen on Tokyo's streets underscores an open-minded approach to fashion that Misha appreciates. "Stylish people in Tokyo don't really worry about their age or what others think about them," she tells us. "They have the freedom to enjoy fashion as much as they want. That's so Tokyo." Misha thinks that it is out of this attitude that subcultures emerge and thrive. "Because subculture is very much alive throughout the city, people are really open to new styles, making Tokyo a place where fashion

sense runs deep." Creative styling is further encouraged by the increasing influence of young, talented designers. Misha says that one thing she finds so attractive about young designers in Tokyo is that "the brand concepts are so elaborate, not only with regard to making clothes, but also establishing themes and designing look books and other publications. The designers each has his or her own unique story to tell. I think Japanese people are really good at creating and designing like this." Seeing so many brands and designers with such developed and original concepts has inspired her to become a kind of ambassador for Japanese designers. "I want more people to know about clothes from these designers, and I want to encourage these designers to develop their skills and talents even more. That's why I try to wear their designs, too, along with promoting them on the blog and elsewhere, to raise their profiles and to encourage them to develop their designs."

As an American living in Tokyo, Misha has a unique point of view when looking at style in Tokyo, much like Akane Sasaki did as a young student when she experienced different and bewildering cultural norms regarding age and appropriate dress codes as a Japanese person abroad (see page 52). While Sasaki's host family thought her short skirts were too adult, Misha has noticed a more open attitude toward dressing your age: "Age doesn't define [Tokyo people's] styles. For example, in other countries, Lolita style is only for young people, and it is natural for adults to move on from that style. But in Tokyo, even grandmothers can wear Lolita fashion." That's not to say there aren't some things about people's approach to age and style that surprised Misha.

"As for hair, makeup, and even gestures, [women] seem to adopt styles that make them look cuter and younger, rather than sexier and more mature [see Chapter 4, page 116, on cute, girly kawaii style for more on this]. For foreigners, this emphasis on cuteness and youth seems really weird at first. But there is so much freedom to enjoy fashion here without caring about body types and age the way that people do in other countries."

"In other countries, there are rules for how to flatter your body shape, like emphasizing your waist, for example. But in Tokyo, these rules don't seem to apply. Women here often make their silhouette interesting without showing off their figures." As if to prove her point, when we meet with her on the street in Ginza, Misha shows off a dramatic silhouette, wearing a striking full-length red coat from the up-and-coming designer Daisuke Tanaka (see page 64). Tailored on top but flowing toward the bottom, the look is original and quintessentially Misha.

The women we've spoken to so far are attuned to their own sense of style—and of self. They dress with intention and are at ease in their clothes, wherever the day takes them. Feeling like yourself in your clothes, taking pleasure in getting dressed, wearing pieces you love, and exploring your interests in other aspects of life, whether it's music, art, or movies, are all common themes that we can get behind, as is a playful, experimental approach to mixing and matching elements from different fashion genres, sources, and time periods. And speaking of embracing eclectic influences, we'll move on to look at Tokyo's passion for hair, makeup, and nails to explore even more possibilities for original styling.

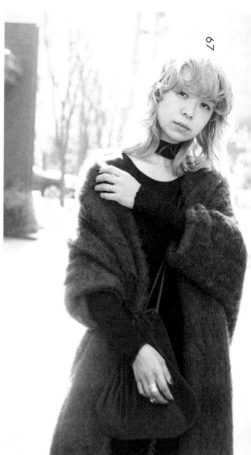

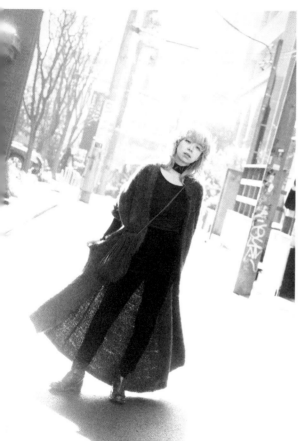

Nagisa Kaneko, nail artist and owner,
DISCO nail salon, combines new pieces
(the full-length sweater) with vintage
(her shoes, bag, and scarf) for a look
that's effortlessly cool and very Tokyo.
"Vintage is indispensible to my style
and it is also an important source of
inspiration for me as a nail artist. I
find so many great vintage pieces in
stores I wander into when I'm traveling."

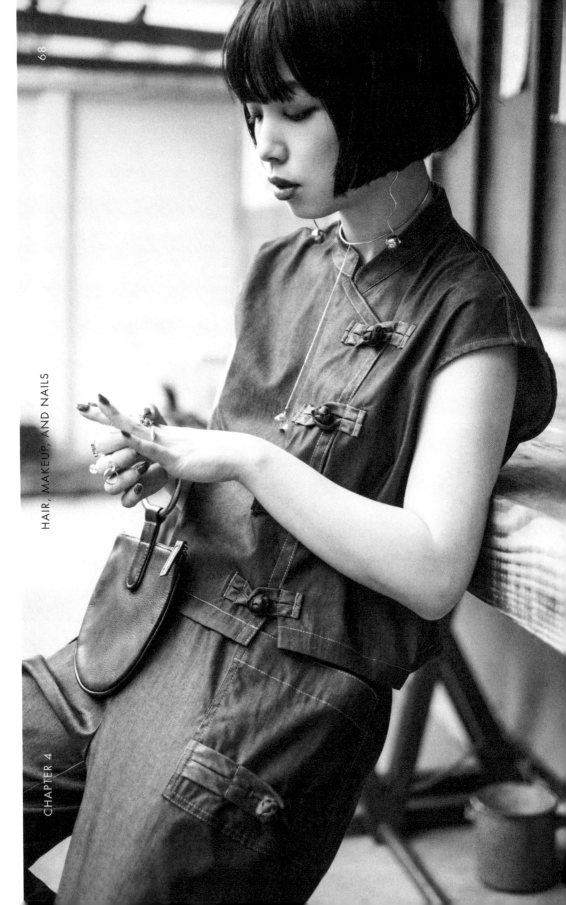

HAIR, MAKEUP, AND NAILS

CHAPTER 4

Style Is in the Details:
Hair, Makeup, and Nails

"Hair and makeup in Tokyo are the most independent in the world!"

—Rei Shito, street-fashion photographer

Increased connectivity in the digital age has influenced many fashion-sensitive Japanese women to take on a more global viewpoint on hair and makeup. It has also given them a new appreciation for the beauty in styles that already exist in Japan, and has inspired experimentation with both influences, with stunning results.

Dark, contoured lips are a regular sight. A bold lip is an excellent contrast to the black hair and sharp-edged bangs that many women wear. Other women change their hair color according to their mood or the season.

Bleached hair is also becoming more common, although it's still a niche trend. Whatever the particular style, hair and makeup, along with nails, are

integral to Tokyo street-style fashion. For insight into current trends, we asked Kenji Toyota, hair and makeup artist at Shiseido, for his favorite looks and his take on the unique Tokyo environment.

"Street style in Tokyo looks like a set of colored pencils. There are so many styles, and everywhere you look there are kids with their hair dyed in different colors."

—Baby Mary, owner, director, and DJ at Faline Tokyo and Miss Faline

OPPOSITE DEPT owner eri's sharp bob, stained lip, and dark nails create a look that is quintessentially Tokyo.

Hair, Makeup, and Self-Expression

Contributed by Kenji Toyota, hair and makeup artist, Shiseido

TOKYO STREET STYLE CONTINUES TO CELEBRATE THE INDIVIDUAL

The hair styles, makeup trends, and nail art that you can see on the streets of Tokyo are endlessly varied, colorful, and inspiring. Although talking about Tokyo style in terms of mainstream trends is somewhat limited in its relevance, given their constant evolution, a particularly exciting development in recent years is worth highlighting because it is responsible for all of the looks to follow. Tokyo style today is very much tied to the power of the individual. We can see this through the influence of new clothing brands—for example, the fashion collective Vetements, which quickly attracted a huge global following through their social media, which featured incredibly diverse people with varied styles. Now, true style value comes from enjoying each individual approach, which can be easily shared with the world. And with this freedom of expression, there is also freedom for people of any gender to enjoy every aspect of fashion, including makeup. Expressions of individual personality are playing a greater role today in street style in Tokyo than ever before and this spirit of experimentation among both

men and women, particularly regarding gender boundaries, is only becoming more accepted. Styling makeup and hair is at its heart a powerful method of individual expression, and is essential for a fuller picture of style in Tokyo. What follows is just a sampling of the ways that people in Tokyo do this.

HAIR COLOR AND STYLE FREEDOM

Although it's certainly a drastic change to go from black to blonde or other light colors, Japanese people are fairly relaxed about this and quite used to it, especially

"I often change my hair color according to my mood."

—Koto Umeda, student, Bunka Fashion College

in Tokyo. We tend not to get caught up in rules about what people should wear or how they should style themselves.

People in their teens and twenties in particular tend to try new things without hesitation or inhibition. For example, when a person says, "I want

BOBS

1 Fashion blogger Sakurako Nanamori wears her hair in a mushroom bob with bright red lipstick for a dramatic look. **2** Mitsuki Mashima, student, Bunka Fashion College, pairs her bob with clean and classic monochrome clothing and a matte red lip.

COLOR

3 Akane Sasaki, publicist, is known for her signature long, wavy blonde hair. **4** Koto Umeda, student, Bunka Fashion College, takes inspiration from the musician Melanie Martinez for her hair and makeup.

1 Kazue Nukui, publicist at writtenafterwards. Nukui's heavy bangs and subtle, feminine lip color, which accentuates the natural curve of her lips, show another way to achieve a mysterious look with bangs and makeup. **2** Erika Gold, salesperson at Faline Tokyo, adds a glamorous touch of red to her monochrome look. Her straight bangs above the eyebrows and direct gaze show a strong sense of individual style. **3** Rie, salesperson at Faline Tokyo, coordinates her red dress with a deep red lip, making the sweetness of her pure white collar pop. Her long, soft locks tumble down past her shoulders for a lovely, romantic look. **4** Designer Yuki Fujisawa wears soft natural bangs with a charming bob and her characteristic deep red lip.

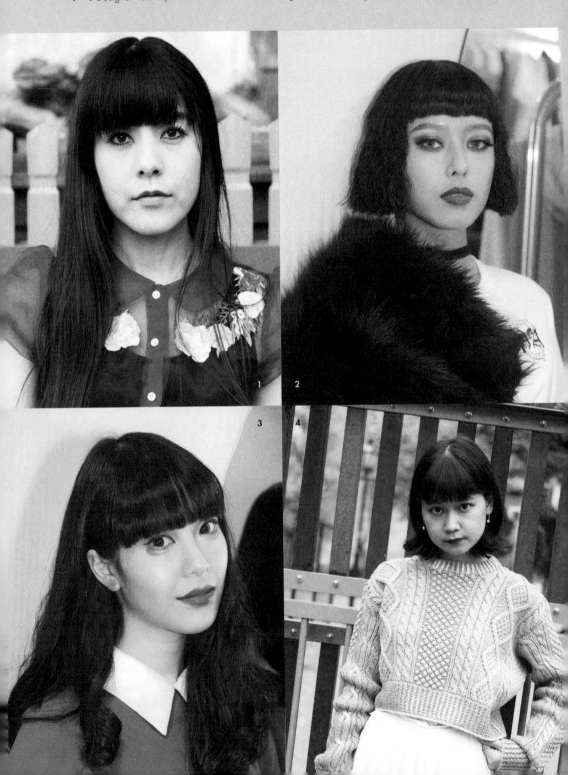

to be like Marie Antoinette!" the "Marie Antoinette" that the person imagines is not constrained by the image or appearance of the actual historical figure. Their inspiration for Marie Antoinette styling might come from an image portrayed in manga or Sofia Coppola's movie.

Here it's common to freely incorporate information and ideas taken at face value (without looking too deeply for historical accuracy) and then mix and arrange them according to individual taste and interest. Having fun mining all kinds of sources for inspiration and combining them into a multifaceted worldview (however refracted from the original sources of inspiration) is a liberating, creative way to express individual personality.

BOBS

One of the most ubiquitous hairstyles has to be the bob. Because a bob is a sculptured, finished look, it is a good hairstyle to bring out a person's facial features. When applying makeup with this style, many people like to go for a dramatic, high-impact look with a slash of red lipstick, which makes black hair seem darker and heavier by contrast. Bobs also go great with any fashion style. With its defined, sleek shape, a bob signals that the person has a strong intention when it comes to fashion, which might be why so many people—including, famously, American *Vogue*'s longtime editor in chief, Anna Wintour—have worn this hairstyle for years. Coco Chanel's bob was revolutionary, since it was the antithesis of women's traditional attitudes toward hairstyles at the time. And some of this rebellious nature is still signaled by the cut today. The mushroom cut is also

"I can't go anywhere without glossy red lipstick on."

—Mayu Hirabayashi, student, Bunka Fashion College

a kind of short bob that is popular in Tokyo, and I think both the bob and the mushroom are styles that display a kind of genderless consciousness.

BANGS AND BROWS

Straight-cut bangs, which create a bold, stark line over the eyes, are a favorite look among fashionable women. Whether or not the eyebrows are visible is a matter of preference, but covering the brows creates a more mysterious look, while cutting the line of the bangs above the brows gives a stronger, more open, upbeat, even boyish impression. Bangs cut short to reveal thick eyebrows enhanced with a dark eyebrow pencil is one of my favorite styles.

PONYTAILS AND BUNS

Inside-out, flipped ponytail styles, called *kururimpa* in Japan, have been a huge hit recently thanks to a huge number of videos online explaining exactly how the style can be done with a loop-shaped tool (or by making a ponytail, separating the hair just above the band to make a gap, and then flipping the ponytail through the gap). The influence of social media on the spread of new trends is immeasurable.

Often ponytails are worn a little messy, with flyaway pieces falling out around the face. Even if it's been styled deliberately, the feeling that it has been easily created, a carefree "Oh, I just pulled it

back!" look, is indispensable to a stylish ponytail at the moment. Color gradations or two-tone ponytails can also add a vibrant style accent.

Hair twisted into a tight bun or gathered loosely into a topknot can balance out a more voluminous clothing style. Pulling the hair up into a bun makes a strong impact. Although the silhouette is compact, I think this kind of hairstyle has a high degree of elegance.

MAKEUP

When I am working with clients, I aim to create a balanced, coordinated look by editing their makeup based on their clothing and hairstyle. The important thing is to be able to add a key detail somewhere, or to take one away somewhere else, as needed. For example, when applying eyeliner to lift the outer corners of the eyes, I avoid using other eye makeup, opting instead for red lipstick. Applying little touches here and there is an easy, subtle way to transform a look.

Many of the recent popular styles in makeup reveal this selective approach. For instance, a little while ago, there was a trend in Tokyo called *mejikara* (a word that refers to the ability to convey strong emotion with the eyes) that was focused on emphasizing large, wide-open, beautiful eyes and was created using bold eyeliner and plenty of mascara. Eyelash extensions to make the lashes longer and fuller were popular, and lashes were curled upward with an eyelash curler.

But lately, the trend has gone more toward adding volume to the mouth rather than the eyes. If eyelash extensions are used at all, they are more subtle and

natural-looking. For example, rather than curling the lashes upward, the trend now is to apply mascara so that the lashes go slightly downward and look fuller because the overall length is kept short. Also, people are using lash extensions without eyeliner to keep the look fresh and natural.

As for lip color, red lips have long been popular in Tokyo, though recently, shades have been shifting toward deep bluish pinks. And while the overall trend is currently a bold lip and lighter eyes, I'm also seeing a comeback in fuller volume eyes in the collections and runway shows, too. In Tokyo, the only constant is that makeup styles are always changing, and we are always freely experimenting with new looks.

NAIL ART: A SMALL DETAIL WITH BIG IMPACT

Gel nails have become really popular in Japan [since the first salons specializing in gel nail manicures opened in Tokyo around 2006], having originally developed in North America [in the 1980s]. Considering how short the history of Japan's nail culture is, the degree of freedom used in nail art is relatively high, with nails becoming miniature canvases on which to draw fine details, such as a Mondrian painting or anime or cartoon characters. The thing that I think is most interesting about

> "I love silver, so my nails, smartphone, and rings are all in silver."
> —Mitsuki Mashima, student, Bunka Fashion College

1 Model Ayana Miyamoto wears a loose ponytail and a fashion-forward deep berry lip shade to coordinate with the moody blues in her outfit. **2** Rin Miura, a college student, goes for a deep, grown-up shade of red with her sleek, ladylike low ponytail and heavy bangs. **3** Kako Osada, pastry chef and founder of holistic food brand foodremedies, wears her long hair in an easygoing ponytail for practical reasons while baking, but it still looks great even when she's off duty. **4** Shen Tanaka, a model, loves deep red-stained lips, which she often contrasts with two girly side ponytails. For this playful summertime look, she adds a touch of sparkle with glittery eyebrow gel.

nail art in Japan is that even when people seem to have fairly basic style when it comes to clothes, hair, or makeup, it's not unusual to discover that they are actually completely obsessed with elaborate nail designs. It's wonderful to discover a person's hidden character when you see their original approach to their nails. So even in this respect, I think Japanese people are really open-minded about nails.

Hair and makeup artist Kenji Toyota joined Shiseido in 2002. He is an influential trendsetter who disseminates new hair styles each season in addition to doing hair and makeup for the company's advertising campaigns. Toyota is also active during the New York, Paris, and Tokyo Fashion Weeks and teaches hair and makeup at Shiseido Academy of Beauty & Fashion (SABFA).

GREAT NAIL SALONS IN TOKYO

As with jewelry and other accessories, nails are a key part of the look and the art is chosen with as much intention (and sense of fun and experimentation) as the rest of their wardrobe. Some people change their nail style every day, depending on their mood, while others go once a week for gel nails or other more intricate nail art. Here are a few shops that are shaping nail art trends across the city:

DISCO
3F 1-14-9, Jinnan,
Shibuya-ku, Tokyo
www.disco-tokyo.com

Inthink
5F The Asai BLDG 6-23-6,
Jingumae, Shibuya-ku, Tokyo
inthink.me

mojo nail
2F (DaB) NEST Daikanyama 28-11,
Sarugaku-cho, Shibuya-ku, Tokyo
Instagram: @mojonail_shokosekine

POOL
4-28-6 Jingumae,
Shibuya-ku, Tokyo
www.poolnail.com

uka GINZA SIX
B1F GINZA SIX 6-10-1 Ginza,
Chuo-ku, Tokyo
www.uka.co.jp

virth+LIM
2F&3F Kirakira BLDG Minamiaoyama,
Minato-ku, Tokyo
www.lessismore.co.jp/virth

1 writtenafterwards publicist Kazue Nukui's red nails complement her colorful palette clutch. **2** Yukiko Suzukawa, a staff member at the concept store Graphpaper, wears dark nail color and a heavy cuff ring for a clean, modern look. **3** Sister publicist Mina Kayama sports irregularly cut rhinestone nail accessories. **4** Bunka Fashion College student Mitsuki Mashima pairs her silver nail polish with her H&M smartphone case for a cool combination. "I love silver, so my nails, smartphone, and rings are all in silver." **5** Staff members at DISCO nail salon show off exquisite marble-patterned nails and vintage rings, along with their own DISCO originals. **6** Street photographer and journalist Rei Shito finishes off her multicolored nail pattern using an artist's paintbrush. **7** Sister director and buyer Yumi Nagao goes to DISCO for this unique blood-red nail art pattern.

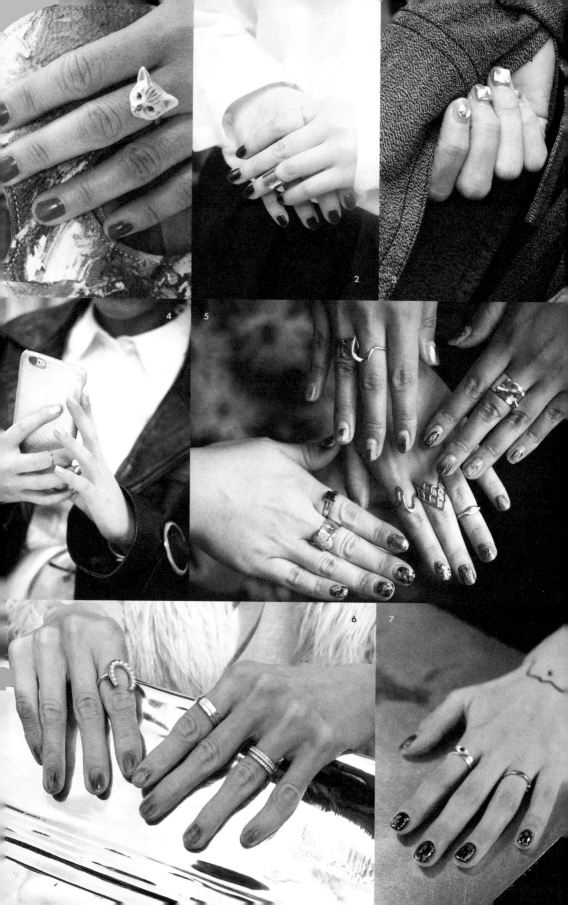

Q&A
Scott Schuman

Photographer,
founder of *The Sartorialist*

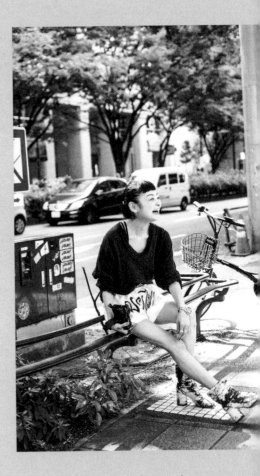

Following fifteen years working in the fashion industry, Scott Schuman began taking pictures of people he saw on the streets who he thought had interesting looks, then began posting them on *The Sartorialist*, which he founded in 2005. His 2009 anthology became a bestselling book, followed by a second in 2012 and a third in 2015. His books have been translated into many languages, he won the CFDA media award in 2012, and his work resides in the permanent collection of the Tokyo Metropolitan Museum of Photography and the Victoria and Albert Museum.

Can you tell us about how you became a street-fashion photographer?

I always looked at fashion magazines and I love them, but I thought there was something else out there. There were all these cool people I saw on the street, not dressed head to toe in designer clothes, and I thought I could learn something from them. With digital media and digital photography, I could do that and share those images. I didn't

Street photographer and fashion journalist Rei Shito is one of Scott Schuman's favorite subjects. He in turn inspired her to start sharing photographs online: "Because the street styles in Tokyo change so fast...I thought that introducing styles on the internet, like *The Sartorialist* was doing, was faster and more suited to capturing [it]."

> **"There were all these cool people I saw on the street, not dressed head to toe in designer clothes, and I thought I could learn something from them."**
>
> —Scott Schuman

have an idea that it would go anywhere. It was just a fun thing. But I still look at magazines for inspiration.

You've been shooting Rei Shito at various locations around the world for more than ten years now. How did she first catch your attention?

It was September 2007 Fashion Week and she was leaning against a car. She had a very slim figure and was wearing a kind of girly-style dress with black high-top Converse, but she had a big, serious camera, and I thought it was intriguing. This was before the real big boom of people shooting at Fashion Week, and there was something just so charming about her. I didn't have to think a lot about it. It was an obvious image waiting to be captured.

Two of The Sartorialist *books have whole sections dedicated to Rei Shito. Can you tell us what makes her style special?*

Rei consistently puts things together in a really unique, interesting way. It always looks like her, but it's also always different. Her style is always evolving.

I like how she really makes her style work even around the job that she does.

Rei is one of the few photographers who actually goes out and shoots on the streets year-round, whereas most of the street-fashion photographers now are more "Fashion Week photographers." And that, to me, is different than street style.

You've been to Tokyo to shoot and exhibit. What are your impressions?

When I went to Tokyo, I thought, "This is going to be great, I'll find a whole city full of Rei Shitos." But I didn't, and that just really shows you how unique Rei is. Maybe it's because she travels. In her heart, she's Japanese, but her travels seem to have really informed and shaped her style. Some women in Tokyo love fashion so much that they seem to have a hard time personalizing it.

And how about men's style?

I really admire Motofumi "Poggy" Kogi [@poggytheman]. He's got great style. He's not too much of one school. Some guys in Tokyo do Italian head to toe. They look great and they do it very, very well, but it doesn't feel real. Or you have guys who dress very English, or they have that whole denim thing where they're so obsessed with getting the original, vintage, perfect denim. But if they don't look good on you or fit properly, well . . .

So, good style is about knowing yourself?

I think so, and it's true for photography, too. I'm old enough and have been doing this long enough that I know what looks cool. A lot of the people who shoot, they don't trust their taste level very much. So they think if someone is wearing a big-name brand, they must be well dressed. For me, I want to make a good image.

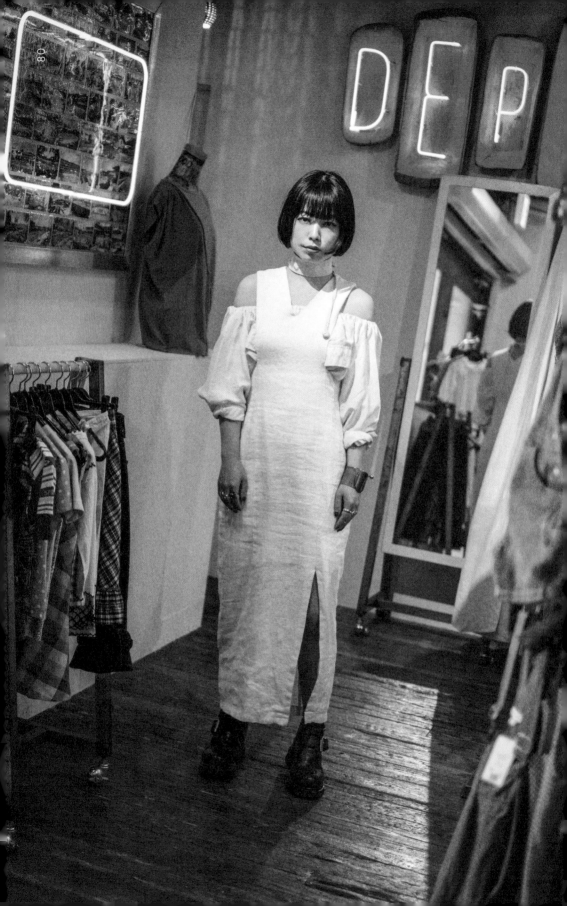

Vintage Finds

"Fashionable people in Tokyo excel at incorporating vintage pieces into their overall look."

—Hitomi Nomura, director, Marte

We can't talk about street style in Tokyo without talking about vintage. Of course, vintage is widely regarded as a rich source for inspiration and unique finds among fashion consumers around the world. What makes Tokyo different? Senior adviser for creative direction at United Arrows, Hirofumi Kurino, says it boils down to the consumers. "People here also are very particular and tend to have high fashion literacy. They are enthusiastic, curious, and good at taking their ideas about what they want and expanding on them. They don't rely on

being taught. Instead, they tend to be self-taught go-getters.

"At the same time," he explains, "vintage stores themselves have become remarkably refined while also being distinctively unique. Tokyo is quite literally a fierce battleground for vintage stores. So many quality vintage stores are crammed into relatively small areas within the city. This is very rare, even when seen from a global viewpoint."

The vintage stores frequented by Tokyo's most sophisticated fashion consumers aren't affected by current trends, but instead actually transmit their own trends and unique points of view, which in turn influence the latest designs. These leaders in vintage not only influence the street scene in Tokyo, but they are also powerful enough to influence the creations of reputable fashion designers all over the world.

The best stores also offer original designs, either remaking vintage items to update them or designing new clothing, inspired by vintage silhouettes, as Kurino explains: "Vintage stores have started to deliver one-of-a-kind originality in unconventional ways by using the knowledge and fashion sense they gained while dealing exclusively in secondhand clothes. I found that the more

OPPOSITE DEPT owner eri wears an off-the-shoulder blouse under a vintage dress with a slit. This white, romantic garment is matched with bulky, tough black boots to lighten up the sweetness of the dress and blouse.

"Most of my wardrobe is vintage. The more I research the origins of clothing, the more I want to wear vintage."

—Hiromi Tsunoda,
staff member at waltz

prestigious the secondhand store, the more quickly they adopted this strategy."

The "remake" process, as it's called in Japan, is not period reproduction, the more common way to wear vintage in the US and the UK in which the patterns, fabric, and details of vintage pieces are copied and produced using new materials. Instead, Tokyo vintage shop owners and designers, such as eri, the owner of the storied DEPT vintage boutique and fashion designer in her own right, take vintage items and use them as the foundation for a new garment, a starting point or frame of reference for a new concept. The garment is deconstructed and then reassembled into a new design. The result might only retain the original detailing or silhouette of the piece, or use the original fabric in new ways, but the look is still essentially vintage in spirit and in construction.

Depending on the piece, such remaking and restyling can be essential before the piece will truly suit a person's individual style. If you wear vintage clothes just as they are, without any adjustments to suit your body and style, it can look dated. Tokyo's most stylish vintage

lovers are never afraid to let a hem out or take the waist in, or take scissors to a grimy edge or legs that are too long. They nearly always remake their secondhand finds to some extent, whether through styling or actual sewing and reconstruction, especially if the clothes are more "costume" than clothing or are especially old.

In this chapter, we'll take you to Tokyo's most original and reputable sources of vintage clothing, from long-established stores to the newcomers on Tokyo's vintage fashion scene, each with its own definition of vintage. We'll also introduce brands that create new designs with a firm foundation in vintage and get an inside look at how these designers, and the people who wear their clothes, use vintage to create their own unique style.

OPPOSITE waltz (see page 234) is an analogue concept store specializing in vinyl records, cassettes, and used books. Hiromi Tsunoda, a staff member, wears a vintage gray sweater and a graphic skirt.

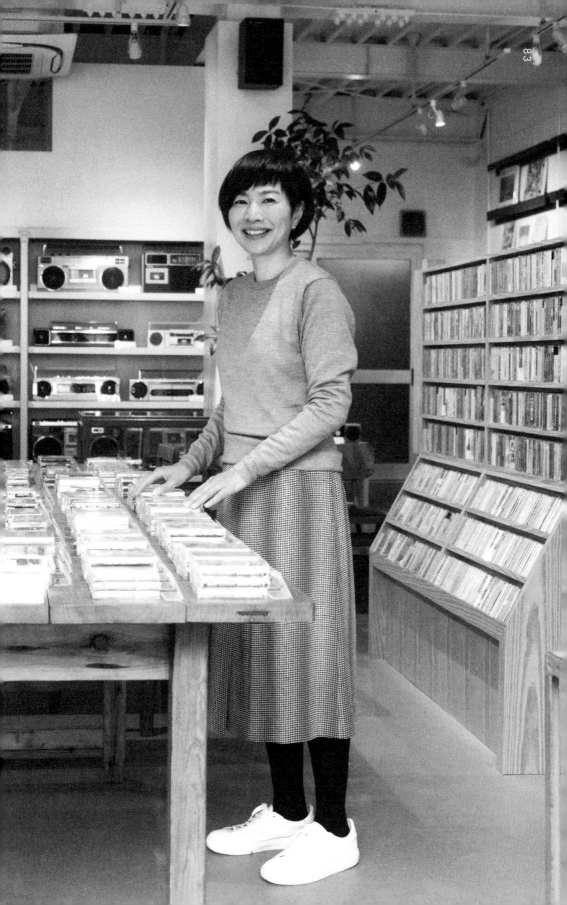

DEPT

"I want to create a new genre of vintage clothing by bringing out the value in vintage clothes in a way that no one has ever tried."

—eri, owner and designer, DEPT

The desire to remember and preserve the past is essential for a vintage shop owner, but it's her independent, fearless approach to fashion that makes eri, the owner of Tokyo's storied vintage boutique DEPT and designer for the labels mother and VTOPIA, so respected. She is actively involved in Tokyo's fashion world in a variety of roles—stylist, fashion designer, vintage shop owner and buyer, and more—and is known for her outstanding fashion sense.

DEPT was first established in San Francisco in the 1970s. Later, it branched out to New York and Tokyo, where it has become a favorite among Tokyo's most discerning customers. From the start, DEPT was not just a place to transmit the subculture of vintage fashion, but also music and art. As such, it has influenced many more people than it might have done if it had only focused on clothing. For more than thirty years, DEPT has cultivated the allure of vintage clothes, influencing

the street-fashion scene in Tokyo and remaining relevant, which is a tremendous achievement.

As you might expect from a designer specializing in vintage, eri has a style that is fluid and borderless in terms of what country or period the clothes come from. The clothes she selects for DEPT and the pieces and jewelry she designs or reworks for her fashion labels project this same sophistication with more than a hint of nostalgia. She tells us when we meet at DEPT, "I want to commit as many of my favorite things to memory as I can, without worrying about what others think."

This attitude was cultivated from an early age as eri grew up among the clothing in her parents' vintage shops (eri's parents owned the original incarnation of DEPT). "As I searched through various vintage clothing styles growing up, I gravitated toward vintage clothes with an Asian-style flair," she tells us. She credits her self-confidence in her own style to her father's influence and being constantly surrounded by different kinds of people and interesting objects from so many eras.

"My father didn't really care what others thought. He collected clothing that he loved, regardless of how well-known or how obscure the designer was. He really had his own unique viewpoint and way of doing things. Like my father, I am the kind of person who focuses exclusively on those things that I like

eri, the owner, outside DEPT Tokyo in Nakameguro, wearing a floaty William Morris-style flower-patterned dress. The glossy black satin dressing gown from China adds a layer of luxury and movement, while the black choker brings the look together brilliantly.

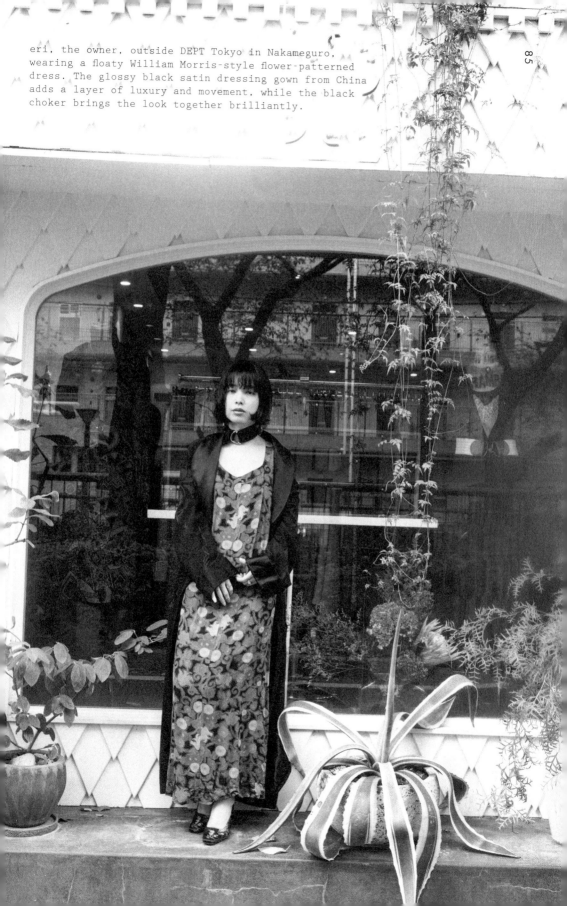

"I don't own any items that can be categorized as 'basics.'"

—eri, owner and designer, DEPT

Since its opening in the 1980s, DEPT has been at the same Harajuku location, on the first floor of VACANT, which is an event space, a bookstore, art gallery, and café in one.

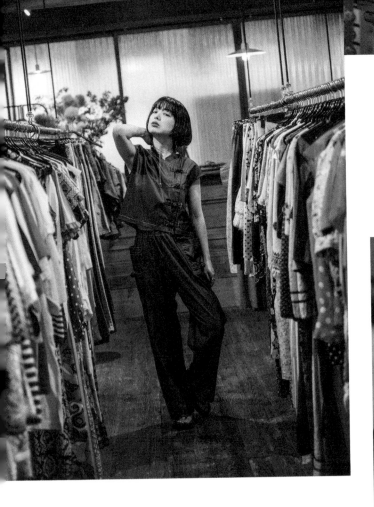

without worrying about what is in style. Other people might doubt their choices doing this, so they look for a variety of information about fashion."

If anything, eri finds that so much available information about fashion makes finding your own style more complicated. "I wear sneakers a lot more than I used to, but I still can't wear Converse! In Japanese fashion, Converse sneakers are considered a versatile standard piece, but it doesn't make sense to me. It is precisely because they are so versatile that I think it is difficult to wear them in your own way. So rather than a go-to basic, for me, Converse sneakers fall into the category of 'tricky items.' In that sense, I guess you could say that I don't own any items that can be categorized as 'basics' [or 'standard,' as they are called in Japan]."

eri's conviction manifests in her look, which, as she explains, changes according to her mood. "It is fun to break away from my 'norm,' whatever that might be. Rather than maintaining the same look or style, or relying on basics, I think it is fun to wear clothes as though I were transforming myself according to my feelings at that moment. I wish people like that would appear more on the streets in Tokyo." But aren't Tokyo people widely regarded as some of the best dressed in the world? "I think that many people still choose their clothes based on current trends and the voice of the majority, rather than judging whether something actually looks good on them," she says. "Fashion is not all about your appearance; I think fashion is about expressing yourself while maintaining some concept of what is within. I absolutely believe that your internal state is expressed through

what you wear and becomes part of your look. I think that's why fashionable people have an obvious and attractive aura around them. It's clear that they pay a great deal of attention to their lifestyle, not just their clothing. Since they know themselves well, they also know what goes well with *them*. Whenever I meet such people, they inspire me tremendously."

In 2011, the store closed its doors briefly when eri's father retired. But in 2015, eri brought DEPT back to life with two locations, one in Harajuku and the other in Nakameguro. While both stores have inherited the alternative atmosphere from her father's original store, eri's own unique worldview fills the space. "I would like to categorize vintage clothes using brand-new criteria. Rather than the conventional standards like country of origin, year, brand name, rarity, etc., I want to focus on introducing new styles, using neglected and no-name pieces, or reworking such pieces into something completely new. I want to create a new genre of vintage clothing by bringing out the value in vintage clothes in a way that no one has ever tried." In addition to offering a broad range of different kinds of vintage clothing and other pieces, more than anywhere else, vintage shops like DEPT have developed the vintage concept further by creating original products, incorporating, reworking, or remaking new designs inspired by the vintage styles that they sell.

While eri's singular vision and personal style permeates the atmosphere at DEPT, our next contributor prioritizes a more neutral stance in her shop.

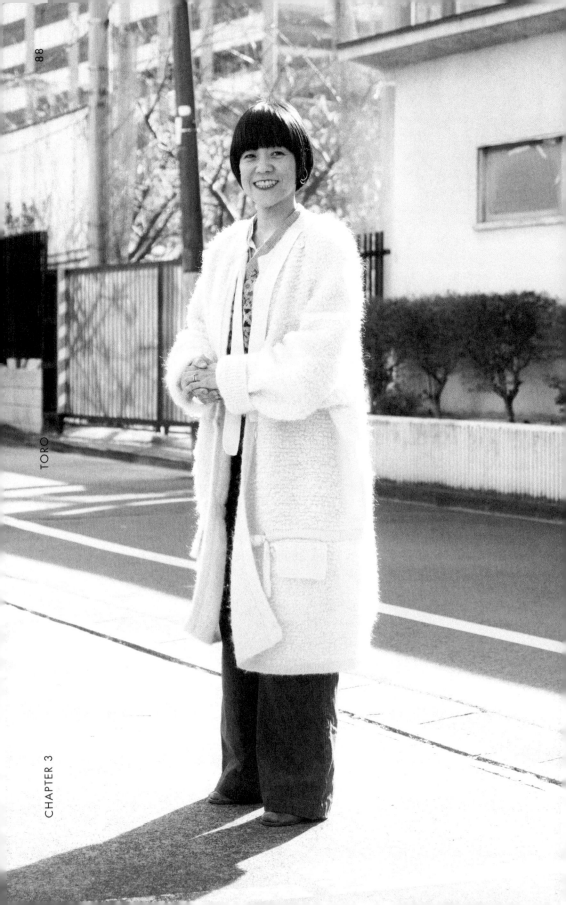

TORO

"When purchasing vintage, I try to always be neutral and without preconceptions."

—Ikuko Yamaguchi, owner, TORO

Neutrality is a virtue for TORO owner Ikuko Yamaguchi. "Fashion is free," she tells us. "I think it is important to enjoy dressing yourself in your own way, without necessarily categorizing yourself. Therefore, when purchasing vintage, I try to always be neutral and without preconceptions. Vintage is something that you discover. And if you have preconceptions you will miss out on rare finds."

Ask anyone in Tokyo who is interested in vintage and they will probably list TORO among their favorite vintage

OPPOSITE Lately, the owner of TORO, Ikuko Yamaguchi, has been rediscovering the pleasures of good vintage knits. Her own knitted accessories are also now available at TORO. "After I entered the world of vintage, the first item I purchased was a sweater. They have a long history and I am attracted to designs that let me feel the warmth of humanity." Yamaguchi wears a vintage Fair Isle vest paired with a white cardigan designed by Sonia Rykiel.

stores. During the nineties the vintage scene in Tokyo was mainly focused on jeans, T-shirts, sweats, and sneakers, and all of these clothes were men's. TORO, on the other hand, was one of the few stores offering good-quality pieces for women, such as Victorian smock blouses and dresses. It has been more than twenty years since TORO first opened, and the store's enduring appeal is likely down to Yamaguchi's approach to choosing pieces to display in the shop.

TORO doesn't just rely on overseas luxury brands. They also gather folk costumes from all around the world, often anonymous but finely crafted products. What is most distinctive about TORO is its excellent and extremely creative ability to suggest in the store's layout a borderless style that blends different elements together without the need for categorizing by country of origin, time period, men's, or women's. It is this openness to all possibilities that made TORO the only vintage store in the world that had permission to display the new Comme des Garçons collections.

The innovative styling of different looks on display are routinely hot topics of conversation in the Japanese fashion press, and have set the standard for those interested in street fashion who want to develop their style through vintage. But a great store and selection is only one side of the equation. As Yamaguchi explains: "I have had a store in Tokyo for a long time and I feel that, when viewed from

"I am so happy when customers compliment us by saying, 'Whenever I come here, I realize how much I actually love clothes and love fashion.'"

—Ikuko Yamaguchi, owner, TORO

a global standpoint, the level of vintage clothing knowledge and understanding in Tokyo, both on the part of the stores that provide it and the customers who buy it, is quite high. I am so happy when such customers compliment us by saying, 'Whenever I come here, I realize how much I actually love clothes and love fashion.' Hearing that makes me strive for that true TORO style and to make this place a source of inspiration."

And it really is. Looking for original styles that fuse countries and genders at TORO expands your worldview and stretches your imagination with each visit. This might sound like a tall order for a single vintage store, but it is backed up by the staff's depth of knowledge and international curatorial experience. Buyers at TORO spend about half of each year abroad looking for new pieces to sell in the store. Many of TORO's regular customers are stylists and designers who depend on this expertly curated collection of vintage finds.

Our next venue, Fumika and Hitoshi Uchida's JANTIQUES, is another key resource for stylists and vintage shoppers from Tokyo and beyond.

OPPOSITE Inside TORO there is a distinctive atmosphere that transcends any individual country of origin. Yamaguchi wears a collarless shirt, menswear from the 1920s, with a Fair Isle vintage vest and jeans from the 1970s.

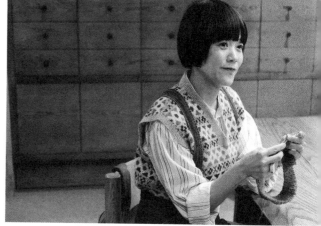

JANTIQUES

"One of the reasons we opened the store was our desire to make vintage a part of everyone's life."

—Hitoshi Uchida, owner, JANTIQUES

An open, inviting atmosphere is something JANTIQUES is known for, thanks to the owners' dedication to helping customers explore vintage on their own terms and at their own pace. In Chapter 2, we introduced Fumika Uchida's eponymous brand, FUMIKA_UCHIDA, and saw how she regularly incorporates vintage pieces into her personal style and takes inspiration from vintage pieces in creating her new designs (see pages 57–59). JANTIQUES is the vintage store that Fumika established with her husband, Hitoshi, who is the store's owner and buyer. Since its opening in 2005, JANTIQUES has been tremendously popular with fashion people from all over the world who see it as an essential stop on any buying trip to Tokyo.

The name JANTIQUES is a portmanteau of *junk* and *antiques*. The store stocks a range of items from many time periods, including clothing, tableware, furniture, etc., which are scattered around the space to give customers a treasure-hunt–style shopping experience. These days, vintage stores in Tokyo such as JANTIQUES have begun carrying more household items in addition to clothing. But back when the store first opened, vintage stores that carried both clothing and furniture were very rare. JANTIQUES overturned this usual separation, becoming one of the pioneers of the idea that fashion is not just for clothing but also for life in general (this is a core ethos of today's Tokyo street style, as we will see in the pages to come).

Looking back on the opening of the store, Hitoshi Uchida tells us: "Before opening JANTIQUES, I used to work at Santamonica as a buyer. Every four months or so, I would go to the United States on buying trips. I became more interested in the American lifestyle each time I went over there and started to dream about having my own store one day that would represent that kind of free lifestyle. In the United States," he continues, "vintage items naturally exist as a part of everyday life. When I started working in the vintage business in Tokyo during the eighties, the majority of people were asking, 'Can secondhand clothes really be a part of fashion?' There were very few people who wanted to fully accept and incorporate vintage into their style. This reluctance was aimed not just at clothing but also household items like furniture. One of the reasons we opened the store was our desire for vintage to become part of everyone's life. And women's vintage was more difficult to find in the early 2000s. So we wanted to open a store that would improve that situation."

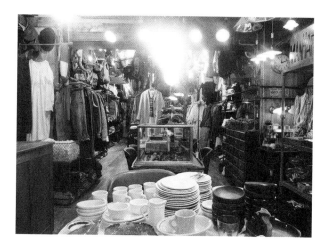

JANTIQUES buyers purchase vintage items from Europe and North America with the utmost care and attention, as if they were bringing each piece into their own home or wardrobe. They buy not only clothing for women, men, and children, but also tableware and furniture. And of course, as with any good vintage store, all items are washed and repaired before being put on display.

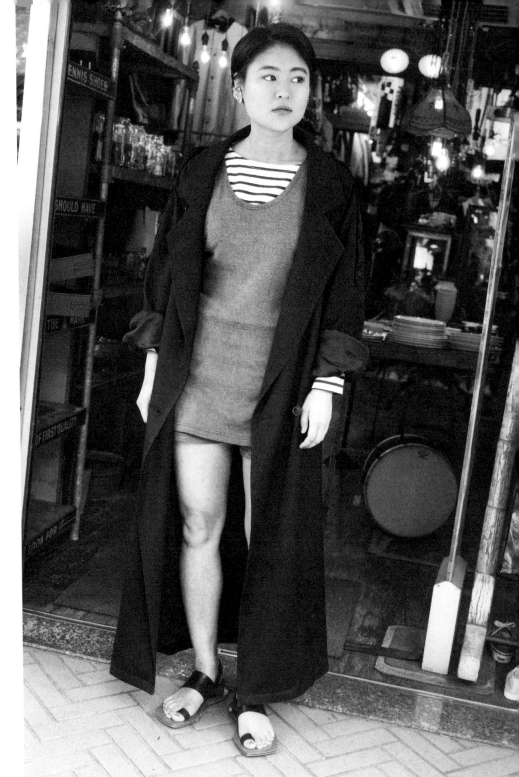

JANTIQUES staff member Eri Ueda's look is all vintage (apart from her Marni sandals). She wears a fresh, witty outfit formed by a swimsuit from the 1920s styled as a romper paired with a boat-neck Breton T-shirt. Her oversize trench coat is worn open like a full-length cloak dress, and the sleeves are rolled up to reveal satin lining, adding a soft, romantic counterpoint to the utilitarian texture of the swimsuit underneath.

"We create spaces for customers to enjoy unconventional styles without any preconceptions or influence from others."

—Hitoshi Uchida, owner, JANTIQUES

Fumika Uchida, also a Santamonica alum, tells us about how her experience there helped her form her own ideas about what a vintage shop should be.

Torn between her desire to make something new while remaining true to JANTIQUES's original concept, Fumika struggled to find a solution. "On the one hand," she tells us, "the original jeans were well-received by our customers and I was pleased. On the other hand, I had been dead set against selling original products, but now that I had produced and sold original products at my vintage shop, I wasn't sure what to do next. I asked myself what I really wanted to do, and ultimately decided to establish my own brand. I am the kind of person who has to go all the way when it comes to pursuing something. If I do it at all, that just means that I have decided to thoroughly pursue creating clothes."

This dedication to vintage is what characterizes the ideal JANTIQUES customer, too, according to Hitoshi. He is inspired by his customers' passion to "master" vintage, whether by buying it, styling it, or building on it to create something new. "I think that nonprofessionals who persist until they master something are very interesting and they obviously enjoy doing many things. Our stores value this mind-set."

Given Hitoshi and Fumika Uchida's strong opinions on vintage, it is a little surprising that, looking around inside the store, they have created a neutral space where anyone can enjoy shopping. We ask them about this choice to step back and let customers discover the selection for themselves.

"The definition of antique is different for everyone," Hitoshi explains. "If someone chooses to think that something is antique, it is! Even if it is actually junk to someone else. Of course, we purchase items while carefully considering their time period and rarity. However, we won't tell our customers that. Their experience shopping at JANTIQUES and their feelings about vintage are the most important thing to us. I think that is the reason for our store's longevity. We create spaces for customers to enjoy unconventional styles without any preconceptions or influence from others."

And what do JANTIQUES customers tend to buy, given this freedom? "Women usually care less about time period, rarity, price, and the condition of an item if that item speaks to them personally," he says. "So, they try men's items without hesitation. Every time I see a returning customer, I can tell how much their eye has improved after visiting us, which really inspires me," he says.

If JANTIQUES is where vintage fans go to sharpen their eye for great vintage finds, our next stop is where most people's experience of vintage in Tokyo begins, whether they are fashion students or young designers, directors of established fashion houses, or tourists visiting from overseas.

"Santamonica Omotesandou is a source of fashion information for me. When I go there, I find out about current trends and also a sense of what's coming next."

—Yuji Honzawa,
 brand director, Red Card

The store has been in the same location in Omotesando since it first opened in 1979. Located in a major sightseeing area near Meiji Jingu Shrine and close to Harajuku, many overseas visitors come to the store. Look for its iconic signboard with an airplane and a palm tree. Aya Sato (above), head buyer for women's clothing, pairs simple ballet flats and a girly hot-pink Italian mohair cardigan with a French Army sweatshirt and perfectly frayed vintage Levi's corduroys.

Santamonica Omotesandou

Santamonica Omotesandou, Tokyo's storied vintage shop on Omotesando, opened in 1979 and remains at its original location. The store tops the list of long-established vintage stores in Tokyo. Besides the Omotesando store, Santamonica has five other locations in central Tokyo. Specializing in American vintage styles for women, men, and children—with buying done primarily in the US—these vintage stores are supported by generations of customers. Some of the regulars are actually grandparents shopping together with their children and grandchildren.

Santamonica is known as a "gateway" store in the Japanese fashion industry because many of the buyers, designers, and stylists who are at the forefront of Tokyo's fashion scene—including Fumika and Hitoshi Uchida—launched their independent careers after working at Santamonica Omotesandou. The store is a special place for vintage enthusiasts. It has been more than thirty years since its opening, but staff there are still skilled at interpreting time periods and good at suggesting overall styling. People in the Japanese fashion industry say that it is one of the best places to find the next fashion trends.

Head buyer for women's clothing Aya Sato tells us that she senses changes in their customers every year. "People's styling skills are improving, and the number of female customers who purchase men's vintage items is increasing. Some customers say that they like military vintage in general, but some of them are very particular about the country of origin or time period. In order to keep them happy, we always need to research and discover good-quality vintage items to offer in the stores."

Perhaps this is why Santamonica Omotesandou has been the go-to store for vintage among Tokyo's fashion elite for decades—they have grown and changed by keeping a finger on the pulse of customers' changing tastes not only in vintage pieces but in how those pieces will be styled to create new trends.

Heading a bit further back in time, all the way to the 1800s in some cases, next we'll take a look at a store that has also played a key role in shaping how vintage is worn in Tokyo, both on the streets and on screen.

Boutique Jeanne Valet

"There exists a certain drama behind vintage."

—Yoshitatsu Fukuda, owner, Boutique Jeanne Valet

Since its opening in 2003, Boutique Jeanne Valet has been a key source for inspiration not only for Tokyo's vintage aficionados, but also its professional costume designers for films and television. It has sold French work clothes, formal wear such as dresses and gowns, lingerie, clothing accessories such as buttons, and also interior decor. Yoshitatsu Fukuda, the owner, says that before Boutique Jeanne Valet, "French vintage items—including work clothes—had not permeated Tokyo youth culture." Fukuda has played an important role in making items such as berets, work jackets, and more theatrical pieces from the eighteenth and nineteenth centuries a key part of Tokyo street fashion.

Buying is mainly done in France, and the collection ranges from the 1800s to the 1980s and includes couture brands such as Chanel and Yves Saint Laurent. Fashion students, designers, and costume designers working in theater or film all visit the store for its wide assortment of pieces. The boutique is seen as a kind of salon, a rich source of creativity and inspiration. While cus-tomers browse, the knowledgeable staff provide context, offering information on each piece on display. Shopping here is like stepping back in time to experience the life and culture of France through-out the ages.

Boutique Jeanne Valet fully embraces the ethos of "revisit the old to under-stand the new." When we meet with Fukuda at his store, he shows us the signboard in the window. "In the corner you'll see a French phrase, *En Habillant l'Époque*, written in small letters."

"I want people to feel the value and historical background of vintage items by wearing them, so I added the phrase, like a subtitle, on the signboard," Fukuda explains. "There exists a certain drama behind vintage. Vintage is really interesting because you can discover the techniques and the culture of the society that created the clothing at that time. I would like to spread this allure and to help our customers feel the thrill of fashion." Inspiring the thrill of dressing up is an admirable goal, one that Eva, the next vintage boutique we'll visit, also aims to achieve.

OPPOSITE Fashion designers, stylists, and costume design-ers stop in regularly to the Daikanyama store. The poetic window display is a well-known landmark.

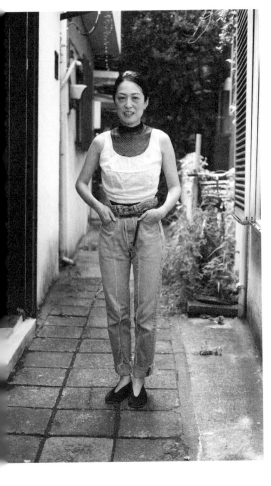
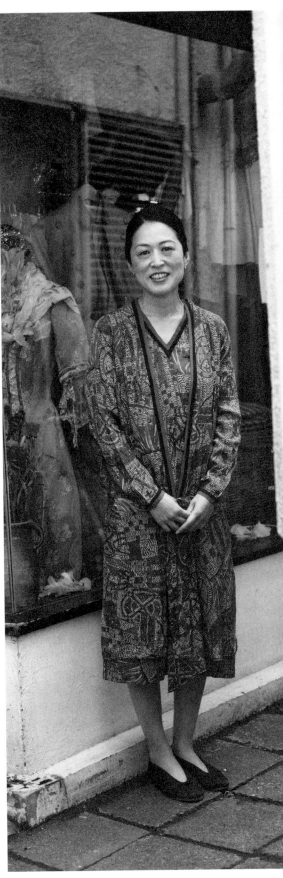

"I want people to feel the value and historical background of vintage items by wearing them."

—Yoshitatsu Fukuda, owner, Boutique Jeanne Valet

Anyone can enjoy hunting for treasures in Yoshitatsu Fukuda's expertly curated selection, while at the same time learning to trust their own feelings. Fukuda tells us that "intuition is so important when it comes to purchasing vintage!" The store is packed with a gorgeous variety of French vintage items, ranging in price from a few dollars to over a thousand dollars.

Haruka Kamata, a staff member at Boutique Jean Valet, is good at tailoring having used to work for a clothing manufacturer. Here she wears a beautiful 1920s dress, and jeans and a top that she altered for a perfect fit.

Eva

"I am always seeking novelty and trying to be flexible when it comes to discovering vintage. I purchase vintage items that I feel somehow destined to have found."

—Seiko Miyazaki, owner, Eva

Seiko Miyazaki opened her vintage boutique, Eva, in 2004. Focused on high-end vintage, the selection here consists of overseas luxury brands, anonymous masterpieces that display the craftsmanship of the time, and also original pieces made from vintage items. Eva specializes in rare items that are not available elsewhere. The ironclad rule for buying vintage anywhere is that if you love it, you have to buy it immediately or you'll miss the chance. But at Eva, this feels particularly apt. Each piece here is something to be treasured and worn with the same elation and thrill that you feel when really dressing up for the first time.

The selection in-store has a decidedly feminine feel, but Miyazaki herself resists easy categories (her first import business initially dealt in vinyl records and motorcycles). Eventually, her business and love of fashion came together and she began collecting vintage clothes. "I've always had ques-tions regarding categories," she says. "Whether fashion or music, I didn't enjoy getting together with people who liked the same things as me. I had a strong desire to communicate with different types of people and to get to know them on a deeper level." Miyazaki's passion and personality manifests in the vintage pieces she displays: "I am always seeking novelty and trying to be flexible when it comes to discovering vintage. I purchase vintage items that I feel somehow destined to have found, and I create original pieces using the vintage items that I purchased."

Miyazaki tells us that she appreciates the freedom that Tokyo offers every time she goes abroad on buying trips. "Tokyo is the only major city where you can walk around by yourself carrying a Chanel bag any time of the day. In the past, I was warned by the police when I tried to do the same thing in other countries." But it is not just physical safety that Miyazaki appreciates in Tokyo. "I think that there aren't many other places where you can be so care-free and safe with your fashion choices as Tokyo. Thinking of this makes me grateful for my current surroundings in Tokyo. Through vintage I would like to prove that fashion can give pleasure and freedom to anyone."

Hitomi Nomura, the director of our next shop, Marte, says that she too believes that pleasure and freedom can be found in vintage clothing—so much so that it has shaped her entire life plan.

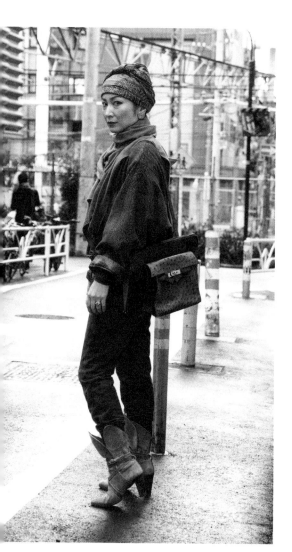

Seiko Miyazaki, the owner of Eva, wears Chanel, Hermès, and Yves Saint Laurent in eye-catching color combinations. These brands and more can be found among the many treasures in her shop.

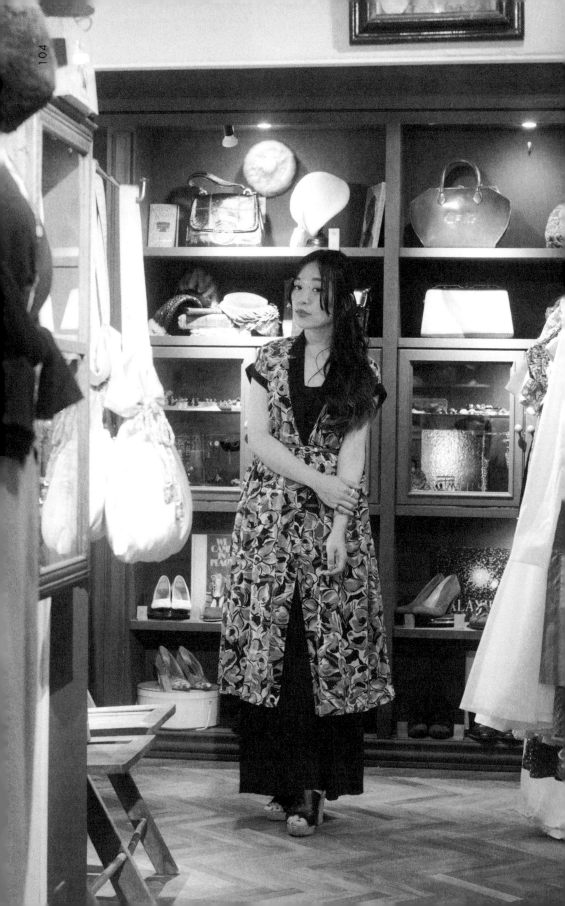

Marte

"I was mesmerized by the natural world shown in Tasha Tudor's works and the charm of old things, and I bought vintage items frantically."

—Hitomi Nomura, director and buyer, Marte

Hitomi Nomura took inspiration for her vintage shop, Marte, from her father's antique watch shop. "I have been surrounded by antiques from a very young age. When I was a junior high school student, one of my daily routines was to go around to different vintage stores just to check things out." Nomura went on to study dressmaking in college. Around that time, she says, "I came across a picture book by the illustrator Tasha Tudor. I longed for her style and the worlds she created, so I became eager to express this desire through vintage clothing. I was mesmerized by the natural world shown in Tasha Tudor's works and the charm of old things, and I bought vintage items frantically."

OPPOSITE Nomura wears two vintage dresses for a tiered look that combines texture and pattern for a chic, elegant look. Her photography on Instagram is a also a must-see (@hitominomura).

Tasha Tudor, "friend to nature" and world-famous illustrator of numerous classic books for children, including Frances Hodgson Burnett's *The Secret Garden*, has a huge following in Japan. Nomura was so inspired by the pastoral world expressed in Tudor's illustrations that she left college and began working in a store that sold vintage clothing. While working there, Nomura developed a style that became a huge trend in Japan and that has spread worldwide: "People around me looked at the clothing styles I put together at the time and started calling it 'Mori Girl.' I was very surprised when this new style quickly attracted a huge amount of attention."

"Mori Girl" (or "Forest Girl") style took off in Japan around 2009, becoming a huge hit among young women who wanted a style that was at once beautiful and romantic while at the same time in touch with nature in the midst of hectic urban life. Hugely influential on street-style trends in Tokyo, Mori Girl style is characterized by flowing floral skirts and coats made from natural fabrics, lace and appliqué embellishments in botanical patterns, and long, loose curled hair, maybe with roses or flowers woven through the tresses.

"Gradually, as I got older," Nomura explains, "my attitude toward vintage and what I really wanted to do did not quite match my reality, and I had begun to lose sight of what my own style really was. I decided to look again at vintage

and go for new challenges and ways of expressions before turning thirty. So, I left the shop I was working in and established Marte."

"What's good about vintage is not only the value of it as a one-off item, but also the picture it paints of a certain time."

—Hitomi Nomura, director and buyer, Marte

Nomura's shop carries vintage pieces from the early 1900s to the 1980s. She travels a few times a year on buying trips to the United States, Canada, and throughout Asia looking for vintage items for the store. Since its opening in 2016 in Harajuku, Marte has been popular among women in their twenties and thirties, among whom the store is known as a brilliantly curated source for vintage pieces. "Fashionable people in Tokyo excel at incorporating vintage items as part of their overall style," Nomura tells us, and this store is for them. Like other vintage stores featured here, Marte also sells a range of original clothing and accessories.

Nomura's personal interest in vintage is full of unexpected combinations. "I am intrigued by older brands such as Laura Ashley," she says, "and items pro-duced long ago by major department stores like Sears," which is perhaps best known in the US for its large home appliances, power tools, and practical work and play clothing for everyday wear. "Observing the details of such clothes really teaches you about the trends at the time, so it's quite fun to look at. What's good about vintage is not only the value of it as a one-off item, but also the picture it paints of a certain time." Although she is not old enough to remember Laura Ashley in its 1980s heyday, Nomura has a clear interest and earnest desire to learn from the styles of these earlier times and make them accessible to women her own age. "I am working with staff from my own millennial generation so that we can spread appreciation of vintage in our own ways."

Our next contributer, fashion and textile designer Yuki Fujisawa, also takes inspiration from secondhand and vintage materials and interprets them in her own unique way, updating older styles to give them a new life.

The store is divided
into pink and blue sec-
tions that signify not
gender but occasion. The
pink section carries
everyday clothing, and
the blue section car-
ries dresses for special
occasions.

Yuki Fujisawa

"It would be impossible to describe either my style or my designs without vintage."

—Yuki Fujisawa, designer

As a textile designer who creates one-of-a-kind pieces by remaking secondhand clothes, Yuki Fujisawa tells us she feels a connection to the people who owned the items before as she works with the material, dyeing each piece by hand herself to create one-of-a-kind sweaters and skirts for her eponymous label. Although Fujisawa creates each piece with great attention to detail and conscious appreciation for the original garment's previous "life," she came to design using vintage almost by accident. She tells us: "I majored in textiles at an art university, and I began to be interested in courses on dyeing fabrics. Gradually, I started to think that I would like to create something that represents my interpretation of color layering. Initially, I used pieces of fabric for dyeing, but I wanted to dye structured fabrics, so I chose secondhand clothes for my attempts. That is when using vintage for everything made sense to me."

For Fujisawa, textures and aging are the most important factors to consid-

er when trying to achieve the desired layers of colors in the dyeing process. After much trial and error, she found a method for applying foil prints after dyeing secondhand clothes. The foil prints are intentionally distressed to catch more light and create exquisite effects. The clothes possess a distinctive allure that comes from dreamlike colors and delicate details.

From sourcing the clothing, sketching, dyeing, applying her signature foil prints, sewing, and so on, Fujisawa handles each stage of the creation process, so the number of pieces available is limited. The appeal of Yuki Fujisawa clothes for those in Tokyo's street-style scene—especially those who love vintage styling—is obvious. Each piece, created by hand, is made to be one-of-a-kind, with its own story and artistic quality. Wearing a Yuki Fujisawa sweater or skirt is like wearing a piece of art.

Fujisawa tells us, "I had never actually worn vintage until I established my own brand," working with secondhand clothing while developing her dyeing technique as an art student. "But now," she says, "I think it would be impossible to describe either my style or my designs without vintage." Born in the 1990s in Tokyo, Fujisawa tells us that the amount of information about fashion and the materials available was overwhelming, so it took her some time to find her

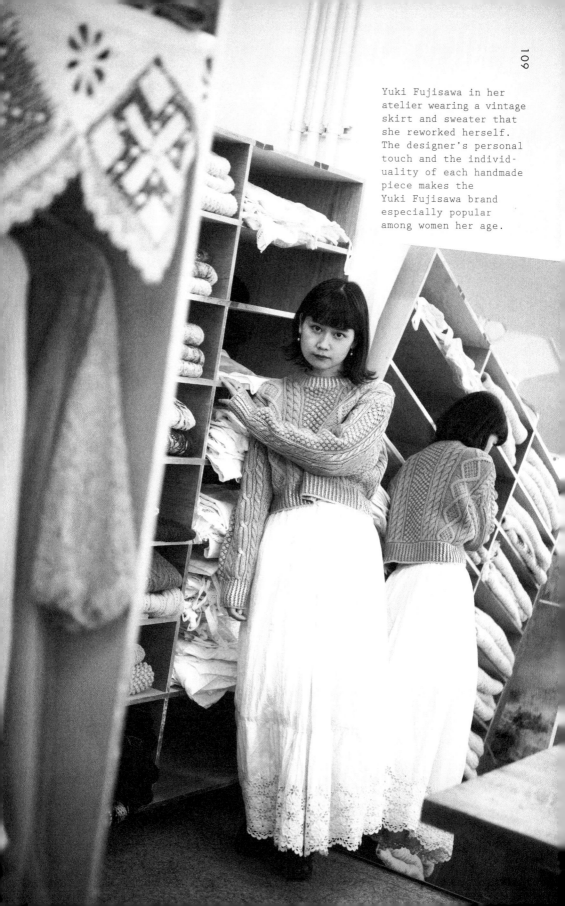

Yuki Fujisawa in her
atelier wearing a vintage
skirt and sweater that
she reworked herself.
The designer's personal
touch and the individ-
uality of each handmade
piece makes the
Yuki Fujisawa brand
especially popular
among women her age.

"Rather than creating new things from scratch, I began to think that I would like to pursue creations that breathe new life into objects that already exist."

—Yuki Fujisawa, designer

Clothes change their appearance over time, and thinking that I am involved in those changes stirs my emotions deeply. I would like more people to find pleasure in such changes, so I want to keep trying to create more pieces."

As Hitoshi Uchida, the owner of the vintage store JANTIQUES, pointed out after observing his customers developing their eye for vintage, with a little experience and patience, anyone can develop the skills to put together stunning and original looks that incorporate vintage. Mastering vintage doesn't necessarily mean wearing nothing but. Wearing head-to-toe vintage—or only pieces from a single time period—is tougher to pull off because the clothes can overwhelm and obscure your own style. Blending vintage and contemporary pieces usually results in a fresher look. Trust your own taste and let your vintage-inspired style develop over time through the pieces that you find and truly love.

We'll stay with vintage in the next chapter, as we explore different ways of styling vintage pieces and the various interpretations and expressions of the rich and often misunderstood Japanese word kawaii, *which means "cute" or "adorable," but in fashion, as we'll see, means so many other things besides.*

creative calling. "Rather than creating new things from scratch, I began to think that I would like to pursue creations that breathe new life into objects that already exist. I thought, 'Dyeing and secondhand clothes, this is it! This is a vehicle for my creativity.'"

And she clearly relishes working with vintage and secondhand clothing. "When I find a stain or a worn-out section, I feel the warmth and presence of the original owner. I also take note of techniques and materials that are no longer in use. Through my hands, a new owner is able to become part of the life of the garment. Foil prints may peel off and dye may fade but the piece of clothing starts to blend in with the characteristics of the new owner.

OPPOSITE Yuki Fujisawa reworks vintage items in her own way, creating colorful designs that evoke the colors of the aurora borealis. Each piece is a unique creation. The foil-print detailing creates one-of-a-kind texture and light effects.

YUKI FUJISAWA

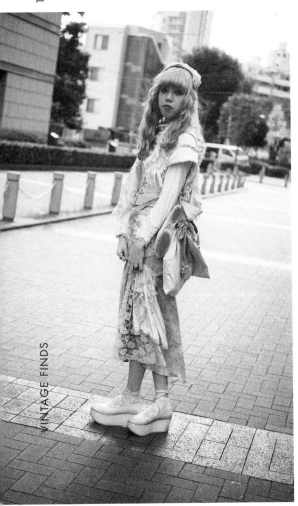

VINTAGE FINDS

ABOVE Koto Umeda, a student at Bunka Fashion College, is a "vintage freak" whose everyday look is made up of coordinated vintage.

OPPOSITE LEFT Bunka fashion student Mayu Hirabayashi's long, tailored coat made from vintage corduroy takes the starring role in her vintage styling.

OPPOSITE RIGHT Rin Miura, a university student, wears a vintage satin robe embellished with embroidered flowers and a phoenix.

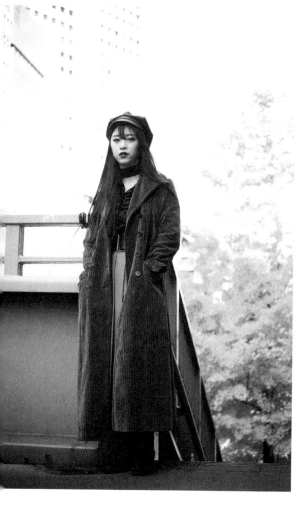

Q&A
Ebony Bizys

Founder of *Hello Sandwich*

Ebony Bizys is an Australian-Lithuanian artist and designer who moved to Tokyo in 2010. She launched the popular blog *Hello Sandwich* to record her original DIY craft projects and other Tokyo adventures and is the author of a book of the same name. We spoke to her about what is inspiring about living in Tokyo.

What kind of fashionable women do you see in Tokyo?

Particularly because I live in Shimokitazawa, one of Tokyo's favorite places for students and young people, it's common to see many women wearing 1980s-inspired vintage styles. Lace is mixed with pearls and denim, thrift store finds are mixed with high-end Japanese design pieces, and unique combinations are formed. I have always admired the Japanese for effortlessly pulling quirky looks together and combining clothes in a style that is playful and unique to Japan. Attention to detail with *kawaii* embellishments, such as a polka-dot manicure, or a fluorescent sock, is so fun to observe here in Tokyo.

What surprises you about Tokyo's street fashion?

My first impression of Tokyo's street fashion was when I was working as deputy art director of *Vogue Living* magazine in Australia and a fashion magazine on Harajuku street fashion published by United Colors of Benetton landed on my desk. I was blown away by the combinations of textures and colors in the ensembles shown in this magazine. This was partially what enticed me to move to Tokyo.

Have you been influenced by Japanese street fashion?

Absolutely. Having access to all of the incredible Japanese fashion magazines, such as *Soen* and *GINZA*, being able to walk into any Japanese designer store, not to mention see the fashion trends live on the street, it's impossible not to be influenced by Japanese street-fashion trends. I particularly enjoy seeing the vintage street-fashion culture and taking note of the creative and unique ways in which Japanese street fashion is put together to form a look. I love Harajuku's Punk Cake store, and thoroughly enjoy their

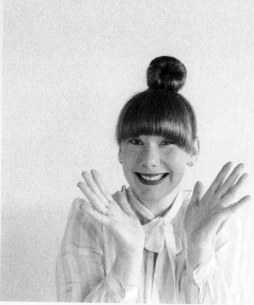

Instagram feed. This type of retro, often eighties-inspired street-fashion look influences my style.

Is there a Japanese fashion brand that you are interested in?

I adore Tsumori Chisato. The beautiful and playful metallic details mixed with pastel, painterly artwork prints always makes for a unique piece. The dream-like lace and satin textures with gold foil embellishing appeals to me.

What brought you to Tokyo?

I fell in love with Tokyo on my first holi-day here when I was eighteen years old. After that, I came to Tokyo nine times on holidays before finally moving to Tokyo in June 2010. I've been living in Tokyo for six years. The design, fashion, people, and way of life suit my needs perfectly. I want to live in Tokyo forever!

"Attention to detail with *kawaii* embellishments, such as a polka-dot manicure, or a fluorescent sock, is so fun to observe here in Tokyo."

Chapter 4

Tokyo's Infinite *Kawaii*

"When I see visually appealing foods, I sometimes accidentally say 'kawaii!'"

—Yukako Izumi, deputy editor, *Time Out Tokyo*

If you were to stop someone on the streets of Tokyo and ask them what *kawaii* means, they would probably offer a simple translation such as "cute," "adorable," or "pretty." But if you pressed them further to ask what images come to mind, they might say something about pastel colors or busy, cartoonish pop imagery, like an overturned box of toys. Some people might say girls in school uniforms or pretty floral dresses are *kawaii*. Others might mention their favorite pop idol, whose makeup emphasizes big eyes, long lashes, a button nose, and a small, rosebud mouth, evoking a childish kind of beauty. Still others might show you a smartphone case with animated characters on it, or a stuffed animal charm dangling from their bag.

Answers like these tend to give outsiders the impression that *kawaii* is a childish

aesthetic, an obsession with all things small, young, and most of all, cute.

For Japanese people, the word *kawaii* itself carries with it all the rich resonances and associations with childhood, nostalgia, fantasy, escapism, youth, beauty, and of course, cuteness, but the word is also used in increasingly complex and diverse ways. Recently, many Japanese women have started to use *kawaii* as a compliment or interjection similar to "great!" "cool!" or "delicious!" depending on the situation, so the term has clearly moved beyond its origins as something simply "cute" or "girly" to describe food, music, and so on. Like other aesthetic styles originating in Japan, such as *wabi-sabi*'s imperfect beauty as expressed in a cracked teacup or the characteristic minimalism of Japanese landscape gardens or flower arrangements, *kawaii* style is an aesthetic that is instantly recognizable, but never simple to explain.

The fact is that it is perfectly natural in Japan for cute characters to appear on credit cards, on airliners and trains, and

OPPOSITE Model Natsume Mito wears a white Sina Suien blouse paired with a jet-black skirt. The sweet Peter Pan collar and puffed sleeves with embroidery and button details are classic *kawaii* touches.

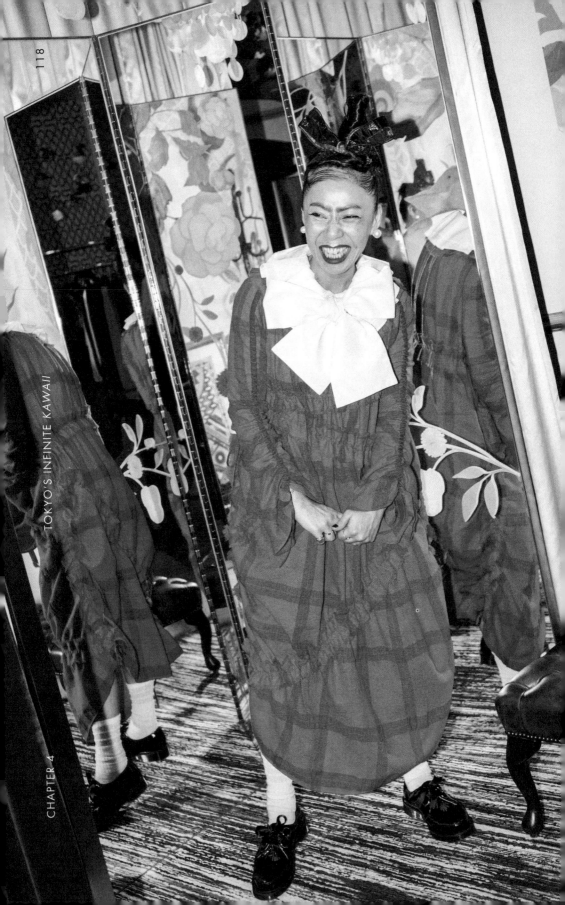

countless other places. This is not because Japanese people are childish—of course, they aren't—or because they long for childhood more than people of other cultures, though nostalgia is certainly one part of *kawaii*'s appeal. While it is a style rooted in fantasy and nostalgia, *kawaii* as a concept is taken very seriously by many of its devotees. Attempting to master a *kawaii* look can be viewed in a similar light to practicing the Japanese traditional arts, such as Bushido (the way of martial arts), Kado (the way of flower arranging), and Sado (the way of tea). Practitioners of these arts find beauty within the prescribed actions and creative results of these disciplines as they strive to attain the highest level of skill possible. The people wearing *kawaii* style on the streets of Tokyo often see their style as a craft. They dress with intention, great attention to detail, and take pleasure in this mode of creative expression, even if they just love *kawaii* style or the way a floaty, floral dress makes them feel, and even if the end goal is simply to have fun.

In this chapter, we'll focus on *kawaii* as it's explored in different ways by women who currently influence and define street style in Tokyo. Through our conversations with these stylish women, we've found that, for some of them, there is an undeniable appeal to dressing up in pretty florals and floaty fabrics as a way of escaping into a fan-

tasy world. There is also the attraction of appreciating natural fabrics and soft silhouettes with intricate detailing as a way of taking pleasure in the little things in life and focusing on your immediate surroundings amid the hectic pace of Tokyo life. So far, so *kawaii*.

But *kawaii* in street fashion is also subversive. It undermines traditional ideas of femininity by juxtaposing harder edges and masculine detailing with floaty fabric and flowers, or uses irony and anachronism to intentionally invert traditional associations with flowers and silk dresses. In this context, reclaiming *kawaii* to experiment with new combinations and styling can be a kind of liberation from what is traditionally considered "girly" and all of the social constraints that stereotypical *kawaii* style entails. The spirit of their style comes from a passion for playful irony, the subversion of expected norms, and rebellious punk music and rock 'n' roll. So, it's no wonder that *kawaii* styles influence street-style fashions and attract such exuberant devotees.

Through the following conversations, we hope you'll begin to see that, rather than following a fixed set of style rules for being *kawaii*, incorporating *kawaii* elements into your own style is as personal as it gets, and relies on having an open, playful mind-set, often mixed with a wicked sense of humor. Let's start by meeting one of the most well-known icons of *kawaii* style.

OPPOSITE Tomoko Inuzuka, director, Vermeerist Beams, in a scarlet Angel Chen dress, a Vermeerist Beams original white shirt with an oversize pussy bow, and Le Kilt × George Cox enamel shoes. The ruching, ruffles, satin ribbons and bows on the shoes, and schoolgirl socks add playful *kawaii* touches.

Baby Mary

Owner, director, and DJ
at Faline Tokyo and Miss Faline

"My version of *kawaii* is edgy spitefulness and sexiness."

—Baby Mary

Baby Mary is a charismatic figure in Tokyo's fashion world, and her influence on street style is undeniable. Walking into her stores, Faline Tokyo and Miss Faline, is to enter a world of *kawaii*, staffed by "Faline Girls and Boys" who are well known on the streets as Tokyo's It girls and boys. Thanks to Instagram and other social media, the Faline staff members are also getting attention worldwide for their edgy, *kawaii*-cool style. Combining her love of Vivienne Westwood and music, Baby Mary nurtures these young style influencers and talents, many of whom go on to careers in music and fashion. For example, DJ and fashion icon Mademoiselle Yulia (@mademoiselle_yulia), who frequently appears in street-photography magazines, is a former Faline Girl.

When we met, Baby Mary reminded us of a character who had just stepped out of an old film or novel, a girl with great fashion sense and a dash of rebelliousness. "My version of *kawaii*," she tells us, "is edgy spitefulness and sexiness."

Although pink florals, ribbons, and Mary Janes are key elements of her wardrobe, Baby Mary exudes edgy coolness. She seems as surprised as anyone that she likes such girly styles so much, given the equal attraction that punk and house music have for her, but she also takes obvious pleasure in the contradiction. It is this subversive strain within the sugar-shock cutesy styles that make *kawaii* so interesting and influential for street fashions in Tokyo.

The first store Baby Mary opened was Faline in Nagoya, a major manufacturing hub that is increasingly associated with the fashion industry. The store originally sold Vivienne Westwood clothes exclusively. Why Vivienne Westwood? "About twenty years ago I saw a corset dress with crinoline that was in a Vivienne Westwood collection and I fell in love at first sight. I immediately rushed to Worlds End in London. I still remember how nervous and excited I was when I opened the door. I think that my fashion life changed drastically from that moment." Vivienne Westwood was selling her iconic "mini-crini" (a mix of a Victorian crinoline and a ballet tutu) that was inspired by the Ballets Russes

OPPOSITE Baby Mary wears a Chloé dress with Louis Vuitton ankle boots with a book-shaped clutch from Olympia Le-Tan. She also sometimes serves tea to customers in the afternoon.

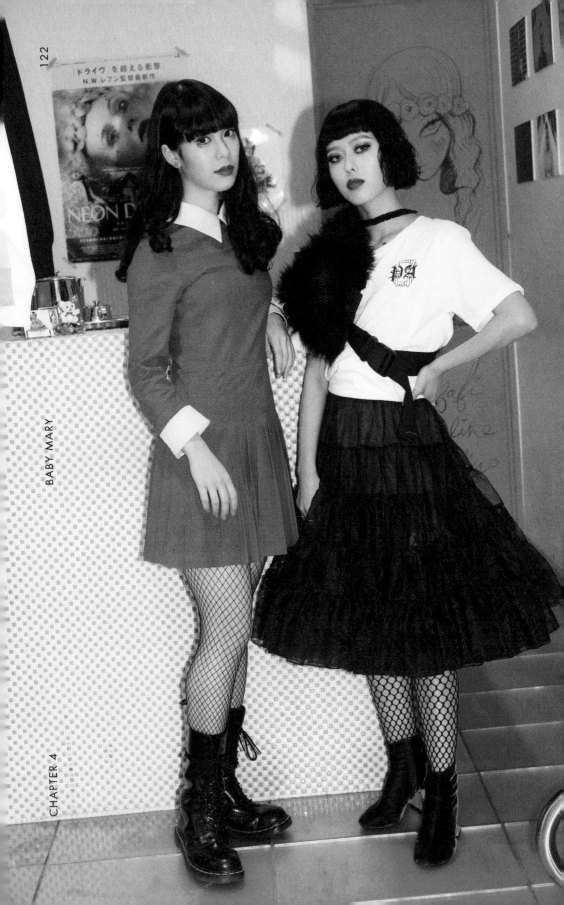

BABY MARY

CHAPTER 4

"My wardrobe hasn't changed much since I was a teenager—ribbons, Mary Jane shoes, and pink clothes."

—Baby Mary

production of *Petrushka* with its glorious music, costumes, and dance. The mini-crini was supposed to be emblematic of both the restrictions of women's clothing, because the Victorian crinoline was worn underneath corseted gowns to help change and conceal the true shape of a woman's body, and also liberation, because the short length exposed the legs and allowed the wearer to move freely like a ballerina.

At the time Baby Mary discovered Worlds End, with its oversize clock over the door that looks like something out of *Alice in Wonderland*, Westwood had moved on from punk to explore fashions that were sexy and nostalgic,

OPPOSITE Rie (left) and Erika Gold, members of the sales team at Faline Tokyo. Shop staff at Faline Tokyo are leaders of the *kawaii* style tribe and are commonly known among young people in Harajuku as "Faline Girls and Boys." Classic *kawaii* pieces—Rie in a short red dress with a sweet collar and cuffs, Erika Gold in a crinoline skirt and T-shirt with a cozy fur cummerbund worn over the shoulder—are transformed into a fresh, original *kawaii* cool look when styled with unexpected details like fishnets and black Doc Martens or a bright red lip and wavy, cropped hair.

even a bit childlike, as a counterpoint to the increasingly boxy, adult, masculine power-suit styles for women in the mid-1980s.

During her time in London, Baby Mary tells us, "I used to hang out every night in clubs with cool people I met through Worlds End. My contact base grew from those encounters in London as I met more and more people at the clubs and exchanged information and ideas about fashion and music with them." Baby Mary went on to collaborate with these designers and creators on her own original brand, including Fifi Chachnil, Olympia Le-Tan, Jeremy Scott, and Fafi (the artist who designed the Faline Tokyo original items).

Baby Mary credits her family for her eclectic *kawaii* style. "My father went on many business trips all over the world, so we had souvenirs from each country he went to all over my house. We lived in a European-style building with a pink-and-orange poodle-motif wallpaper that matched the orange carpeting. My mother used to cook roast beef or escargot on special occasions like Christmas. Back then I thought it was normal, but looking back at it now I think that I was brought up in a very Westernized environment. But that experience made me who I am today. When Miss Faline was just about to open I saw the completed interior design and thought, 'Oh, this is just like my parents' house!' The foreign books and tableware on the bookshelves were identical to my parents' decor. Perhaps it's part of me—ribbons, Mary Jane shoes, and pink clothes."

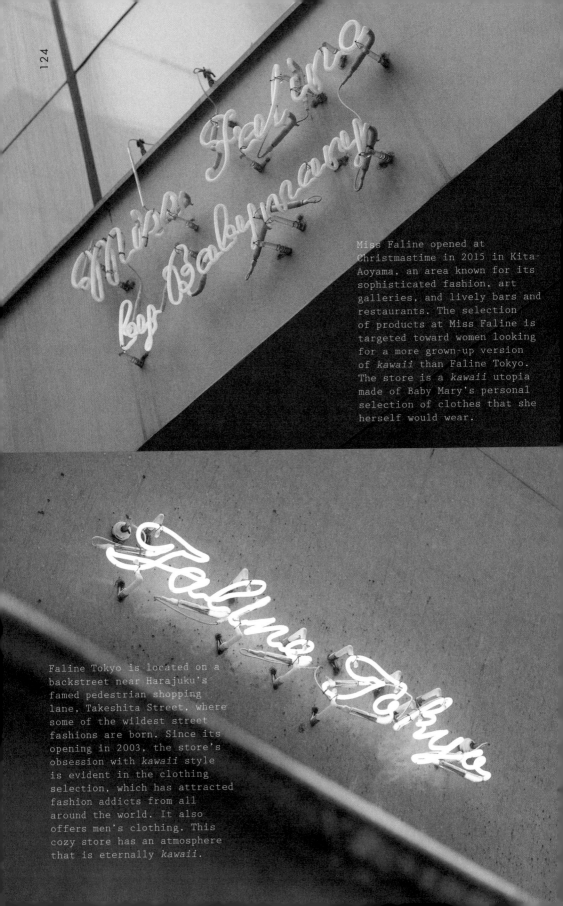

Miss Faline opened at Christmastime in 2015 in Kita-Aoyama, an area known for its sophisticated fashion, art galleries, and lively bars and restaurants. The selection of products at Miss Faline is targeted toward women looking for a more grown-up version of *kawaii* than Faline Tokyo. The store is a *kawaii* utopia made of Baby Mary's personal selection of clothes that she herself would wear.

Faline Tokyo is located on a backstreet near Harajuku's famed pedestrian shopping lane, Takeshita Street, where some of the wildest street fashions are born. Since its opening in 2003, the store's obsession with *kawaii* style is evident in the clothing selection, which has attracted fashion addicts from all around the world. It also offers men's clothing. This cozy store has an atmosphere that is eternally *kawaii*.

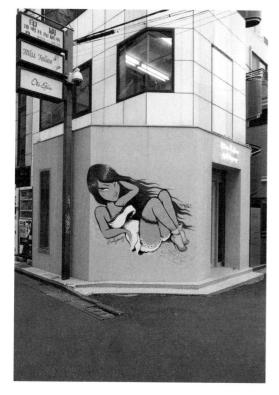

The out-sized wall paintings by the French artist Faß, featured on both the exterior of Miss Faline and the store interior of Faline Tokyo, belie the tiny, intimate shop spaces inside. In addition to Baby Mary's hand-selected clothes, the shelves at Miss Faline are stocked with the most adorable *kawaii* finds, including novels, interior decor, collectibles, perfumes, tea cups, and more.

Tomoko Inuzuka

Director, Vermeerist Beams

"When I feel passionate about fashion, it is always about *kawaii*."

—Tomoko Inuzuka

Well versed in UK rock culture and, of course, fashion, it is no surprise that Tomoko Inuzuka is also a fan of Vivienne Westwood. When we meet at her select shop in Harajuku, Vermeerist Beams, Inuzuka tells us, "From the 1980s to 1990s, many cool musicians based in Tokyo were wearing Seditionaries," Vivienne Westwood's brand from the 1970s. Her subversive clothes were influenced by punk music and were sold by Westwood and McLaren's King's

Road shop (called SEX at that time, but later refitted to become Worlds End). "I had a great deal of admiration for [those musicians'] style. Back then, fashionable people knew all sorts of things about music, film, etc. . . . they were really cool. I wanted to be like them, so I would often go to places where they would gather to try to get to know them and learn more about their style."

Vermeerist was established as a branch of Beams, the pioneering select shop in Japan. Vermeerist is named after Johannes Vermeer, and the store's aesthetic is inspired by the sumptuous fabrics, ribbons, botanical embellishments, and hairstyles that figure prominently in the Dutch master's paintings. At Vermeerist, these motifs are transformed into something larger than life, thanks to an installation from the illustrator and display artist Przemek Sobocki. Giant painted floral motifs adorn the floors, wind their way up the legs of display cases, and spill onto the glass, and flowers hang from the ceiling.

Inspired by Vivienne Westwood-style punk, Inuzuka's own signature style is Tokyo *kawaii* through and through and is well known and admired by her customers. She is super-attuned to pretty, nostalgic looks with an edge, clothes that are beautiful to look at and fun to wear but that also have a

OPPOSITE Inside the store, we got lost in a pop-art wonderland designed by the artist and illustrator Przemek Sobocki. Vermeerist Beams owner, Tomoko Inuzuka, holds a copy of Johannes Vermeer's famous painting *Girl with a Pearl Earring*. The shop is named for the Dutch master. Like other influential boutique owners that we spoke to, Inuzuka tells us that she only carries clothes that she herself wants to wear, and the store feels like her closet, with each corner and shelf full of *kawaii* pieces.

smart concept behind them, and she endeavors to support such fashion at Vermeerist Beams. "When I feel passionate about fashion, it is always about *kawaii*." Clothes at Vermeerist Beams are selected based on Inuzuka's personal preferences—if it makes her say, "*Kawaii*! I want to wear that!" it's in. Her preferred floral and plaid patterns, floaty fabrics in unusual silhouettes, or heavier chintz draped elegantly around her body are the epitome of *kawaii*, but her styling always includes edgier details—rock-chic makeup, heavy boots, unexpected accessories, twisted, sculptural hair adorned with ribbons, and so on.

something fun is central to *kawaii* street style. As for the selections on display at Vermeerist Beams, Inuzuka looks for artistic passion as much as *kawaii* design: "Whenever I meet someone who puts their own ideas into something, my heart swells," Inuzuka tells us. "When I find designers who create like this, I always make sure to buy their products, regardless of the 'value' attached to the designer's name." The next designer we will meet, Akiko Aoki, is one of these passionate *kawaii* creators.

"When I see a girl walking down the street in Harajuku who has clearly gone to great lengths to get done up right, I just can't help but feel the *kawaii* essence that girl's style expresses."

—Tomoko Inuzuka

Inuzuka also has a keen eye for up-and-coming *kawaii* style and takes inspiration from the streets, even as she herself shapes street style through her store's selection and her unique style. "When I see a girl walking down the street in Harajuku who has clearly gone to great lengths to get done up right," she explains, "I just can't help but feel the *kawaii* essence that girl's style expresses." This joyous appreciation of fashion as a hard-earned skill and as

OPPOSITE Akiko Aoki (right) and Mari Terasawa of Tokyo Kaihoku (left) at the unveiling of a new Akiko Aoki collection. Terasawa wears a pink Akiko Aoki vest.

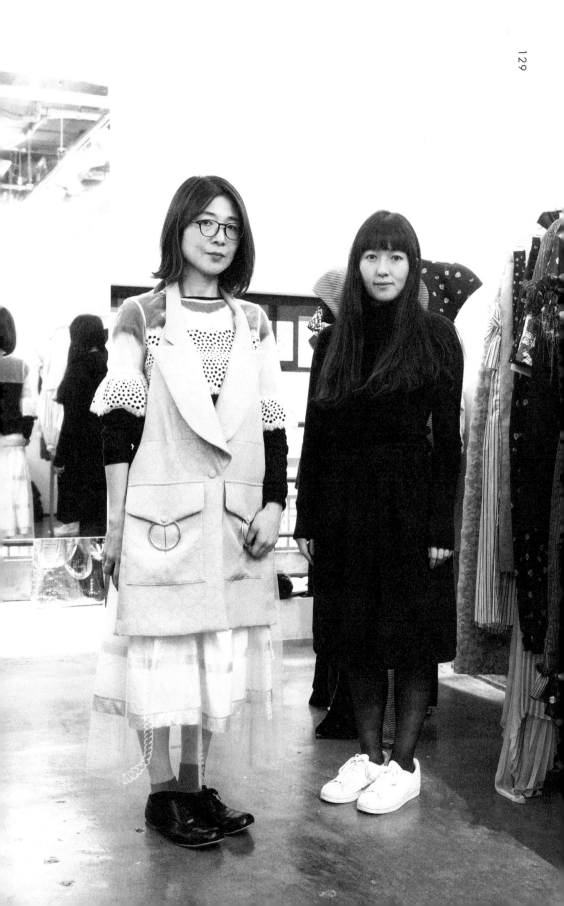

Akiko Aoki

Designer, AKIKOAOKI

Designer Akiko Aoki's eponymous label, AKIKOAOKI, is an up-and-coming brand that has been grabbing the attention of global fashion media for its new type of *kawaii* that is classic and girly, but also contemporary. One of Aoki's main motifs is the school uniform, but her designs are unlike any uniform you've ever seen before. Pleats, ruffles, and ruched edges are characteristic details, along with billowing sleeves, scalloped lapels and hems, and Peter Pan collars like something out of the manga series *Sailor Moon*. "I have always been fond of school uniforms, with their white blouses and sailor collars," Akiko Aoki tells us when we meet her behind the scenes at the unveiling of a new collection in Tokyo. We ask her about her penchant for uniform styles. "It is not just me, though—Japanese women like school uniforms, don't we? Some girls even go to the trouble of buying a school uniform to wear even though their school didn't require one!"

We ask Aoki about the evergreen appeal of school uniform styles. "I think people like them because they're a kind of cosplay, allowing the wearer to morph into whatever they want. In a uniform, you can 'mask' the self, or dissolve into your surroundings, or even adopt a different persona. I think this is why many people still have affection for uniforms, even after we grow up. I'm definitely one of those people." So it's partly about familiarity and partly about concealment. "Like kimonos," Aoki explains, "school uniforms have design elements that are somewhat plain and that conceal the shape of the body. This concealment is probably the reason why uniforms will always be perennial favorites."

"But," she continues, "as a designer, I endeavor to pay attention to the beautiful curves of the female body and to create unique forms by accentuating or deconstructing those curves to create novel and original designs." Pleats are one of Aoki's signature details that create dramatic movement against the body and that have been particularly popular each season with many fashion-conscious women in Tokyo. Looking at the so-called school uniforms in Aoki's collections, it's easy to understand why anyone, even those not keen on returning to school-style fashions, would want to wear her clothes.

Next we speak with Etsuko Yano, the director of the influential *kawaii* bouqitue Lamp harajuku, who also is drawn to school uniforms and is a fan of AKIKOAOKI for elevating the traditional school uniform into a fashion genre in its own right and cementing it as a cornerstone of *kawaii* style.

> "Like kimonos, school uniforms have design elements that are somewhat plain and that conceal the shape of the body. This concealment is probably the reason why uniforms will always be perennial favorites."
>
> —Akiko Aoki

Akiko Aoki's collections showcase her distinctive, feminine design elements that coexist with an edgy, contemporary feel. Here we see pleated skirts reminiscent of school uniforms, which appear in Aoki's collection every season, along with other floral designs and motifs printed on voluminous sleeves and puffed skirts from one of Aoki's popular lines.

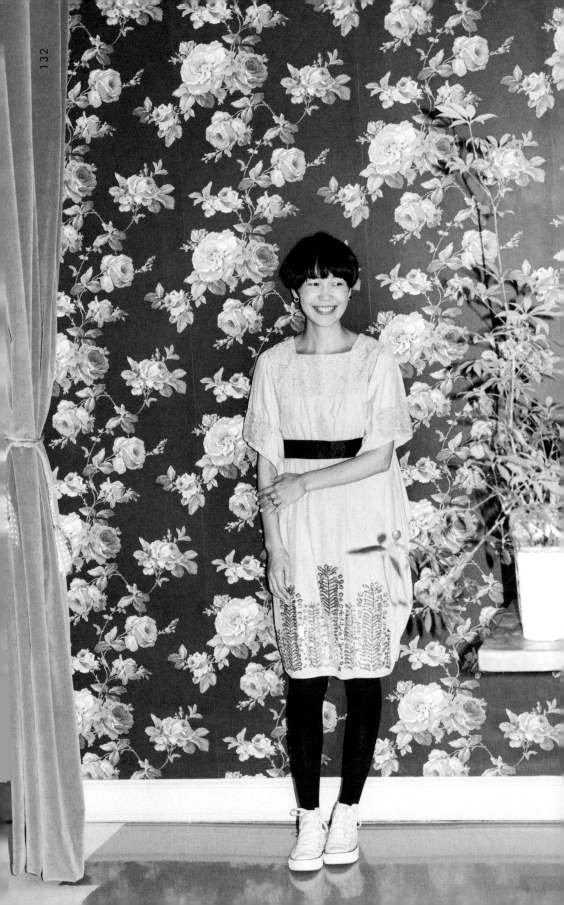

Etsuko Yano

Like high school students the world over, Etsuko Yano, director of *kawaii* boutique Lamp harajuku, used to push the limits of her school uniform, trying to wear it in her own way. She also loved listening to punk music, and, when not in uniform, she always wore clothing and platform shoes inspired by her favorite bands. In contrast to the neat bob she sports today, Yano's preferred after-school hairstyle was once a faux-hawk, which she would create before going to gigs. Her affinity for punk music has shaped her style, as has her love of movies.

Etsuko Yano cites Sofia Coppola as a major influence on her sense of style. "I have an affinity for the musical expression and the beauty in her films. I find her worldview to be romantic, but it also encapsulates a somewhat dangerous darkness within it." Think *Marie Antoinette* (2006), with its anachronistic combination of over-the-top frills, soft pastels, and edgy rock soundtrack. "I'm a very perverse person," she tells us. "I just don't find things that everyone else loves to be desirable. I'm always looking for something different. Lamp harajuku was born because of this perversity."

"When I was younger, I loved Vivienne Westwood's punk-feminine styles, even though I couldn't afford her clothes as a student." It is hard to imagine Yano's high school look based on her current style—she is wearing a delicately embossed floral dress the day we meet with her—but you can see a kind of punk attitude infused within her style if you look closer.

Yano's punk spirit and independent attitude, which she calls "perversity," influence the store's merchandise, as well. It is probably this rebellious spirit hidden within the *kawaii* pieces in her store that has given Lamp harajuku its enduring appeal to its young-at-heart clientele. She also keeps things fresh by regularly hosting style exhibitions to showcase new designers' creations.

Lamp harajuku is a multilabel store that has been in business at the same location in Harajuku (where businesses come and go as swiftly as the trends they carry) for over fifteen years. Like Baby Mary's Miss Faline (page 120), Lamp harajuku offers grown-up *kawaii* styles and is known as an excellent source for beautiful, one-of-a-kind pieces from designers both in Japan and around the world, but especially those from exclusive, high-concept Tokyo-based labels. Sina Suien, featured next, is a perfect example of the brands sold here—items created by designers with an artist's sensibility.

OPPOSITE Etsuko Yano, director of Lamp harajuku, pairs Converse high-tops with a Cosmic Wonder Light Source dress from their 2012 season.

> "I have an affinity for the musical expression and the beauty in [Sofia Coppola's] films. I find her worldview to be romantic, but it also encapsulates a somewhat dangerous darkness within it."
>
> —Etsuko Yano

Lamp harajuku is located on a backstreet near Omotesando in Harajuku, Tokyo's center for youth fashion. The store is heaven for those looking for truly original *kawaii* clothes presented in a dynamic, gallery space.

"I'm a very perverse person. I'm always looking for something different."

—Etsuko Yano

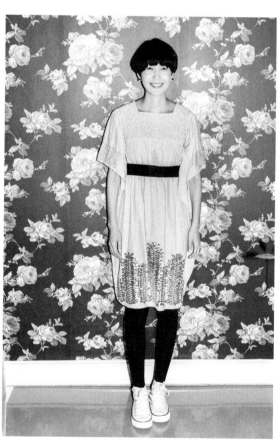

ABOVE An art installation by the creative duo, magma (magma-web.jp) on display inside the store.

Yumiko Arimoto

Embroidery artist and designer,
Sina Suien

"When I was a student, I loved to read the manga series *Honey and Clover* . . . I was very fond of the female character, Hagumi, and I used to dress like her, always wearing cute dresses with soft silhouettes."

—Yumiko Arimoto

For Sina Suien designer Yumiko Arimoto, *kawaii* style has a very personal, intimate feel. Every Sina Suien dress is made by Arimoto and created using a slightly different embroidery design and combination of textiles. Supply is limited and only a small selection of stores, including Lamp harajuku, sell Sina Suien clothing. (Arimoto has also exhibited her work at Lamp harajuku's gallery space.)

Sina Suien dresses are priced for true devotees, but even so, the brand gets attention from women of all ages from college students on up. In fact, Sina Suien is so popular that there are even enthusiasts who collect Sina Suien

clothing exclusively. If you pay close attention to the highly artistic embroidery and the unique use of textiles that create an oriental atmosphere in Sina Suien clothing, you will find something intriguing, hidden under a veil of secrecy and intimacy and with an air of sophistication that transcends the normal conception of *kawaii* as merely "adorable" or "precious," and contrasts with the edgier, sexy, cool *kawaii* of Faline Tokyo and Vermeerist Beams.

When we meet with Arimoto in her atelier in Tokyo, she tells us she sometimes finds inspiration for her fashion ideas in manga and anime. "When I was a student, I loved to read the manga series *Honey and Clover*," a Japanese comic series by Chica Umino, popular among women in their teens and twenties, which was later adapted into a feature film. "I was very fond of the female character, Hagumi, and I used to dress like her, always wearing cute dresses with soft silhouettes. Back then, Mori Girl style was becoming popular. So my friends started calling me 'Mori Girl.'" Arimoto's shy demeanor belies a sophisticated introspection, a sharp eye for detail, and a craftsman's preeminent skill. She has loved drawing ever since she was little and has even exhibited her own original illustrations.

"Contemporary art really inspires me," she tells us. "I tend to draw representa-

Sina Suien designer and embroidery artist Yumiko Arimoto pairs a red skirt, which she made herself, with a secondhand sweatshirt transformed by her own embroidery embellishments. The spring/summer 2017 collection, examples of which are shown here, is inspired by Buddhist monks' sashes and features exquisite embroidery.

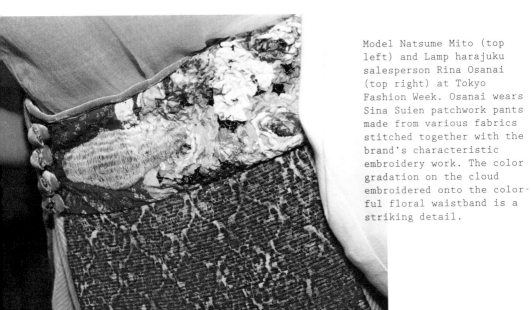

Model Natsume Mito (top left) and Lamp harajuku salesperson Rina Osanai (top right) at Tokyo Fashion Week. Osanai wears Sina Suien patchwork pants made from various fabrics stitched together with the brand's characteristic embroidery work. The color gradation on the cloud embroidered onto the colorful floral waistband is a striking detail.

tions of things in a way that mixes fashion and art." Arimoto says she is particularly inspired by designs from Cosmic Wonder, the Japanese fashion label we saw earlier on Etsuko Yano from Lamp harajuku (see page 132), and Susan Cianciolo, the Brooklyn-based artist known for her avant-garde fashion designs and mixed-media art installations. "Recently I have become more interested in Japanese traditional arts as well," Arimoto continues. "I produced my 2017 spring/summer collection based on the ideas of Buddhist monks' sashes. I presented the collection at a Buddhist temple in Niigata like an art exhibition and it felt like I was breaking new ground. It also gave me a strong desire to create clothing using kimono fabric, which made me appreciate my own country as a source of inspiration more than ever."

Arimoto's unique combinations of design elements from manga, anime, contemporary art, and traditional Japanese culture are what make Sina Suien's clothes so interesting. She is always looking for fresh inspiration. "I find that those who have a personal fashion style that showcases their own individual attractiveness are really *kawaii*. Whenever I see such people I try to draw them—it's a habit of mine. I sometimes get an idea from these illustrations and go on to create a new dress."

Again and again, we noticed how music, film, literature, and other interests beyond fashion have influenced how the women we spoke to explore kawaii *style. The passion and artistic intention that go into creating intelligent music and film and so on, especially works that critique contemporary social and artistic norms and show unexpected or subversive aspects of those norms, are values that appear again and again in* kawaii *styles. Of course, it is possible—and fun!—to enjoy beautifully* kawaii *florals and feminine details on clothing simply for what they are. But the ways in which the women we've spoken to approach this beauty, looking deeper to find something more interesting and revealing about the idea of* kawaii, *and about themselves, are fundamental elements of Tokyo's street culture.*

Moving on from the feminine kawaii *style we've seen in this chapter, we'll explore genderless style, which has been getting increasing attention worldwide but which has been quietly developing for over a generation here in Tokyo (see page 145). Like* kawaii, *genderless style is as individual as the person wearing it and is just as expressive of a person's style ethos and identity. Let's take a look at the fashion designers, brands, select shops, and concept stores that are exploring the possibilities afforded when you take gender distinctions out of the style equation.*

Q&A
Olympia Le-Tan

Born in London and raised in Paris, Olympia Le-Tan began her fashion career working under Karl Lagerfeld at Chanel and later at Balmain with Gilles Dufour. In 2009, Le-Tan launched her eponymous accessories label, combining her passion for embroidery and literature (Le-Tan is the daughter of the French illustrator Pierre Le-Tan) to create one-of-a-kind bags and clutches. Le-Tan launched her first ready-to-wear collection at Paris Fashion Week in 2012. She is also a regular visitor to Tokyo and has done a number of collaborations with Japanese brands including Uniqlo.

What do you find appealing about Tokyo style?

I am attracted to Tokyo in general, not just the fashion. The fashion for me is a small part of it. I see the whole city as a very inspiring and stylish place from a fashion point of view. I like the mix of tradition and modernity; I like the strangeness; I like the fact that everything feels fast but slow at the same time. I like the freedom; I like how daring the Japanese people are with what they wear. Some are really conservative, but some are so extreme. They take everything to such a level that nobody else dares to go to. I like how specific they are about everything. There is no city in the world that is so precise and specialized in so many random things.

Do you have a favorite Tokyo designer?

I really admire the work of Jun Taka-hashi and of course Rei Kawakubo. Although they show in Paris, it is still Tokyo fashion. Their shows are always so unbelievably creative and extreme. There is nobody else like them.

What styles stand out for you when you come to Tokyo?

To me the most fashionable and elegant women in Tokyo are those in traditional dress.

Do you have a spot in Tokyo that inspires you?

Tokyu Hands is always inspiring in an unexpected kind of way. I can get inspired by some new kind of food utensil I have never seen before, or by the crazy amount of stationery. I also find the workers' uniforms at Mannen-ya very inspiring. The colors and the shapes are so different. I love looking at the patterns on vintage kimonos, or samurai armor at the Tokyo National Museum in Ueno. Everywhere is inspiring for me, from the food markets to the beautiful gardens . . .

"I like the mix of tradition and modernity; I like the strangeness; I like the fact that everything feels fast but slow at the same time."

Olympia Le-Tan's signature book-clutch is a favorite of Tokyo style icon Baby Mary (see page 120). The shelves at Miss Faline regularly feature Olympia Le-Tan's embroidered clutch styles.

Is Tokyo Street Fashion "Fake"?

Contributed by Hiroshi Ashida

Thinking about street fashion in Tokyo, many so-called street styles such as the Karasu-zoku (The Crows) and Takenoko-zoku (Bamboo Shoots) actually came from famous brands like Comme des Garçons and shops like Boutique Takenoko, which were heavily influenced by Western culture. So in that respect, what we commonly refer to as Tokyo's street fashion was part of a hierarchical structure, with high-end designers, mainstream brands, and popular shops, influencing style lower in the structure. But street fashion became a sensation in Europe and America because it supposedly reversed the trickle-down flow of style from the fashion establishment, and upended the hierarchy in which high fashion culture influenced low street style culture. If street style in the West can be thought of as a way of expressing authenticity and resisting established norms for good style, street style in Tokyo seems fake.

But even if the origins of a native street style in Tokyo came about from Japanese designers imitating the spirit of street style overseas in their designs, and then acting as mediators for people on the streets of Tokyo, that doesn't mean there aren't interesting possibilities for original styles to emerge from this context.

"When fakes are confused with originals, it's easy for boundaries and definitions to break down. This is why some describe Tokyo street fashion as 'chaos.'"

For clarity's sake, we need to distinguish between a "copy" and a "fake" as these terms are understood in Japanese fashion. A copy is something that seeks to imitate superficially the original design or idea. It does not create anything new; it just tries to pass as or replace the original. A fake, by contrast, looks to the original as a starting point for creating something new that occupies a parallel position in relation to the original. In this sense, a fake in Japanese carries with it a positive sense of creative artifice rather than the negative artificiality that a copy carries as an imposter. Adopting or creating fake styles comes with endless possibilities for invention. I would argue that although Japan doesn't have a true, indigenous street fashion as in

Packed with stores selling the latest styles and brands from up-and-coming designers, the backstreets of Harajuku ("Ura-Harajuku") was once the place in Tokyo where new styles were born.

other countries, Japan's street fashion culture is significant precisely because it is fake. As outsiders looking in at the countercultural movements that gave rise to original street style overseas, Tokyo designers can explore new styling possibilities more openly and objectively without cultural preconceptions.

Japanese fashion designers and people styling their own looks on the streets today are likewise expanding the possibilities for style and street fashion by "faking" street style from overseas. When fakes are confused with originals, it's easy for boundaries and definitions to break down. This is why some describe Tokyo street fashion as "chaos"—there are so many "original" influences out there being admired and then transformed by innovative designs that it becomes almost impossible to separate the originals from the fakes. Japanese designers and shops categorized as *kawaii* have understood fake style very well and relish the chaos. By adding large amounts of lace and frills, prints and dyes to vintage clothes, these designers deconstruct the originals and create something new. Their fakes have become *kawaii*, even if the individual item would not have been called *kawaii* in its own right. Designers in Tokyo have broadened and challenged conceptions of what original street style really is. They have even been credited for creating street style themselves because the fake styles they came up with are so unique. So by saying that true street style in Tokyo doesn't exist, I mean that fake street style is often confused for real street style. But the fact it is fake doesn't detract from its significance.

Tokyo's unique mix of designers, stylists, select and concept store buyers and consumers possesses an imaginative, flexible approach to fashion that is incredibly diverse and distinct, and their fake brands of street style are arguably the most creative and influential in the world. If street style didn't originate in Tokyo in the strictest sense, it seems fair to say that fake Tokyo street style is set to spawn new fakes on the streets of cities around the world.

Hiroshi Ashida has been a lecturer in Fashion in the Faculty of Popular Culture at Kyoto Seika University since 2013, after working as Associate Curator at Kyoto Costume Institute. Ashida serves on the editorial board of Vanitas, *a Japanese fashion critique magazine, and is a cofounder of kotobatofuku ("words and clothes"), a concept store in Kyoto that sells both books and clothing.*

Chapter 5

Genderless Style

What is genderless style? Is it women wearing men's clothing, and vice versa? Is it removing labels such as "men's" and "women's" to create new ways of speaking and thinking about fashion? Is it a political act of resistance to gender norms? Is it self-expression?

"Ageless and genderless fashion are becoming ever more in demand."

—Hiromichi Ochiai, designer, Facetasm

As we have seen from talking with the individuals featured throughout this book, fashion-conscious people pursue individuality in fashion—styles that are true to themselves and what they love—without much regard for the latest trends. Challenging the typical gender norms in fashion is another way to express this individuality, and this approach has a special resonance in Japan.

OPPOSITE jonnlynx designer Mariko Hayashi wraps up in an orange and gray reversible coat of her own design. Sho is drawn to silhouettes that are neither overtly feminine nor masculine.

LIKE THE BOYS

It is nothing new for a woman to put on a tailored pantsuit or man's shirt, styled with a belt at the waist and paired with a pencil skirt. Women have long borrowed from menswear for new silhouettes, more practical cuts and fabrics, increased comfort and utility, and of course, great style. To be clear, a woman wearing "men's" clothing does not necessarily make the look genderless, any more than a man wearing a dress is adopting a style without gender. A classic tuxedo jacket and cigarette pants can be cut and styled to feel "feminine"—that is, by accentuating the waist and bust, or elongating the legs through the cut of the suit, a woman can make men's clothes look more womanly. These are oft-repeated tips given in fashion magazines—even now—for how to borrow from the boys yet still look like a woman. This is not new, and isn't likely to disappear soon, but this kind of fashion advice and gender-bending styling simply reinforces the idea that to be "feminine," you have to narrow the waist or lengthen the leg, even if you are doing it in a man's clothes.

OVERCOMING GENDER BOUNDARIES

What *is* new, however, is that at international fashion shows and on the streets

of New York, London, Paris, Berlin, and other world fashion cities, we see an ever-increasing flexibility and openness about what people are choosing to wear, however they identify in terms of gender, and a more widespread enthusiasm for experimenting and exploring new cuts and styles, free from gendered constraints. More and more men are choosing genderless or "feminine" clothing to wear in everyday life, and it should be no surprise that they end up looking great. It is old news that Jaden Smith wears skirts and that Pharrell Williams collaborated with Chanel to promote their new handbag by wearing a classic Chanel tweed jacket and pearls. It has been a long time since women were able to shock others by wearing men's clothes; now, when men are doing it, society often accepts these new styles quite readily.

Increasing awareness of gender fluidity and the experiences of transgender people is also fueling the popularity of genderless fashion. Preoccupations with whether or not the resulting look is "feminine" or "masculine" seem dated and irrelevant. Fashion weeks now feature menswear and womenswear together on the same runway, while some designers intentionally blur the differences to explore new possibilities.

In this chapter, we'll look at the origins of genderless style in Tokyo and how designers working with genderless styles today are influencing trends worldwide. We'll hear from fashion designers, select shop directors, and other influential figures in fashion to see how they have each created a style beyond gender that is as original as they are.

THE ORIGINS OF GENDERLESS STREET STYLE IN TOKYO

Although global trends are undeniably shifting toward genderless fashion, Hirofumi Kurino, senior adviser for creative direction at United Arrows, tells us that even prior to this, "Japanese people were less concerned with gender differences in fashion, and we already knew how to dress ourselves stylishly by simply creating our own style using whatever fine garments we could find." The designers Rei Kawakubo, Issey Miyake, and Yohji Yamamoto were experimenting with genderless fashion for decades before their counterparts in the West caught on.

A NOTE ON TERMINOLOGY

Throughout this book, we have used the term used in Japanese, "genderless," to mean not only "without gender"—though that is certainly part of it—but also to include blended androgynous and unisex looks to suggest a borderless approach to style free from old-fashioned gender categorizations. We have maintained the labels "men's" and "menswear" to mean clothing traditionally designed for men (suits, waistcoats, neckties, jumpsuits, flight jackets, workers' clothing) and "women's" and "womenswear" to mean clothing and accessories traditionally identified as being cut and designed for women (skirts, dresses, form-fitting skirt- or pantsuits, heels, handbags) so that the comments from our contributors can be discussed more easily.

Publicist for the multilabel store Sister, Mina Koyama, wears a shirtdress from one of her favorite New York designers, Matthew Adams Dolan, with long tabi boots by Maison Margiela.

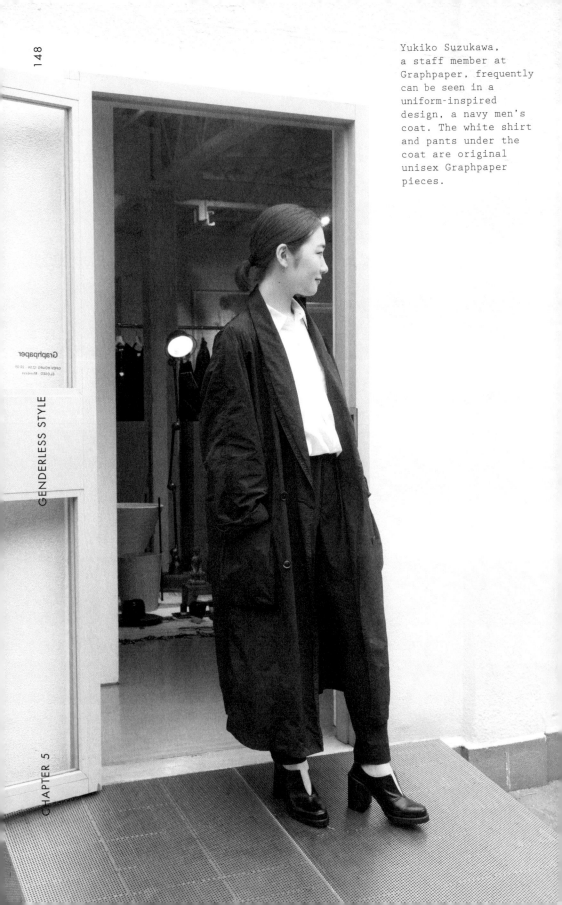

Yukiko Suzukawa,
a staff member at
Graphpaper, frequently
can be seen in a
uniform-inspired
design, a navy men's
coat. The white shirt
and pants under the
coat are original
unisex Graphpaper
pieces.

> **"Both women and men are highly conscious of fashion. They are sensitive to trends, care about hair and makeup, and even with inexpensive clothing they have the skills to coordinate fashionably."**
>
> —Adrian Hogan, Australian fashion illustrator based in Tokyo

As Kurino says, "Fashion-conscious women [in Tokyo] began wearing men's clothing as many as forty years ago, using female fashion stylists' private collections as a catalyst. Once women grasped the fact that men's clothes were basically superior in functionality and comfort, they wanted to enjoy fashion freely without being conscious of arcane gender rules such as 'buttons are on the left side of a blazer for women.' Women in modern Tokyo have increasingly become less bound by fashion taboos, and they seem to truly enjoy genderless looks."

LIKE THE GIRLS

Although Japanese people have become accustomed to genderless styling, many overseas visitors to Tokyo are sometimes surprised to see men's fashions in particular. According to Kurino, "Worldwide, Tokyo might have the most fashionable men in any single city. Overseas, strong gender stereotypes are still in place related to labeling fashionable men as gay, so when foreigners come to Tokyo, they can be quite surprised." Kurino gives tote bags as an example of a gender-biased cultural flashpoint: "To people in Japan, a tote bag is a very ordinary fashion item for men. However, overseas, a man carrying a tote bag will often be viewed as somehow more feminine because of the bag." Japanese mainstream pop culture also routinely features men wearing women's clothing. "Every day of the week," Kurino points out, "Matsuko Deluxe [a very famous cross-dressing Japanese personality] can be seen on TV. And for many years men who dress in feminine styles have confidently walked the streets of Shibuya and Harajuku. In the end, I think that the reason behind this acceptance of so-called femininity among men is not just a lack of strict gender classifications, but also a loosening of strict social constraints in post–World War II Japan."

> **"Long before the 1990s, Tokyo was a city that showed tolerance toward genderless fashion. I hope fashion can spread an attitude of being proud of the way you are, without hesitation or any disguise."**
>
> —Rei Shito, street-fashion photographer

"I adore wearing clothes that make me feel sexy. Not erotic, but rather a kind of cool, handsome sex appeal."

—Fumika Uchida, designer, FUMIKA_UCHIDA

FREE FASHION FOR ALL

While visiting our favorite boutiques in Tokyo, many of the designers and staff members we speak to echo Kurino's assertion that genderless fashion is integral to Tokyo's street style. When we ask Takayuki Minami, the director of the concept store Graphpaper, for his take on gender and fashion, he tells us, "I don't want to be categorized under a certain genre. That applies to both myself *and* the stores that I produce. So, I think men and women freely enjoying fashion without any restrictions is really cool."

Located on a quiet residential street between Shibuya and Aoyama that's difficult to find on a map, Graphpaper's two-story building has a bar where coffee and beer are available. It takes first-time (and even second- or third-time) customers some effort to find it, which is exactly as Minami intended. "Since this is an era when you can purchase anything on the Internet, the store must be a place that is worth visiting," Minami explains. "Creating an environment is an important task for select shops like us. After losing their way trying to find the store, our customers are all the more amazed at discovering the destination once they finally arrive. I was very particular in selecting the location of the store because I wanted to create a store that could provide just such an experience." This experience of the store as an art gallery and site of discovery is key to inspiring customers to find their own sense of style, according to Minami. "Style is something that customers create individually, so we created a space where the imagination of our customers can expand as if they were viewing art in a gallery."

As for categories within the store, Minami tells us, "We separate our original merchandise into men's and women's clothing, but we've noticed lately that women are buying men's clothing, and men are buying women's. I think that, like women, men who choose clothes based on their silhouette or design are increasingly common. I think this proves that the number of people who grasp fashion from diversified viewpoints is growing."

"I don't want to be categorized under a certain genre. That applies to both myself *and* the stores that I produce."

—Takayuki Minami, director, Graphpaper

OPPOSITE Graphpaper is a multilabel concept store that presents its fashions in a gallerylike setting. Black canvases, which can be pulled back to reveal clothing, tableware, and household items, hang on white walls throughout the space.

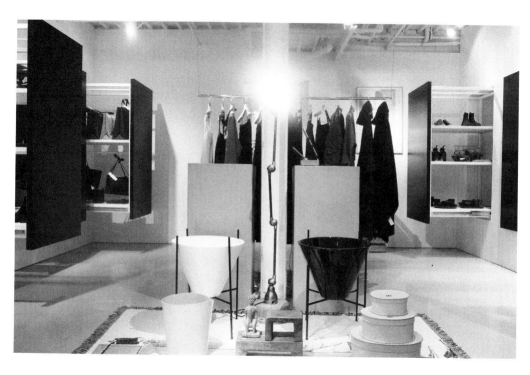

"When I choose clothes, I decide on silhouettes that don't obviously appear to be women's or men's, and I pay close attention to the shape of the clothing I create and wear."

—Mariko Hayashi, designer, jonnlynx

a biker jacket over a bare body, like Hiroto Komoto [a famous Japanese rock musician], very attractive. I am always taken aback when I see someone whose style exudes their way of life, regardless of gender, like Robert Plant and David Bowie. I think such people are living life while being themselves without being influenced by gender norms and trends. I would love to spend each day without regrets while refining a style through which I can just be myself."

Designer Mariko Hayashi was an early adopter of this mode of dressing. She has preferred "masculine" styling since her teens and naturally gravitates toward men's clothing, both in her clothing line, jonnlynx, and in her own personal style. "When I choose clothes," she tells us, "I decide on silhouettes that don't obviously appear to be women's or men's, and I pay close attention to the shape of the clothing I create and wear. However, I seem to be naturally attracted to the silhouette of men's clothing. Maybe I am fond of male musicians' styles? I find wearing

"Women in modern Tokyo have increasingly become less bound by fashion taboos, and they seem to truly enjoy genderless looks."

—Hirofumi Kurino, senior adviser for creative direction, United Arrows

OPPOSITE At the jonnlynx atelier where Mariko Hayashi comes up with her creations, she shows off her simple, chic styling, created by pairing a men's Dolce & Gabbana vest worn with a black bra underneath and jonnlynx jeans. "I own a lot of clothing with pockets because I really don't want to carry a bag. I regularly use a billfold wallet because I can carry it in my pants pocket."

THIS PAGE AND OPPOSITE Mariko Hayashi pairs a vintage MA-1 flight jacket with a jonnlynx T-shirt, pants by the Japanese brand L'Une, and Maison Margiela tabi boots. The silver bracelet is Chigo, a Japanese jewelry brand. Needed or not on this cloudy day, her Savile Row rounded sunglasses add extra attitude to an already edgy look.

BELOW Hayashi styles
this jonnlynx wrap coat
in bold orange to create
a warm, luxe silhouette.

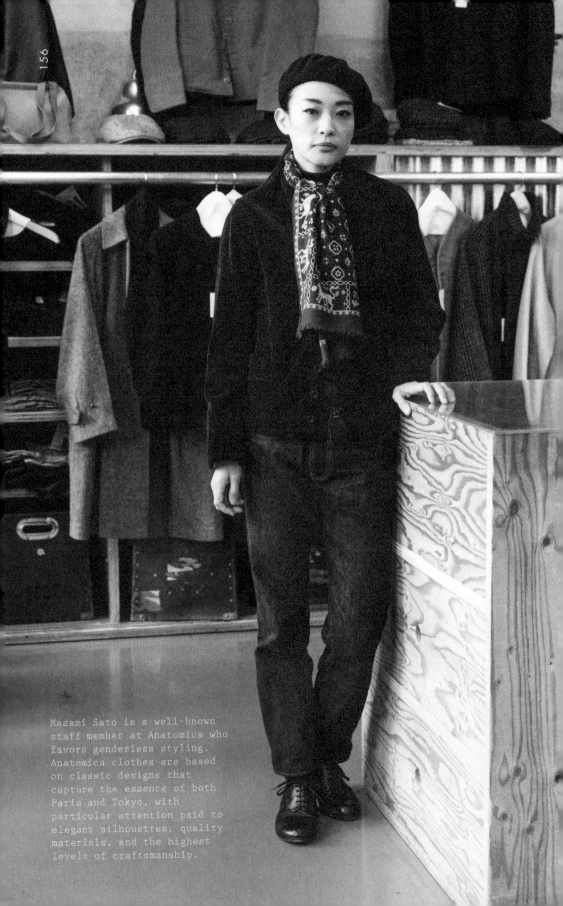

Masami Sato is a well-known
staff member at Anatomica who
favors genderless styling.
Anatomica clothes are based
on classic designs that
capture the essence of both
Paris and Tokyo, with
particular attention paid to
elegant silhouettes, quality
materials, and the highest
levels of craftsmanship.

> # "I find the distinctive, straightline silhouette of men's clothing very attractive."
>
> —Masami Sato, staff member, Anatomica

Masami Sato, also a fan of biker jackets, works at Anatomica, a popular select shop located on the east side of Tokyo. Sato is a well-known staff member there, and, when we meet up with her along Tokyo's Sumida River, she tells us American culture is what inspired her own experimentation with men's clothing.

"I have been interested in men's fashion since I was a teenager. I was particularly fond of military styling, so I carried around a military bag everywhere when I was in high school. I still wear basic men's clothes almost exclusively. I find the distinctive, straight-line silhouette of men's clothing very attractive. I don't own any skirts and I am not really fond of *kawaii* styles at all. I am really myself in those cool pants styles."

Sato lists photography collections, like those by Bruce Davidson or Danny Lyon, as her fashion textbooks. It's immediately obvious how much she loves the cool and tough worldviews she first saw in American culture as a child. A beret is her trademark accessory. To see how she styles it differently every day, achieving handsome new effects each time, check out Anatomica's Instagram (@anatomica_tokyo).

COOL AND COMFORTABLE— SOMEWHERE IN THE MIDDLE

As we've seen in Mariko Hayashi's designs (see pages 154–155) or Masami Sato's styling (see opposite), binary labels such as "masculine"/"feminine," "menswear"/"womenswear" increasingly fail to reflect the concerns of fashion designers and people who wear their clothes. What's more, they no longer seem adequate for how people— however they identify—actually live their lives or get dressed every day. If the point of fashion is to express individual style or a particular mood or a love of vintage or quality construction and tailoring, narrow, restrictive gender-based labels are simply not appropriate anymore. We see this reflected more and more by the up-and-coming people in the fashion industry.

> # "I feel more like myself when I am in boyish outfits."
>
> —Riona Nakagome, student, Bunka Fashion College

Riona Nakagome, a model and student at Bunka Fashion College, tells us that her standard look is a pants-style outfit that complements her boyish facial features. "I own dresses and skirts, but I wear pants far more frequently than those. I own a fair amount of men's clothing. I feel more like myself when I am in boyish outfits. And they make me feel more comfortable anyway. Maybe it has something to do with my boyish personality or maybe it's because I have lots of male friends."

"I often wear men's clothes because I prefer larger silhouettes . . . I also specifically check out men's fashion."

—Mitsuki Mashima, student, Bunka Fashion College

Mitsuki Mashima, also a student at Bunka, who often wears monochrome looks, is addicted to masculine styling. "I often wear men's clothes because I prefer larger silhouettes. Many of the clothes I choose are coats and shirts, which is to say, tops. I also specifically check out men's fashion, and I like K-pop and British punk rock music and styles. I'm always checking out men's styles on Instagram." Mashima and Nakagome, both pursuing their interest in styling and international fashion at Bunka, prefer "cool" styling to *kawaii*, and are definitely ones to watch.

NEW AND EVOLVING BRANDS

New brands are forming and existing brands are adapting to this increasingly popular trend. For example, Comoli, launched in 2011, is basically a men's brand, but it attracted a strong following among female stylists, magazine editors, and buyers. The brand responded by repositioning itself as a unisex brand with smaller sizes for ladies. We ask designer Keijiro Komori why the brand attracted female customers, too. "One reason that women support our brand might be that our

style falls between casual and formal," he explains. "As young people grow older, those who don't usually wear suits for work increasingly find themselves working with people in suits, so casual styles gradually end up being less practical and appropriate for their jobs and lifestyles. But a sudden switch to formal suits wouldn't work for them either. I myself am that kind of person, and I want a style that comes between casual and formal—that's why I make clothes."

What is striking about this brand's clothing is its genderless shape. The clothes are based on box silhouettes without curves, but the way the clothes rest on the shoulder, back, and hip is beautiful. The designers work with pattern makers who specialize in suits, which certainly influences the structured yet elegant lines. Even though the styles look loose, the overall effect is sophisticated and pulled together. The clothes seem both

OPPOSITE LEFT At Omotesando, Riona Nakagome rests the Moussy men's motorcycle jacket on her shoulders rather than wearing it properly—this is quite calculated. The sweater is Perverze, a Japanese fashion label. The pants are from Zara. The cap is by 6(ROKU), which is an original brand from United Arrows.

OPPOSITE RIGHT In Shinjuku, where Bunka Fashion College is located, Mitsuki Mashima is wearing a customized vintage leather coat. She took in the length of the arms and cut up the belt to make cuffs around both sleeves. Her white shirt-dress is Alexander Wang and her shoes are Gucci. Both were found in vintage stores. Her Versace bag was passed down from her mother.

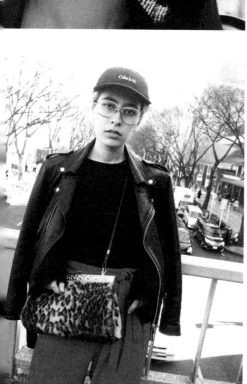

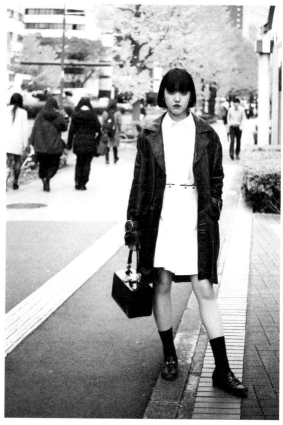

"One reason that women support our brand might be that our style falls between casual and formal."

—Keijiro Komori,
designer, Comoli

relaxed and to exude serious intention. Small collars on the shirts and jackets give an added air of formality to the clothes and the thick fabrics with sheen make them great for everyday looks and special occasions. Unlike other countries where people switch styles for different kinds of events, many Japanese people prefer to stick to one style, whether going to work or a cocktail party. Comoli offers looks that are designed to transition from day to night, a key reason why the brand is a favorite of men and women alike.

At the up-and-coming genderless clothing brand Hender Scheme, based in Tokyo, the first letter of "Gender" is replaced with an *H*—one letter after G in the alphabet. We meet designer Ryo Kashiwazaki and publicist Megumi Inoue, at the Hender Scheme brand store to ask them about this. As Inoue explains: "We aim for creations beyond the borders of gender." Kashiwazaki, who first trained in psychology, creates designs that are neutral yet witty, a playful embodiment of this ethos. Using leather as the primary material, he designs genderless shoes, bags, and wallets, created in collaboration with experienced leather craftspeople using their meticulous leatherworking tech-

niques. His fashion label is gaining popularity among both men and women in Japan (many couples visit their store in Ebisu and shop together) and the brand is also getting attention worldwide.

Another exciting label, Auralee was established in the 2015 spring/summer season. The designers and manufacturers put a lot of effort into their original textiles, and are extremely particular about their production. Their popularity is growing, especially with people in the fashion industry. Their basic styles like work or military are durable and classic. Although they categorize their clothing by gender, these are clothes for everyone, and recently more women are deliberately choosing their menswear.

THE THING TO WEAR

When we ask fashion designers and industry leaders why they think Japanese designers have been at the vanguard of the genderless fashion movement, some suggest this early acceptance of "genderless" clothing has something to do with Japan's traditional clothing cul-

OPPOSITE Comoli does not categorize their clothes by gender; instead they have a range of smaller sizes—0, 1, 2, and 3—that are more likely to fit their female clientele. The jumpsuit that staff member Yoko Komori is wearing is size 2. With her Yves Saint Laurent short boots, Hermès watch, and Hervé Van Der Straeten earrings, she has realized a luxe-casual style.

The designer Keijiro Komori prefers a monochrome style—often in navy, khaki, or beige—and he frequently incorporates a belt made from the same color and material as the rest of the design.

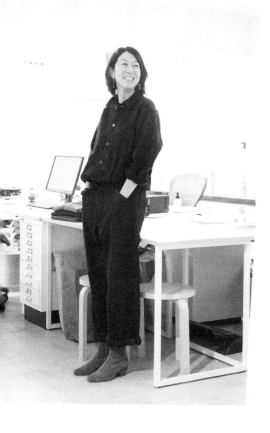

"We aim for creations beyond the borders of gender."

—Megumi Inoue, publicist, Hender Scheme

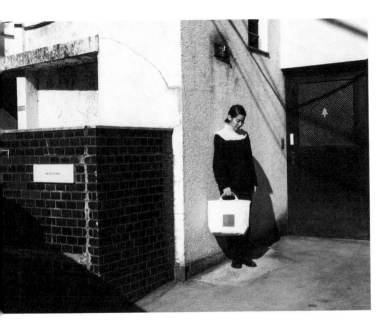

LEFT Megumi Inoue, publicist, at the Hender Scheme store in Ebisu. The brand specializes in genderless shoes, bags, wallets, and other leather accessories enjoyed by both men and women.

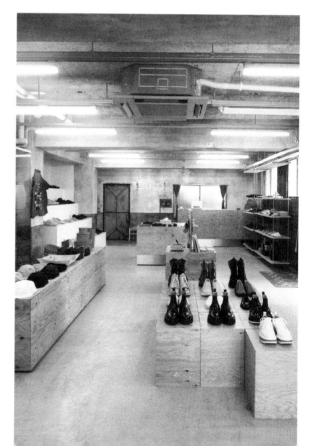

ture. As Hirofumi Kurino explains, "For me, there is no conscious decision to separate men's and women's clothing" in traditional Japanese clothing culture. "If we consider Japan's 'kimono culture,' we see that the concept of [men and women] wearing a single garment [draped and wrapped around the body] remains with us, almost like it is in our DNA." Both men's and women's kimonos are cut in basically the same way, though the fabrics, design patterns, and ways of wearing them differ slightly according to gender. But for both men and women, the large, planar cuts of kimono fabric must be folded, adjusted, and secured *each time they are worn* to fit the wearer's body. Wearing a kimono is basically styling a large, geometric, loose-fitting garment to fit your body in just the right way (albeit with strict rules as to how this should be done). This is why, according to Kurino, "Japanese people are good at adjusting the size of clothing [whether it's vintage, menswear, or kimonos] by simply taking in or rolling up fabric to fit one's body, while simultaneously gauging its overall silhouette." They have to do it every time they wear kimonos, and this tradition has been handed down from those who used to wear them much more regularly.

Like traditional men's clothing in the West, kimonos have straight silhouettes and don't expose much skin. They wrap

OPPOSITE Kanae Arai, fashion publicist at the Japanese brand Auralee, prefers loose silhouettes in her sweaters and T-shirts. "The more female stylists and magazine editors like fashion," she tells us, "the more they end up choosing men's clothing." Here, Arai wears an oversize Auralee men's knit cardigan.

"Japanese people are good at adjusting the size of clothing by simply taking in or rolling up fabric to fit one's body, while simultaneously gauging its overall silhouette."

—Hirofumi Kurino, senior adviser for creative direction, United Arrows

around the body like a suit jacket and are secured with ties and the obi (a decorative belt made of thick, woven, or brocaded fabric), which is tied in complicated ways that are not unlike tying a necktie. The finished look is not the same for men and women, but the way of dressing, taking something that is inherently gender-neutral and creating a gendered look with it, is what seems to have inspired Japanese fashion designers who have pioneered genderless designs. The kimono tradition is also inspiring for its individuality, how it makes the wearer look slightly different each time it is worn. When wearing kimono, the concern is less about whether the wearer's gendered body is suitably displayed and more about whether the kimono itself is fastened properly.

The conversation is no longer about "How can I make my boyfriend's jeans and white Oxford shirt look feminine?" or "Isn't this vintage French work jacket supposed to be for girls?" Wherever they are in the world and wherever their inspiration comes from, stylists, fashion editors, and everyday people

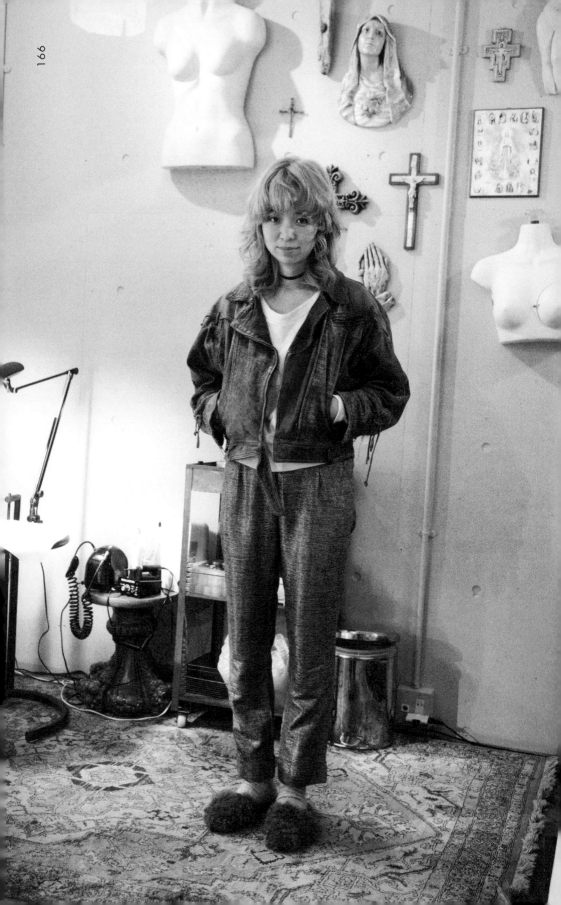

"I often share clothes with my husband."

—Nagisa Kaneko, nail artist and owner, DISCO nail salon

are becoming much more concerned with an overall effect looking great on whoever is wearing it, rather than being concerned about women's and men's categories.

If the 1990s can be said to be a watershed moment in street fashion, when people changed from head-to-toe coordination of high-end DC brands to more eclectic ways of dressing, the 2010s could be said to be another transitional moment from gendered to genderless fashion worldwide. And we seem to have Japanese designers and people on the streets of Tokyo experimenting with genderless styling to thank, at least to a point. It's not hard to agree with Kurino when he says, "Tokyo currently leads the world in genderless fashion styles."

Building on our exploration of some of the select shops specializing in kawaii *styling and genderless style, in the next chapter we'll continue looking at different iterations of Japan's unique select shop phenomenon and how this has created a new genre of even more specialized concept stores. We'll see how these boutiques offer total life styling—from clothing and accessories to food, music, and interior design, each store's individual styling concept is uniquely expressed, offering customers not only items to wear, but also guidance on*

how to wear them; not just what to eat, but how to enjoy the whole dining experience and appreciate where the food comes from; not just what to buy, but how to live a fully stylish life. From expertly curated collections of up-and-coming designers to reworked vintage designs, the next chapter offers a glimpse into Tokyo's vast range of possible lifestyles and unforgettable shops to explore.

GENDERLESS STYLE

OPPOSITE Nail artist Nagisa Kaneko inside her DISCO nail salon in Shibuya. Kaneko's look, including her vintage biker jacket, is pure boyish styling.

Chapter 6

Fashionable Lifestyle, Tokyo Style: Concept Stores

"The mission of multilabel stores is to suggest an overall style rather than just to simply offer up merchandise."

—Hirofumi Kurino, senior adviser for creative direction, United Arrows

In Japan, multilabel stores that gather various fashion items from both national and international sources are known as select shops. These select shops offer a carefully curated selection of clothing, shoes, and accessories as their core business, but then usually include something more in their selection to augment the store's theme, whether it's artworks and ceramics created by local artists, delicious cakes and organic foods by a chef with a strong following among the store's customers, fresh flowers, home goods, interior design merchandise, or a variety of other specialty goods.

FROM "WHAT TO WEAR" TO "HOW TO WEAR IT"

One of the original pioneers and founders of select shops in Japan is Hirofumi Kurino, who joined the multilabel select shop Beams in the late 1970s. In 1989, Kurino and some of his colleagues at Beams started up another multilabel store, United Arrows, where he is now senior adviser for creative direction. As we have discussed, until the late 1980s, DC brands (see page 16) such as Yohji Yamamoto and Comme des Garçons defined street fashion in Tokyo. The key to being fashionable was deciding which brand to wear—in effect, deciding which brand's fashion ideals expressed your own conception of self. Stylish people in Tokyo would wear co-ordinated outfits by the same DC brand with very little mixing in of other brands.

But the late eighties and early nineties were a watershed both for fashion and for street style in Japan. Kurino attributes changing attitudes to "the desire of Japanese youth to do new things," against the backdrop of the "bubble economy" collapsing in the late 1980s and, as we saw in Chapter 5 (see page 145), "a genderless fashion spirit, which feels very natural to Japanese people, [becoming] especially prominent through designs produced by Rei Kawakubo at Comme des Garçons, Issey Miyake, and Yohji Yamamoto." And around the same time, fashionable people also began looking beyond the carefully coordinated looks made up of

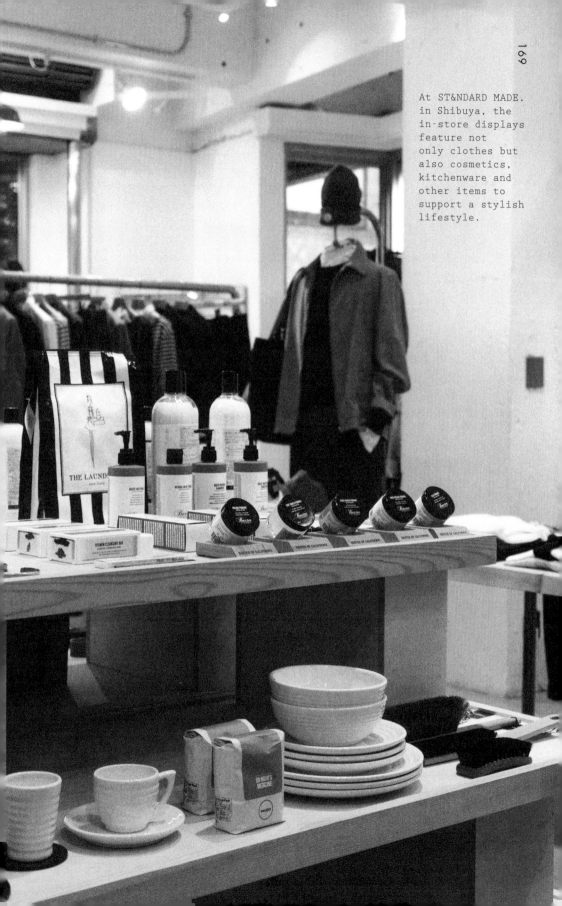

At ST&NDARD MADE.
in Shibuya, the
in-store displays
feature not
only clothes but
also cosmetics,
kitchenware and
other items to
support a stylish
lifestyle.

pieces from one of these DC brands, favoring styles that were more varied instead.

Following the lead of Beams and United Arrows, select shops began opening across Japan in the 1990s, each with its own style concept and selection of brands, and they still form a large part of the fashion market in Tokyo. As the number and popularity of these select shops increased, the key to being fashionable changed, turning the question "Which brand do I wear?" into "How do I wear this?" Select shops met this new demand by prioritizing styling and selection rather than dictating what was cool to wear from certain fashion lines. Showing customers how to combine pieces to create certain styles led to increasing interest in developing individual style. Within this context, people began to style themselves with a much broader range of clothing types, and street-style fashion in Tokyo evolved and diversified accordingly.

SELECT SHOPS' INFLUENCE ON STREET STYLE

Street style in the 1990s also made casual fashion more mainstream. Kurino tells us that at this time, "street-style fashion brought over from Europe made a huge breakthrough in Japan. Casual items such as sneakers, T-shirts, and jeans created an atmosphere that allowed people to explore more kinds of fashion every day, not just special occasions." Consequently, he says, "the definition of *when* someone should be fashionable changed. For my parents' and my generation, young people only got dressed up properly when going out to special places such as a big department store or a fine restaurant. We often used phrases like 'dressing

up,' 'being formal,' 'special occasion,' and 'Sunday best.' Today, going to a department store while wearing sandals is nothing to be concerned about, and you are rarely refused entrance to a prestigious restaurant just for wearing jeans." For Tokyo's most stylish people today—across generations—getting dressed up and going out in clothes they love is a daily pleasure. Here, it's always time to get dressed up and go out, taking in the latest styles from fellow pedestrians as well as the luxury boutique and select shop windows.

INCUBATORS FOR NEW STYLES (AND NEW TALENT)

Select shops serve as a kind of incubator for new ideas and talent, as well as a commercial staging ground for new brands to launch their designs. This mentoring ethos has been a key element of select shops from the beginning, and select shop directors take their role as mentors quite seriously. As for Kurino himself, in addition to his pioneering role in developing the idea of select shops, and his current creative leadership role at United Arrows, he also serves as a graduation competition judge in fashion at the Royal Academy of Fine Arts Antwerp and as a judge for the LVMH Prize for Young Designers. By suggesting an overall style, nurturing young designers and new brands, and leading the growing trend among Tokyo's most stylish people, fashion leaders like Kurino and the directors of select shops continue to exert an enormous amount of influence over style in Tokyo today.

The concept store OCAILLE is located in a single unit of a vintage apartment building in Harajuku. In this compact space, the passion of the owner and buyer Tokie Onda to feature exceptional merchandise is easy to recognize.

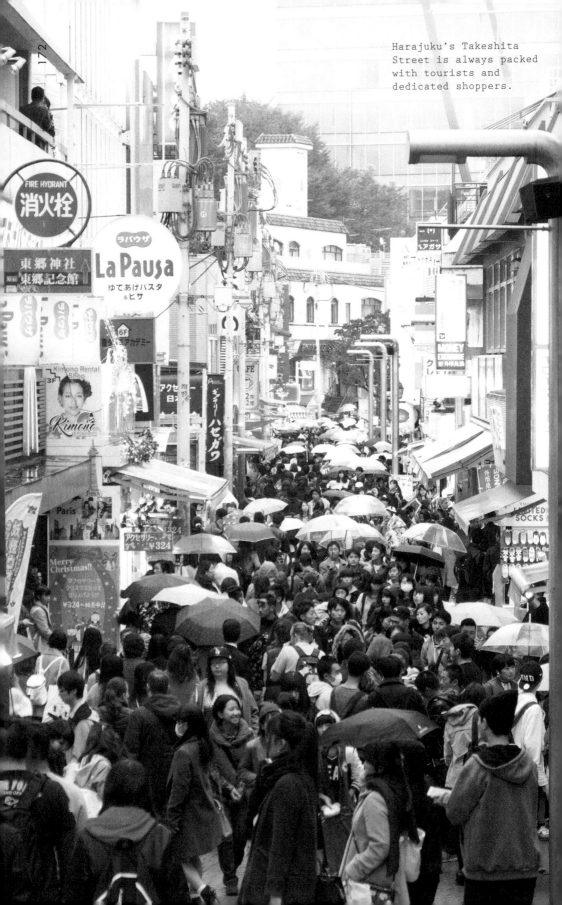

Harajuku's Takeshita Street is always packed with tourists and dedicated shoppers.

THE BIRTH OF THE CONCEPT STORE

Of course, fashion is always in flux, so after a decade-long select shop boom, some customers and retailers began to question what a select shop was really meant to be. So many businesses were selling such similar items that the uniqueness of each store and the styles they presented had begun to disappear. To resist obscurity, in the early 2000s, some select shops that had particularly firm ideas of the styles they wanted to promote started to call themselves "concept stores" in order to differentiate themselves from other multilabel stores that just focused on style combinations.

Concept stores believe that style is not just the styling of garments—how to wear the clothes, what accessories to pair with them, and so on. For them, style is a philosophy, which centers on the belief that fashion enriches life. The merchandise, the architecture of the store, the demeanor of staff members— every element of a concept store is unique and consistent with the store's philosophical intention. Each store takes great pains to achieve an excellently curated collection that showcases that intention.

At the moment, there are still relatively few true concept stores in Tokyo compared with the number of select shops, and each of them is supported by a devoted customer base who personally identify with the store's niche concept to express something unique and original about themselves. With such a clear, strong intention behind each store's individual concept, these stores will inevitably influence the street-fashion scene as much as select shops have.

WHAT'S THE DIFFERENCE?

The difference between select shops and concept stores is not always clearly defined. Many so-called concept stores overseas would be considered select shops in Japan and vice versa. Even in Japan, many select shop and concept store owners resist any kind of categorization at all.

In this book, we define select shops as multilabel stores that offer a wide selection focusing on brands. The items are presented in ways that suggest new approaches to styling based on the selected brand's common themes.

Concept stores also offer a curated selection and suggest an overall style, but the personality of the owner is felt more prominently within the store and in the selection. Nurturing new brands and designers is also a priority for most concept stores. Concept stores also support their customers' total lifestyle by offering clothing, accessories, homewares, furniture, music, and more, all centered around the unifying concept or the owner's personality. But whether you are in a select shop or a concept store in Tokyo, chances are good that you'll be able to explore a meticulously curated selection of goods.

Here, we offer a varied selection of Tokyo's most original and influential concept stores shaping street fashion at the moment. Whether these concept stores specialize in clothes and homewares or music and vintage magazines, they all give a sense of how people in Tokyo discover new style inspirations and enjoy taking a holistic approach to styling their lives.

FASHIONABLE LIFESTYLE, TOKYO STYLE

Desperado

In 2000, Desperado opened its doors in Shibuya, taking "the fusion of fashion and art, objects and people" as its theme. Eiichi Izumi is creative director and buyer at Desperado. He is credited with bringing fashion labels like Dries van Noten, Marc Jacobs, Christophe Lemaire, Marimekko, Il Bistonte, and others to Japan. Over the last thirty years he has kept a keen eye on global fashion trends and is a true fashion expert.

Like vintage stores, multilabel concept stores are increasingly offering original products, having defined themselves by the collection of brands they offer. Desperado, by contrast, has always dealt with young designers and new fashion labels that Izumi has discovered from all over the world. "I want to see things I have never seen before, so I'm always chasing after new fashion," Izumi tells us. "That's why young fashion labels get my attention. Unfortunately, very few multilabel stores willingly accept clothes created by unseasoned designers, especially ones from overseas. I think it's because 'name value' hasn't been attached to these designers so there is too much risk involved."

However, Izumi and his staff are willing to take this kind of risk. Inside Desperado, items from fashion labels that you can't find anywhere else in Tokyo are lined up. The selection seems endless, and endlessly new. The novel designs and silhouettes give the appearance of unisex or gender-free emphasis at the store, but in fact Desperado carries women's clothing exclusively. However, perhaps not surprisingly, given the increasingly blurred boundaries between clothing labeled for men and for women, about 2 percent of their clientele are men.

Izumi is a person with foresight, but that doesn't mean he is blind to the realities of the fashion business. "Of course, I need to manage our store properly so I have to weigh a new label's potential against possible risk. But I think that fashion is something that enriches our lives. If we don't open up to different societies, we can't guarantee the future of fashion, and neither fashion nor street-style fashion can regenerate and revitalize. I must propagate the courage, joy, and amazement that one can gain through fashion. To do this requires seeking something groundbreaking, while at the same time possessing a challenger's spirit. It is with this spirit that we at Desperado strive to be like an incubator for these up-and-coming designers." Izumi's gambles seem to pay off more often than not. Fashion labels discovered by Izumi and nurtured at his store later become labels that influence street fashion worldwide. At Desperado, you will see the future of street-style fashion.

Our next store also aims to showcase new talent and goes to great lengths to create an open and egalitarian space for developing personal style.

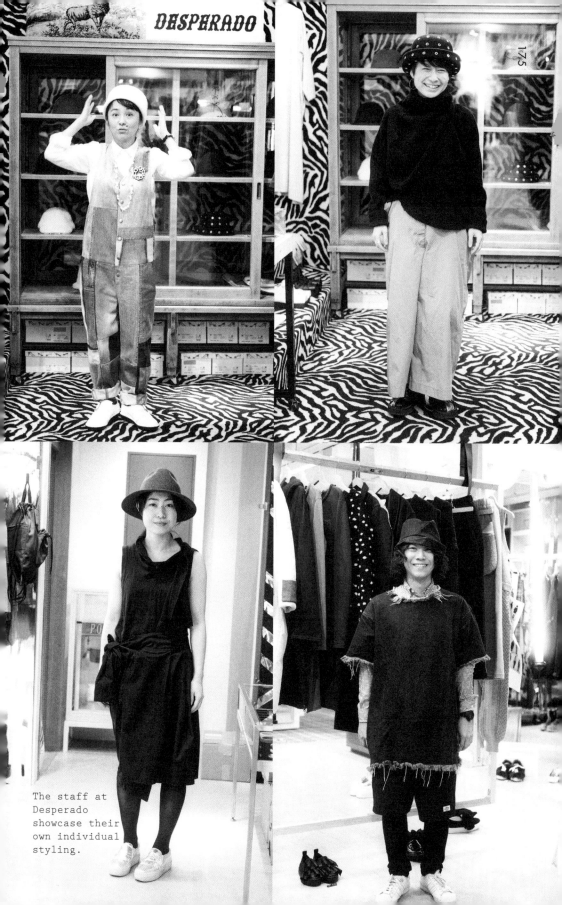

DESPERADO

The staff at Desperado showcase their own individual styling.

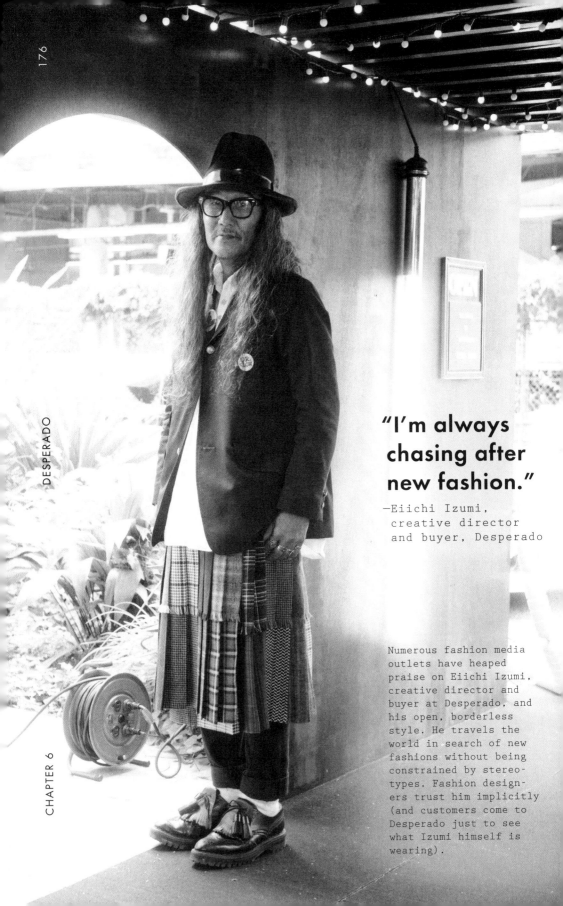

DESPERADO

CHAPTER 6

"I'm always
chasing after
new fashion."

—Eiichi Izumi,
creative director
and buyer, Desperado

Numerous fashion media
outlets have heaped
praise on Eiichi Izumi,
creative director and
buyer at Desperado, and
his open, borderless
style. He travels the
world in search of new
fashions without being
constrained by stereo-
types. Fashion design-
ers trust him implicitly
(and customers come to
Desperado just to see
what Izumi himself is
wearing).

The Desperado store is a mix of different styles. For instance, one section is brown tile while another has zebra-patterned floor and walls, creating a unique and inspiring space for customers to create new style combinations.

Super A Market

Since opening its doors in 2011, Super A Market has embodied Tokyo's no-rules street-style ethos with its varied selection of items casually arranged side by side like in a supermarket. This egalitarian approach to displaying their products reflects the store's ethos that all of the items they offer are equally distinctive, stylish, and valuable. The store has also installed a café and bar to bring not only clothes but also food and drinks to customers, anticipating the rising trend for food fashion (which we'll look at throughout this chapter) and in so doing has inspired other se-lect shops to do the same.

browsing both categories in search of genderless styles easy.

Super A Market is a great place to people watch, try out their well-known brand offerings for men and women, and also to add a touch of style to your living space. For further style inspiration, head to our next concept store, Laila Tokio, where the constantly changing collection includes designs from influential couturiers and young, up-and-coming designers.

"We offer a fun and lively space for those who have a firm idea of their own style values."

—Naoki Umimae, staff member, Super A Market

Shop staff member Naoki Umimae explains the store's mission: "We offer a fun and lively space for those who have a firm idea of their own style values." Whether that style involves men's or women's clothing, Tokyo's most stylish people rely on Super A Market for the varied selection. Although Super A Market is divided into the "ladies' cor-ner" and "men's corner," both sections of the store are connected, making

OPPOSITE Satomi Onodera (left) and Hoshi Matsumoto (right) outside Super A Market. Onodera's layered look fea-tures a few nods to French-worker-chic with the satin quilted blouson jacket, Breton stripe T-shirt, and wide-leg pants, but the bohemian-style printed dress in the same gold color as the quilted blouson adds texture and volume when worn over the pants, com-pletely transforming the look. Matsumoto wears a gorgeously embroidered Chinese-style jacket in deep blue, with a similar quilted texture to Onodera's blouson. Matsumoto softens the angular cut of the jacket (and of her own sharp, stylish bob) with a floaty black skirt.

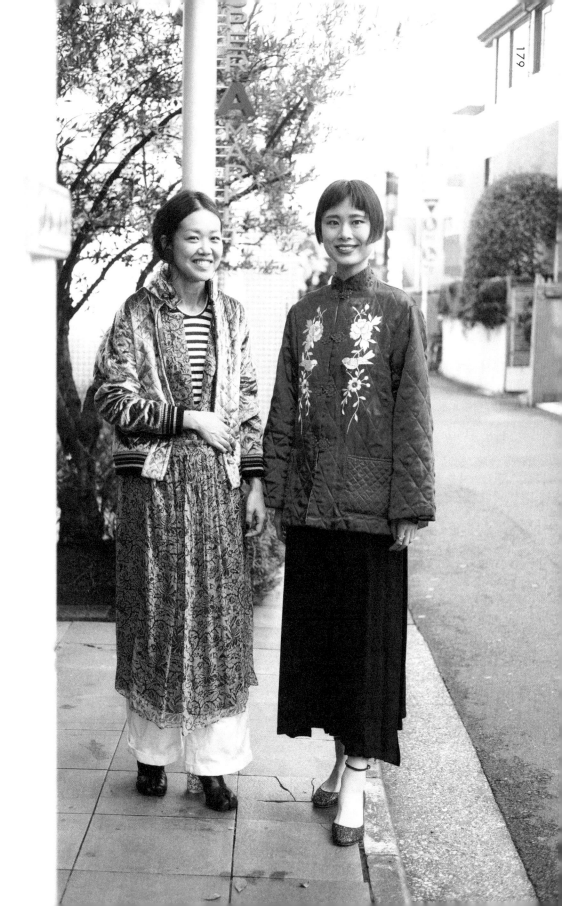

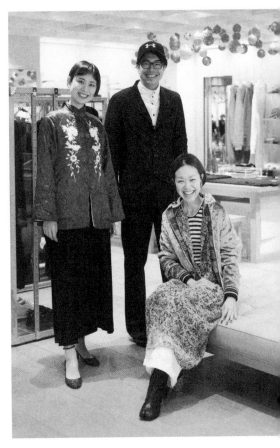

The varied selection of clothes, shoes, and accessories, along with home goods and food, are arranged side by side like in a supermarket.

ABOVE Custom services, such as applying vintage buttons to items purchased in-store, are also available.

CENTER RIGHT Shop staff members Hoshi Matsumoto (left), Naoki Umimae (center), and Satomi Onodera (seated). Their styles skillfully mix casual and elegant pieces, mirroring the store's eclectic range of items.

The spacious café-bar on the second floor is a nice place to sit and take in the atmosphere.

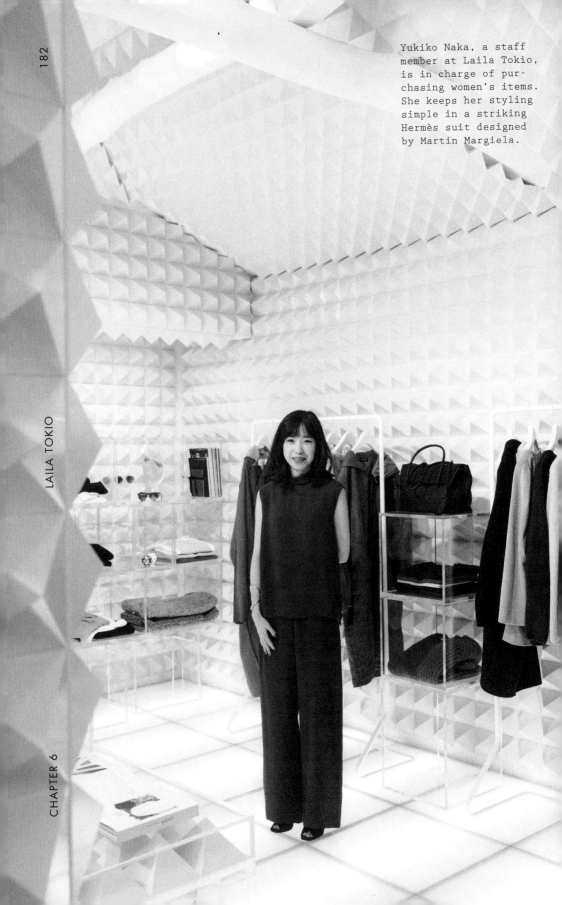

Yukiko Naka, a staff member at Laila Tokio, is in charge of purchasing women's items. She keeps her styling simple in a striking Hermès suit designed by Martin Margiela.

LAILA TOKIO

CHAPTER 6

Laila Tokio

"I want to transmit true originality through our stores by focusing on designers who create new value."

—h. hashiura, director,
Laila Tokio

In this respect, Laila Tokio continues the tradition of its precursor and sister store, Laila Vintage. Established in 2002, Laila Vintage remains on every international fashion designer's list of must-shop vintage stores in Tokyo. Keeping pace with their competition, Laila Vintage has been relentlessly expanding beyond the traditional scope of a vintage store by offering vintage items from fashion labels all over the world alongside new collections.

Taking "new couture" as its theme, Laila Tokio focuses on designers such as Martin Margiela, Raf Simons, and Helmut Lang, who have created new directions in fashion. The store offers a wide selection, from vintage pieces to new designs by young brands and designers, and sometimes even stages exhibitions focusing on a single designer that presents an archive collection of the designer's work. The selection isn't meant to showcase major global trends. It's simply a collection of pieces that struck the director, h. hashiura. The store's commitment to offering the best and most original "new couture" is unrivalled. Its rigid commitment to this theme makes it a classic example of a Tokyo concept shop.

Director h. hashiura explains the guiding philosophy at Laila Tokio: "Tokyo's chaotic fashion scene makes it hard to recognize true originality." All of the pieces in hashiura's selection exude this originality and celebrate the power of fashion to inspire and encourage young creators.

Hashiura tells us, "We want to create a space in which you can see original designs that have shaped [and] continue to shape fashion. I love seeing customers from overseas shopping here who say, 'We haven't found a store like this anywhere else in the world,' or talking with creators who ask me, 'What are you collecting now?'"

With vintage as a gateway, Laila Tokio celebrates fashion, and how wonderful various kinds of creations can be. The brilliantly curated store appeals to young people sensitive to street-style fashion in Tokyo, as well as professionals in the fashion industry both in Japan and overseas. The chance to find something new and groundbreaking brings a wide variety of people to visit the store. If you are looking for true originality, Laila Tokio is the place to find it.

Our next store is another staunch supporter of originality—its very name emphasizes freedom and an open-minded approach to all things new.

Located in a historic, renovated Japanese-style house, Laila Tokio's selection of vintage and new designs by some of the world's most influential designers, including Helmut Lang, Raf Simons, and brands such as Maison Margiela, makes the store a top destination for fashion designers coming to Tokyo from overseas.

The store interior itself, from the glass display cases with jewelry pieces and look books arranged like a gallery to the architectural pyramid motif designed by the urushi lacqueware artist Koichiro Kimura, has been carefully curated by director, h. hashiura, whose intention of showcasing "new couture" permeates the space.

Tokyo Kaihoku
Isetan Shinjuku Store

Mari Terasawa is the buyer at Tokyo Kaihoku, a concept store located inside Isetan, the iconic Japanese department store in Shinjuku. For Terasawa, wearing clothes by young designers based in Tokyo is indispensable to her own personal style, the selections she makes while buying for the store, and to fashion and culture more generally. Her unique point of view and skill in selecting clothing and products means that her personal wardrobe is a kind of bellwether for predicting the next up-and-coming brands in Tokyo.

"Ever since Tokyo Kaihoku began introducing items from Tokyo-based creators," Terasawa says, "wearing their clothes is my way of cheering them on and saying, 'Keep going!' Recently, young designers are becoming really particular about making textiles, and many of their designs are so elaborate. They all impress me, not just with their clothing creations, but also with how intensely their concepts are thought out. When I wear their clothes, that pure feeling of 'fashion is fun,' which I had when I was young, comes rushing back."

Kaihoku in the store's name means "Liberated Zone," and the collection that Terasawa curates inside Tokyo Kaihoku expresses a truly free approach to style, full of possibilities and openness to new things. Terasawa has always been a voracious consumer of

"Tokyo is a great compilation of niches."

—Mari Terasawa, buyer, Tokyo Kaihoku Isetan Shinjuku store

information about fashion. "When I was a student I gathered information about Tokyo from magazines. I loved to read magazines. I read every page and I actually went to visit any stores introduced in the magazine that I found interesting. Looking back, I see that what I did then is quite similar to my current work. After all, it is necessary to physically visit a store when you intend to gather genuine information about new brands."

Tokyo Kaihoku often holds non-fashion-related events while working with food bloggers, musicians, and manga artists, as part of its goal to connect fashion to other cultural genres. "I've been feeling strongly recently that fashion in Tokyo is not only about clothing. Fashion reflects the state of affairs and culture of the time. Fashion doesn't mean only clothing. I think that food, art, and manga are also fashion." The buyer for Sister, our next store, would agree with this statement. Yumi Nagao's love of film has influenced the designs on display.

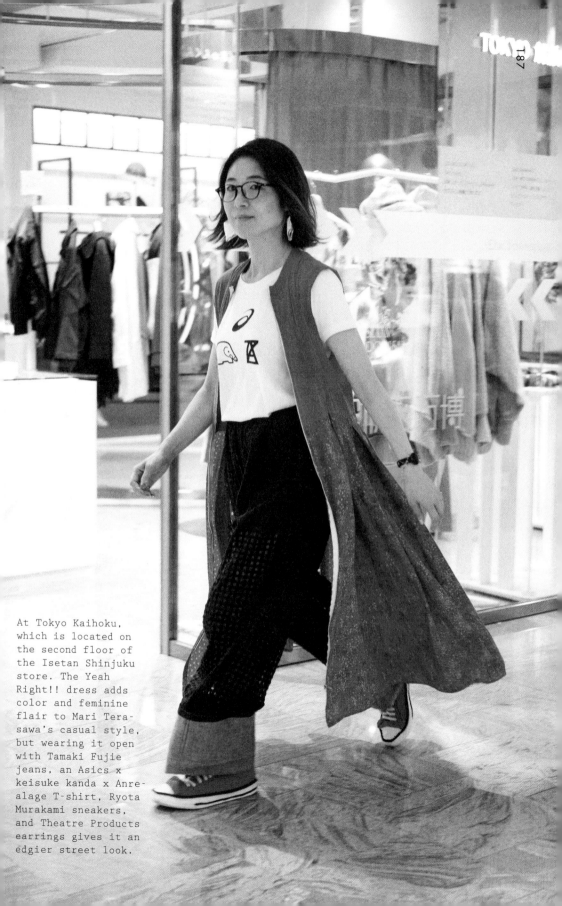

At Tokyo Kaihoku, which is located on the second floor of the Isetan Shinjuku store. The Yeah Right!! dress adds color and feminine flair to Mari Tera-sawa's casual style, but wearing it open with Tamaki Fujie jeans, an Asics x keisuke kanda x Anre-alage T-shirt, Ryota Murakami sneakers, and Theatre Products earrings gives it an edgier street look.

Sister, the influential concept store in Shibuya, is like a microcosm of Tokyo style. Under the direction of Yumi Nagao, the store offers a sought-after collection of vintage and new clothing and jewelry designs; creative cross-media collaborations, such as the T-shirts Nagao created in collaboration with film director Lucile Hadžihalilović for the movie *Évolution* (above); and is actively pursuing innovative ways to incorporate books, music, and culture into their selection. The staff here regularly spark new trends. Mina Koyama, publicist at Sister (right), is pictured here in a Matthew Adams Dolan shirtdress and Maison Margiela tabi boots.

Sister

"If it's just clothes, it's not fashion . . . I want to actively seek out and offer other related things like books and movies to go with the clothes."

—Yumi Nagao, director and buyer, Sister

Sister first opened in 2008 as a vintage clothing store. Since then, it has grown into a concept shop that carries not only vintage, but also Japanese and international designers alongside Sister's own original designs. The selection, curated by Yumi Nagao, gives an impression of elegance, expressing a woman's inner beauty, combined with an element of mystery and darkness. It's no surprise, then, to learn that Nagao is obsessed with classic and cult movies. Following this interest, Nagao recently expanded Sister's offerings to include original collaborations, such as the T-shirts they designed with film director Lucile Hadži-halilović for the movie *Évolution*.

These various aspects create a stimulating atmosphere that has made Sister an essential source for street looks and style inspiration. The shop's publicist, Mina Koyama, and her fellow staff members are quickly becoming popular fashion icons in Tokyo. The store's concept and what the girls at Sister are wearing there are a popular topic on social media. The superb selection of Japanese and international brands, presented alongside vintage, has earned Sister a strong reputation from international fashion media, too.

We ask Nagao about her collection when we meet at the store, located near Shibuya's Miyashita Park in the same building as their partner store, Candy. "When I started out, I selected clothes based on what I really loved, but more recently I try not to stick to clothing so much. I think if it's just clothes, it's not fashion." This is something we hear from many of the fashion designers and influencers, shop owners and directors. Fashion is an approach to lifestyle that includes other cultural aspects such as food, music, movies, and more. So how is the selection at Sister likely to develop in the future? "From now on," Nagao muses, "I want to actively seek out and offer other related things like books and movies to go with the clothes." Considering the exciting collection of vintage and designer brands currently on offer at Sister, we can't wait to see what Nagao will offer next.

As we've seen, combining art and clothing is a preoccupation that connects many of the shops we like, and the next venue takes this to the next level, hosting regular art exhibitions in the white, gallery-like space.

OCAILLE

"I love clothes with elegance, sharpness, and poise."

—Tokie Onda, owner
and buyer, OCAILLE

Another concept store that looks beyond fashion is OCAILLE. Tokie Onda, owner and buyer here, has earned her place among Tokyo's fashion influencers through her carefully curated selection of some of the most beautiful, dreamy items for women. After working as a buyer for a major apparel company in Tokyo, she started OCAILLE in 2002. Onda's store is situated in a quiet apartment in Harajuku. In this tranquil space, where white dominates, both current designers' clothes and vintage pieces are on display. The shop also carries cosmetics and food and regularly hosts art exhibitions.

Onda favors pieces that fuse femininity with minimalism, but still have a kind of *kawaii* playfulness that makes you smile. Her selections are popular with the fashion establishment and street stylists alike.

We ask Onda what characterizes her taste: "Cute but sophisticated, while also being witty . . . In other words, I love clothes with elegance, sharpness, and poise." Onda buys pieces for the shop mainly in Europe (Paris, Germany, Italy, etc.) and the sleek sophistication of her store has an unmistakably Continental flavor to it. "Having managed this store for over a decade," she tells us, "I finally realized that I love presenting items that I have discovered personally, at my own pace and according to what I really love. I think maybe it's this approach to buying that has helped me keep moving forward." And like other good fashion buyers, Onda loves scouring flea markets throughout Europe to check out vintage clothing.

The owners of the next shop, Cow'n, also truly relish the process of sourcing unique finds, only featuring what they truly love.

OPPOSITE The white boutique interior is a soft, soothing backdrop for Onda's collection of clothes, accessories, and decorative objects. Tokie Onda, owner and buyer at OCAILLE, wears a Wolcott: Takemoto vest, a Christophe Lemaire shirt, Studio Nicholson pants, and Roberto Del Carlo boots.

Cow'n

"We gather only things that we love and are not bound by any particular concept."

—Taeko Ushikubo, Cow'n, co-owner

Cow'n in Shibuya focuses on fun and offers a joyfully and passionately curated collection of eclectic one-of-a-kind styles. Taeko Ushikubo and Miki Teramoto, both veterans in the fashion industry, started Cow'n in 2014. The store is a direct window into Ushikubo and Teramoto's own charming and whimsical preference for niche fashion. "We are just a small business, so we feel that it isn't necessary to overextend ourselves just to be in sync with fashion cycles that dominate the world," Ushikubo tells us when we visit the store. "We gather only things that we love and are not bound by any particular concept. Because of this, we are proud to showcase our finds to our customers."

The pair's enthusiasm is contagious, but their own personal styles diverge quite a bit. Ushikubo tells us she is the kind of person who prefers to keep special pieces, like her favorite basket for storage, for a long time and to always dress in a similar way. Teramoto, on the other hand, is the kind of person who will try anything. "I prefer putting together outfits in my own way, without falling into the trap of categories, while still expressing my feelings at that

moment." She is eager to incorporate anything that tickles her fancy into her look and will happily transform her style according to the occasion.

With this flexible approach, Teramoto maintains a discerning point of view when buying new pieces. "I explore new fashion from everywhere—whether from overseas luxury brands or more economical specialty stores—and look deeply into each style," she explains. "My style has undergone so many transitions that I can't really put it into just a few words. One thing that hasn't changed, however, is that I always prefer items that are original. I mean items whose origin I can truly appreciate. At Cow'n, we carefully select our merchandise so that we can offer our customers such originality." Even though Ushikubo's and Teramoto's styles contrast starkly, Cow'n manages to fuse the two women's distinctive viewpoints to offer countless ideas. Stepping into their world, you can definitely feel their mantra: "Be stylish and be passionate!"

This passion for sourcing truly special merchandise is a common thread connecting all the stores in this chapter. The concept stores we've seen so far focus on new designers and innovation in their selection. But among people looking for new street styles, there are also those who want excellent basics in which style meets function. The selections on offer at the next store meet this growing demand by keeping classic styles cool and current.

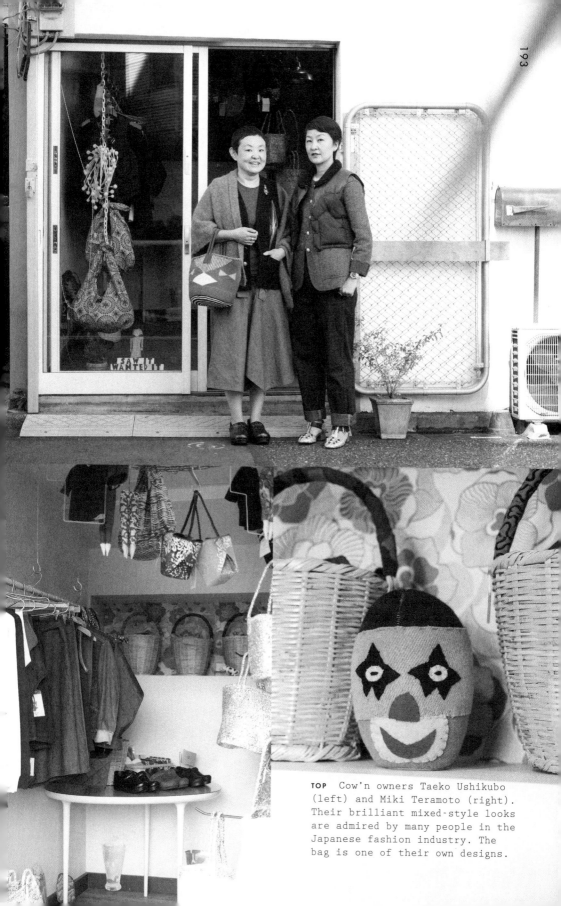

TOP Cow'n owners Taeko Ushikubo (left) and Miki Teramoto (right). Their brilliant mixed-style looks are admired by many people in the Japanese fashion industry. The bag is one of their own designs.

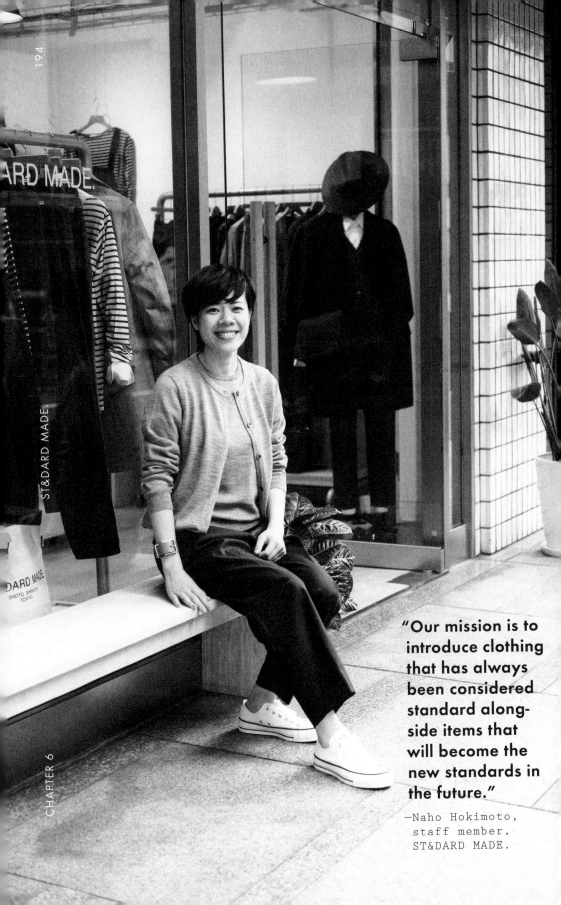

"Our mission is to introduce clothing that has always been considered standard along-side items that will become the new standards in the future."

—Naho Hokimoto, staff member, ST&DARD MADE.

ST&DARD MADE.

In Japanese fashion, "standard"—meaning the go-to basics of any stylish wardrobe—is a fashion genre on its own. Fashion magazines around the world routinely do features on "the new basics" or how to style a basic white tee, black dress, or whatever. But these stories emphasize how to use basics to build a look, using them as a kind of blank canvas to showcase a great jacket, interesting accessories, or other statement pieces. By contrast, Japanese fashion magazines elevate these basics ("standards") to their own category worthy of attention and development through specialist brands and select shops.

ST&DARD MADE. is a select shop that focuses exclusively on classic and up-and-coming "standard" pieces. Located in Okushibu, an area of Shibuya where bistros serving world-class food line the streets, the store's mission is to advise customers on both present and future standard clothing.

But how do you decide what is a standard? Each person's standard will be different. The important thing is to discover your own "standard" style, and shops like ST&DARD MADE. can help.

As ST&DARD MADE. staff member, Naho Hokimoto, tells us, "Too many ideas about fashion are available in Tokyo. I think that there are people who are a little bit lost when it comes to deciding about what sort of clothing they should choose. So we created a multilabel store focusing on the word 'standard.' Our mission is to introduce clothing that has always been considered standard alongside items that will become the new standards in the future. We want to offer standards that customers can incorporate into their existing wardrobe easily."

ST&DARD MADE. distributes classic, somewhat preppy private labels and work clothes, along with good-quality casual styles that fuse French, American, and British taste in Japan. There are rare brands and specialty pieces created for and available exclusively at ST&DARD MADE. (the "MADE" part of the store's name). The store is full of simple, chic items for men and women that are uninfluenced by changing trends but at the same time feel fresh and enduringly stylish.

Aside from clothing, ST&DARD MADE. also offers household items like tableware. In order to provide customers with a relaxed shopping experience—and truly Japanese hospitality—customers are served coffee, and sofas are available throughout the store. The overall shopping experience is also front of mind for Iko Natsukawa at our next shop High and Seek.

OPPOSITE ST&DARD MADE. staff member Naho Hokimoto combines Converse sneakers made in Japan with a Vincent et Mireille sweater set, Sofie D'Hoore trousers, and a leather bangle by Maison Boinet for a simple, chic style that is anything but basic.

High and Seek

"I only display pieces that I personally want to wear in my shop. When I purchase items, I always listen to the designer's story about making the clothes. I try their clothes on until I understand all about their style."

—Iko Natsukawa, buyer and director, High and Seek

It is important to maintain balance in every area of life. However, sometimes being one-sided can help you be true to yourself in a healthy way. Meeting Iko Natsukawa, director and buyer at High and Seek, shows us the value of such intense focus. Natsukawa's passion for fashion is inspiring.

The name High and Seek is a play on "hide and seek." While "High" suggests the level of quality and cultural value that the pieces she chooses must have,

and "Seek" suggests the hidden location of the actual store, located in an old apartment building, Natsukawa tells us that the most important reason for choosing the name is based on Natsukawa's dedication to searching for and buying only what she really loves.

As we have seen so far, multilabel stores normally try to offer customers a balance of different brands and types of clothing, purchasing tops, bottoms, outerwear, and jewelry in equal measure so that customers can put together their own outfits. Natsukawa, by contrast, prefers a fairly irregular pattern of buying for High and Seek. For example, she might only offer shirts in the store at certain times. When we meet with her, we are surprised to find that there are neither jackets nor coats available, even though it is winter. "I'm a picky nerd, so I might only order ten styles or less, even if there are a hundred garments in a showroom, like at Vetements. It's kind of an extraordinary way of buying and I appreciate brands and designers who understand this approach and work with me in this way."

Natsukawa takes this single-focused vision even further by creating an all-female space for women to explore the pieces on display. A multilabel store that sticks to its ideals to the degree that High and Seek does is very rare, even in Tokyo, but Natsukawa's efforts are all focused on the customer. "I simply want women to have a relaxed shopping experience."

Natsukawa's way into fashion was through her own intense personal interest in clothes and style. Prior to starting this store, she had no experience in fashion or retail. "I used to be a writer (it's my life's work) so I love playing with words. I lived in Mexico, traveling all over for two years, before I found my passion in this job." Throughout the 1990s, she loved high-fashion brand-name pieces from designers such as Helmut Lang, Jean Colonna, John Galliano, and Alexander McQueen. At the same time, Natsukawa wrote about international fashion on her personal blog, which would prove to be her springboard into the fashion world. One of the owners of High and Seek read her blog and asked her to manage the store.

"Fashion is culture."

—Iko Natsukawa, buyer and director, High and Seek

"I do everything myself—purchasing, store displays, customer service, and so on—and when I do these things, I really don't want to compromise on anything." Since taking on the management of High and Seek, Natsukawa has taught herself everything, guided by her sharp fashion sense and deep love of beautiful clothes.

"I only display pieces that I personally want to wear in my shop. When I purchase items, I always listen to the designer's story about making the clothes. I try their clothes on until I understand all about their style. If I don't do this, I can't explain that beauty to my customers."

And her taste is impeccable. The lines of clothes stocked by High and Seek have beautifully silhouetted couture-like elements, just like Natsukawa's own outfits. As you listen to her enthusiastically explain each piece in the store, you get a sense that thanks to Natsukawa's discerning eye, at High and Seek, you will see only carefully curated pieces that strongly reflect the creative vision and philosophy of each designer.

Natsukawa sees such careful selection as serving a larger purpose. "Fashion is culture," she explains. "If you start with the idea that fashion is a gateway and then you go deeper, you will find that fashion is actually intimately connected to music, art, and philosophy. I think that spreading this depth of fashion is an important role for multilabel shops." At our next concept store, art takes center stage both in the store displays and in the clothing designs.

OPPOSITE Despite Iko Natsukawa's casual style, the elaborate details and careful styling give an air of sophistication. The silver jewelry complements her outfit: a shirt by Ensou, jeans by Vetements, and Le Yucca's ankle boots.

H BEAUTY&YOUTH

H BEAUTY&YOUTH opened in 2016 in the Minami-Aoyama area of Tokyo. The store caters to those who love encountering the unexpected. As staff member Aki Honna tells us, "We strive to be an art gallery-style select shop that stretches everyone's imagination." Tasteful items across genres, including street, sport, couture, and vintage are arranged over three floors. The store is packed with items from all over the world and promotes a very Tokyo-like, borderless, mixed style of fashion fused with art. The shop is a branch of United Arrows, one of Japan's original select shops, but, as their counterparts in the UA group pursues their own concept in the selection they offer, so too does H BEAUTY&YOUTH. Here, the store has its own unique art-gallery atmosphere with artworks by artists such as Madsaki (known for his graffiti-inspired pop-art style) on display throughout the store.

Keeping up with recent movements in street fashion toward a preference for unisex fashion, the store features a uni-sex/gender-free section alongside other sections that categorize merchandise into men's and women's fashion. But they do have a somewhat eccentric rule about staff attire—male staff members' outfits must feature only one color, while female staff can choose between a two-color look or a high-contrast black-and-white look while working in the store.

The place has a youthful, down-to-earth, anything-goes attitude. As if to challenge expectations and stretch cus-

"We strive to be an art gallery-style select shop that stretches everyone's imagination."

—Aki Honna, staff member, H BEAUTY&YOUTH

tomers' imaginations further, they also feature a pizza place on the basement level of the store in Daikanyama. This delicious pizza has made the store a popular spot in the area. Like many of Tokyo's coolest fashion spots at the moment, H BEAUTY&YOUTH is savvy about incorporating food into their concept in order to meet demand from their discerning customers in need of some gastronomic inspiration while hunting for street-style finds. However, if pizza isn't your thing, there is always coffee at our next concept shop's in-house café.

OPPOSITE Artworks by many different artists hang on the shop's walls, creating a gallery-like shopping experience, where even the sneakers and the clothing are arranged in careful displays that can make the merchandise look like works of art. Staff member Aki Honna looks cool in black and white. The original shirt is by H BEAUTY&YOUTH, coveralls are by Toga, and the shoes are by Martiniano. The earrings, by Tokyo brand The Dallas, add a feminine touch.

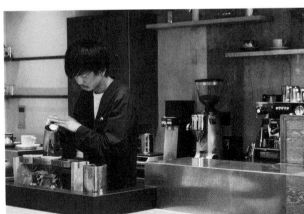

RIGHT Bloom & Branch Aoyama staff, Kasumi Nishimura, wears a knit sweater by Seya, the Paris-based Japanese designer, with Phlannel trousers and a Mimi bag.

ABOVE At Bloom & Branch Aoyama, the rich aroma of Nel drip coffee being brewed at Cobi Coffee Aoyama fills the space, which has been designed as a fusion of Western and Japanese style. Customers can even get their shoes shined at The Bar by Brift H.

Bloom & Branch Aoyama

"Fashionable people are particular about their coffee and tableware, and they never neglect taking proper care of their shoes."
—Yohei Kakimoto, director, Bloom & Branch Aoyama

Bloom & Branch Aoyama is a concept store that responds to their customers' desire for a lifestyle that is stylish in every aspect, both in their surroundings and food choices, and also, in terms of clothing, quite literally from head to toe. A coffeehouse called Cobi Coffee Aoyama and a shoe care shop called The Bar by Brift H are situated inside the store. We've seen select shops that include homewares and fabrics in their selections, but a shoe repair shop is unusual. "Actually, fashionable people are particular about their coffee and tableware, and they never neglect taking proper care of their shoes," Yohei Kakimoto explains. "At our store, the more people care about fashion, the more they tend to seek out food and household items that reflect their sense of style," he continues. This store's particular angle is developing style (which is what the word *bloom* alludes to) that endures through generations (hence the word *branch*). The selection showcases excellent craftsmanship and accessibility in both Japanese and Western styles. "We strive to create an atmosphere that appeals to people by offering them thorough hospitality and a place to curate and care for their own selections themselves."

The move away from only selling clothing is calculated. In Tokyo, where there are so many curated selections available, stores search for ways to stand out from the competition. As Kakimoto puts it, "Lately, trends have been just flooding in. Under such conditions, Bloom & Branch Aoyama aims to make high-quality items that anyone would wish to pass down to the next generation. To achieve this, we have to shift our focus to things other than garments."

Looking at a wide range of concept stores, we've seen that to keep pace with the demands of Tokyo's most discerning customers, fashion brands and retailers need to think hard about their individual niche and offer unique concepts and well-designed goods that also augment a completely stylish way of living. The concept stores we've seen have more than met this challenge and, with the support of their devoted fans, continue to refine their contributions to a fashion environment that is constantly changing. In the last chapter, we'll hear about the connection between fashion and food and explore the favorite spots of Tokyo's most fanatical fashion followers—affectionately called "maniacs"—along with a shopping guide and recommended stores in each of Tokyo's most stylish areas.

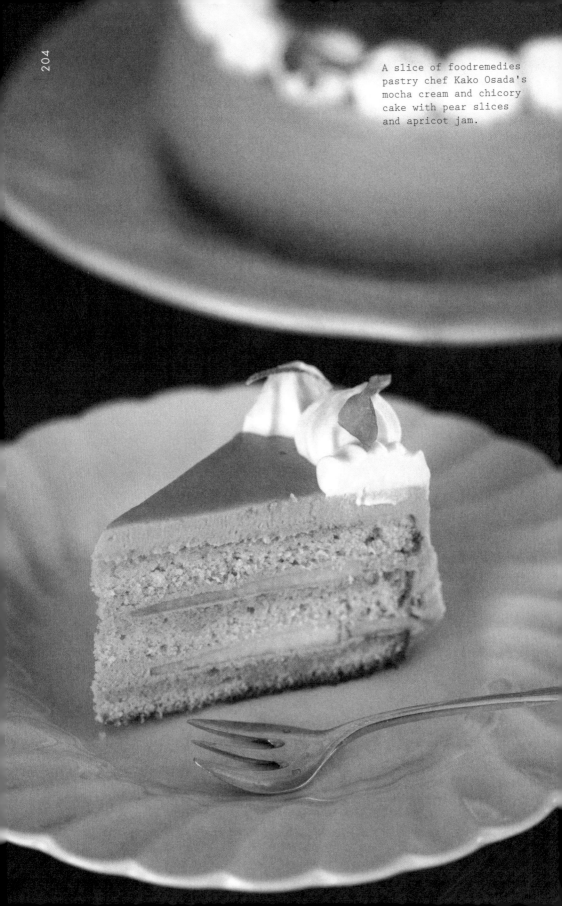

A slice of foodremedies pastry chef Kako Osada's mocha cream and chicory cake with pear slices and apricot jam.

Chapter 7

Fashion, Food, and More: A Tokyo Guide

"I am attracted to Tokyo in general, not just the fashion. The fashion for me is a small part of it. I see the whole city as a very inspiring and stylish place."

—Olympia Le-Tan, designer

In Tokyo, there is a huge demand for what is known as total life design—style in all aspects of life, from music to clothing to food. Tokyoites are among the world's most discerning customers, expecting (and receiving) the best customer service and craftsmanship in terms of the products they buy as well as their overall shopping, drinking, or dining experiences. As we have seen, select shops and concept stores are continually adapting to meet these demands.

While this level of discernment is the norm throughout the city, some take their passion for the totally stylish life to the extreme. These fashion "maniacs," as they are affectionately known, spend a lot of time and effort seeking out the most original, avant-garde places from the vast array of choices the city has to offer.

FASHION INSPIRES FOOD

One aspect of life that Tokyo's fashion maniacs are particularly obsessed with is food. When Mari Terasawa, director and buyer at the select shop Tokyo Kaihoku, tells us, "Fashion doesn't mean only clothing," we couldn't agree more. Fashionable people in Tokyo are gluttons for excellent food especially—and they have plenty of delicious offerings to sample, given the very high standard of restaurants, from the most casual stand-up ramen noodle bar to the legendary Michelin-starred restaurants Tokyo is famous for.

The food and fashion worlds are continually colliding. As we've seen already, Baby Mary serves tea to her customers at Miss Faline, Super A Market sells a variety of food and drinks, the concept store Graphpaper has a bar with great food upstairs, H BEAUTY&YOUTH Aoyama has a pizza place inside the shop, and Bloom & Branch Aoyama sells coffee, the cups to drink it from, towels to clean up with, and more. All of these places—and many more like them—acknowledge that, like good clothes, good food is a basic necessity, so why not make the entire experience of cooking, eating, and cleaning stylish, too?

"The ability to under-stand fashion and cuisine is very similar."

—Hirofumi Kurino,
senior adviser for creative
direction, United Arrows

Hirofumi Kurino of United Arrows says that the link between fashion and food is a natural one in Japan: "The ability to understand fashion and cuisine is very similar. We use splendid ingredients, we carefully prepare everything, and we are very hospitable—this same obsessive attitude applies to fashion. In Tokyo, we often see chefs that are quite stylish simply because the level of both fashion and cuisine is very high."

Mike Abelson, the founder of and designer for Brooklyn-founded and now Tokyo-based brand Postalco, agrees. Abelson has been living in Tokyo for more than twenty years, creating leather bags, stationery, and accessories for the Postalco label as well as through collaborations with clients such as Issey Miyake. After twenty years of living in Japan, he says, "I regularly find new things that really impress me. We make all of the Postalco products in Japan and mostly around Tokyo. But the reason we are here is really because there are so many things we like about being here in Tokyo—the culture, how the city is run, and especially the food. For example, the way fish is often grilled with only salt and just a simple relish of grated daikon on the side. There is an excellent sense of preparing ingredients simply and then combining them very well. So much attention is paid to details in so many different areas that there are always unknown pockets to discover."

Since the advent of smartphones and Instagram, posting delicious-looking food on social media before eating has become a norm. However, as debates about too-thin models and eating disorders rage elsewhere, fashionable people in Tokyo see food as something to be enjoyed without any guilt—but also without excess.

This is easier in Tokyo because portions in Japan are generally smaller and the food is largely based around rice, fish, and steamed vegetables, but there are plenty of popular bakeries, tempura bars, street vans selling curry rice, and many other tempting spots, each serving up some of the most delicious food in the world. The key, of course, is moderation. And, as we'll see, it is not just the food itself that people are obsessed with—there has also been a surge of interest in the styles of celebrity chefs. People want to know what aprons they wear and how they coordinate those with the clothes underneath. They want to know what tools the chefs prefer to use in their kitchens and also the kinds of bowls and other tableware they use in their restaurants. Tokyo style is not just about fashion, but an interest in good food and stylish ways to prepare and enjoy it.

In this chapter, some of the chefs who are getting attention in Tokyo's street-fashion scene share their take on food and style, and a journalist who is responsible for covering the vibrant food scene comments on the continual quest of fashion maniacs for local, unique establishments, both food and fashion focused. But first, we'll head to Harajuku, a fashion-centric neighborhood that is also filled with some of the city's best restaurants.

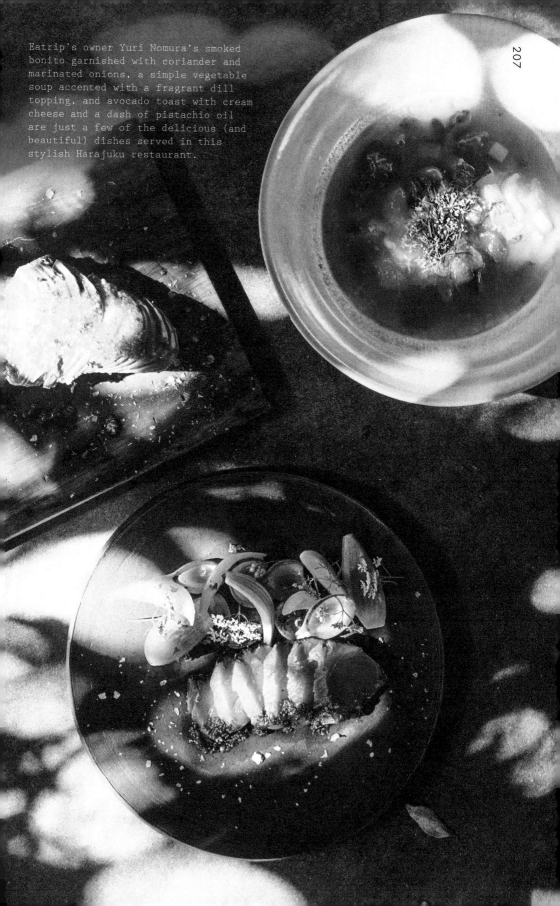

Eatrip's owner Yuri Nomura's smoked
bonito garnished with coriander and
marinated onions, a simple vegetable
soup accented with a fragrant dill
topping, and avocado toast with cream
cheese and a dash of pistachio oil
are just a few of the delicious (and
beautiful) dishes served in this
stylish Harajuku restaurant.

Yuri Nomura

Owner, Eatrip

*"**Whenever someone puts a lot of effort and care into food and produce, you can really taste the love that went into it.**"*

—Yuri Nomura, owner, Eatrip

Tucked away on a quiet backstreet in Harajuku just off Omotesando, the restaurant Eatrip serves a predominantly Japanese menu that changes daily, depending on what is available from nearby farms, along with fresh regional specialty foods. A selection of wines from famous wine-producing regions complement the meals, including some recent additions of selected organic wines. The food is created to stimulate all five senses, with the goal of evoking memories of food and fun to take you on an imaginary journey to places you've never been before—hence the restaurant's name, which combines the words *eat* and *trip*.

Sharing this special spot with Eatrip is the Little Shop of Flowers, a well-known florist run by Yukari Iki, who is Nomura's business collaborator and long-time best friend. Coming here to eat or pick up some flowers is like stumbling upon an oasis the two friends have created amid the hustle and bustle of Omotesando.

To find the restaurant, follow a narrow path from the street until you find a small hut. On the way, you might also encounter a secret flower garden (look for a mysterious spot with light emanating from it). It is the kind of place that seems designed for magical happenings. When we meet with Nomura at the restaurant, she tells us about a special evening they've just had. "The other day, I was doing an event together with a friend from California who makes olive oil in Joshua Tree. During the course of the evening, our other friends began playing instruments and singing, right there in the garden under the night sky, and the event became an impromptu live music gig. That night, my friend said to me, 'Whenever I'm here, I never know what country I'm in.' I was so happy to hear that my food could transcend borders like that."

When we ask her about the link between food and fashion, she tells us, "When a person leads a fulfilling life, they exude that satisfaction with their fashion. It's the same idea with food. Since people have to eat every day, what you eat shapes your personality and style from the inside." She takes this all-inclusive view, beyond just serving food, in passing along her knowledge, producing regular video tutorials on various aspects of cooking (look up her "Oishii Notes" series).

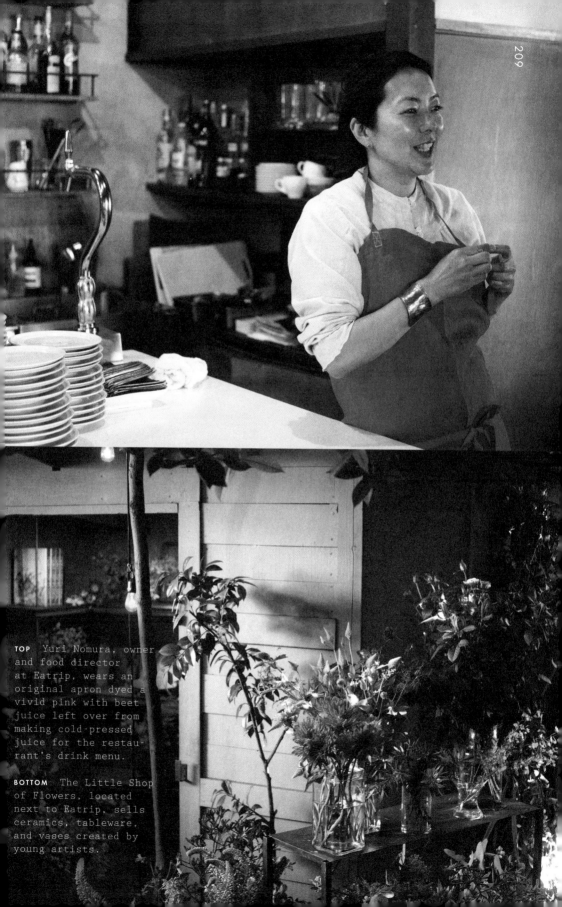

TOP Yuri Nomura, owner and food director at Eatrip, wears an original apron dyed a vivid pink with beet juice left over from making cold-pressed juice for the restaurant's drink menu.

BOTTOM The Little Shop of Flowers, located next to Eatrip, sells ceramics, tableware, and vases created by young artists.

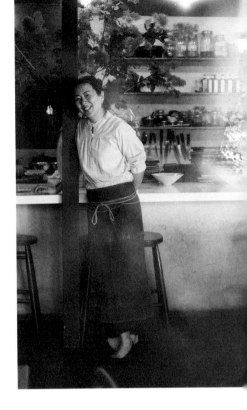

Nomura is also friends with many fashion designers, supporting their designs by wearing their clothes under her aprons. One of her friends, Yoshiyuki Miyamae, who handles Issey Miyake's women's clothing line, says that "making clothes is like making food," since the creative and technical processes are similar, just with different materials. Nomura explains, "Whenever I go to Miyake's exhibitions, Miyamae always explains new designs using food analogies. As a food person, it's something I can relate to. When I wear clothes with this idea on my mind, without fail, people ask me, 'What are you wearing?' It must be some kind of vibe that I give off, right? It's like they can read my mind and want to know more about the clothes."

Nomura tells us that she never intentionally wears coordinated designer looks. "I'm not fussy about designer labels or planning out my outfits. I like to wear what goes with my feelings at the time, whatever the brand. I might change buttons one at a time as needed, and it's fun to fix things up or restyle them to suit the time." This approach to style—putting in a lot of effort to maintain clothes you love and staying in tune with what feels comfortable for

"I think that people who wear clothes that make them feel comfortable and like themselves are the most stylish people."

—Yuri Nomura, owner, Eatrip

your own lifestyle—shines through, according to Nomura. "I think that people who wear clothes that make them feel comfortable and like themselves are the most stylish people," she says. Being casual and true to yourself like this is not easy, though the results are worth it. "When it comes to food and ingredients, too, whenever someone puts a lot of effort and care into food and produce, you can really taste the love that went into it. This is probably *kawaii* to the core, but I love cooking while cherishing the intention and care that those people put into the food. It's thrilling."

And she's right; the thought processes involved in both food and fashion are very similar, making it natural that stylish people would have an affinity for great food. As we've seen throughout this book, when we talk about fashion, we're not just talking about clothes. And at Eatrip especially, the sense that fashion is a way of life is something you can feel, while indulging both your mind and body. The next chef we'll hear from, Kako Osada, of the pastry brand foodremedies, agrees with this sentiment, but specializes in indulgences of a different sort—cakes and cookies that are particularly popular among women in the fashion industry.

OPPOSITE Fresh, seasonal ingredients are featured in dishes that are both delicious and stylish, designed to stimulate all five senses in combination with the restaurant's unique atmosphere. The denim apron that chef Yuri Nomura wears is an original collaboration between Eatrip and the San Francisco-based brand Small Trade Company. Nomura wears loose-fitting pants in the kitchen so she can move around easily.

KAKO OSADA

CHAPTER 7

Kako Osada

Pastry chef and founder, foodremedies

"The turning point for me was working for my favorite fashion brand as a pastry chef."

—Kako Osada, pastry chef, foodremedies

Before breaking out on her own to start foodremedies, which caters fashion events in Tokyo and conducts special baking classes and other food-related events, Kako Osada worked for the fashion brand YAECA, which is known for its simple yet impeccably designed clothing. When we meet Osada in her foodremedies test kitchen, she tells us more about her time there and about the unexpected connection between a cookie recipe and fashion.

OPPOSITE Both of Kako Osada's garçon aprons are from vintage clothing stores. The white coatlike apron is also vintage. It used to be a nurse's uniform in the US army. She pairs a gray turtleneck with YAECA chinos and white Repetto shoes, while making a mocha cream cake that has a hint of chicory powder with a layer of thin pear slices and apricot jam.

"The turning point for me was working for my favorite fashion brand as a pastry chef. At YAECA, the clothes are simple but well thought-out, and also really comfortable. Beautiful, fashionable people came in and out of YAECA every day, so it was quite stimulating for me. I was in charge of creating recipes that matched the brand vision. I baked and arranged the tablescapes for the re-freshments we served at receptions or parties. I even designed the packaging for some of the foods we made. Having those responsibilities taught me how to develop delicious new recipes, but I didn't just learn to pursue taste. I also learned the importance of a product's fashion appeal. I think this emphasis on delicious taste and a good sense of style through product presenta-tion is reflected in my current work at foodremedies."

Finding her signature method of baking took trial and error. "In the past, I re-peatedly experimented with my recipes and did so much tasting that my palate was damaged by the sweetness of the sugar. Ever since then I have thought a lot about how to make cookies that were not overly sweet but that would satisfy any sweetness cravings with just a few bites. I asked myself if it was possible to reduce the amount of sugar to the point where its sweetness could just barely be tasted. After a lot of test-ing, I managed to find the right sugar

balance, which has resulted in the distinctive flavor of foodremedies cookies, cakes, and pastries." Though coffee and tea might be the usual beverages of choice to pair with baked goods, Osada also considers alcohol pairings with her recipes. "Cookies and cakes baked with lots of spices and herbs go well with alcohol. Since I enjoy drinking, I think about the kind of sweets that go well with wine or sake as I'm developing new recipes." (For more about sake, see page 224.) When Osada brings foodremedies sweets to fashion events, they always sell out quickly because of the reputation her recipes have earned.

true of Osada. Her poised, gentle, and dignified style comes through in the subtle sweetness and complex flavors of her recipes and the value she places on presentation. That is key for all of the creators we spoke to—and our next chef has an original, unforgettable way of styling one of the most common Japanese meals.

"I didn't just learn to pursue taste. I also learned the importance of a product's fashion appeal."

—Kako Osada, pastry chef, foodremedies

At first glance, the pastries at foodremedies look rustic and unembellished, but their flavor is unforgettable. Osada's practical but distinctive fashion sense is similarly memorable. She says: "On certain occasions—like when I sell sweets at an event or when I serve cake to guests—I always wear something white or a crisp, neat apron in order to make my cakes more appealing. Most of the time I wear pants when I'm baking and I don't wear an apron where the strap goes around my neck . . . I am very particular about aprons. I either find them in vintage clothing stores or I have them made." It's often said that a chef's personality is reflected in the taste of her dishes; this is certainly

OPPOSITE Osada keeps her jewelry very basic, with just a bangle from YAECA and no rings or other jewelry on her hands. She wears a vintage velour skirt with black Dansko clogs. She uses simple tools to make her delicious confections, such as her popular rosemary cookie (top). The tools and clothing that female chefs in particular are using and wearing have become hot topics among fashion-conscious women in Tokyo.

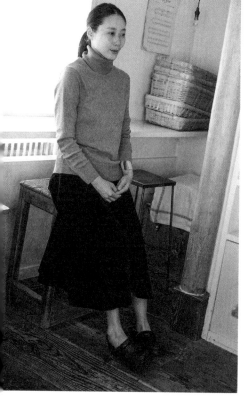

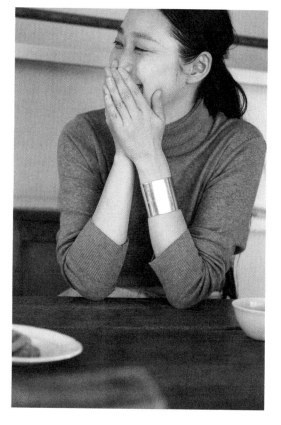

Chiori Yamamoto

"If someone told me that they could see a sense of style in a bento box I created, I would be thrilled."

—Chiori Yamamoto, chef and founder, Chioben

The word *bento* refers to the ubiquitous Japanese portable meal where rice and various side dishes are packed into a small box-shaped container. Just as with clothes, fashions in bento change with the times, and at the moment, Chioben bento boxes are the ones that fashionable women in Tokyo love best.

We meet with Yamamoto and her staff at the Chioben kitchen, where she tells us about how she got started as a chef. "I ran a normal restaurant for a long time back in my home of Hokkaido. In my forties, I moved to Tokyo. My career had many twists and turns, but I eventually ended up working at a place that was selling bento. Our customer base gradually increased by word of mouth." Seeing an opportunity, Yamamoto started up her own catering business and pop-up shop specializing in bento.

Yamamoto's company, Chioben, has been in business since 2011. People call her bento "the dream bento" be-cause they are in such great demand—and supply is so limited! The thing that grabs your attention when you open one of the Chioben bento boxes is the volume of colorful side dishes packed inside, arranged just so, to express the four seasons in Japan. As a graduate in fine arts, it is no wonder that Yamamoto creates bento that look so beautiful. Of course, they are not only beautiful but also delicious, featuring a range of textures and nostalgic home-cooking-style flavors. These bento are a total sensory experience.

"Before I started serving bento, I was doing lunches with multiple side dishes being served on a single plate." Normally in a bento box, side dishes are divided by thin, colorful paper or strips of plastic to keep everything at its best until it's time to eat. But at Chioben, the side dishes are arranged without dividers, something that has become their signature—if unusual—style. When she designs a bento, Yamamoto told us, "I decide roughly what goes where by thinking of the side dishes as 'blocks,' because filling the bento box with side

OPPOSITE A classic Chioben bento full of color and a variety of delicious tastes and textures. Steamed fish, spring rolls, meatballs, croquettes, hardboiled egg, octopus, and mountain berries are stylishly arranged on rice.

dishes is somewhat similar to playing Tetris. Like falling Tetris blocks, the ingredients for our bento change every day, which means that the wheels in my brain are always spinning, trying to come up with new combinations."

Since Yamamoto first appeared in women's fashion magazines in 2012, she has attracted many customers who work in the fashion industry. "During my youth, in the 1980s, fashion magazines were at the height of their popularity. I used to read anything I could lay my hands on and I used to dress in the style that was popular. When I started my catering business in Tokyo, I met fashion designers and stylists that I admired and I was interviewed by highly coveted fashion magazines. This attention made me very proud, but I also felt very humble. It made me want to try even harder. Since there is a long history of bento culture in Japan, I think that people have very high standards regarding their bento. I always think of our customers as our top priority and so I dedicate myself to creating food that looks as gorgeous as it tastes, while also being filling and satisfying."

Yamamoto's passion and enthusiasm are also reflected in her approach to fashion. When we speak with her, she is in her work clothes, of course: "This apron was hand-sewn by my mother. It's cut down the middle so I can move easily, but it is also torn because I use it all the time. My mother has very good hands and she is good at both sewing and cooking. She often makes aprons out of extra fabric and then gives them to me and my staff. As for clothes, I know some chefs prefer natural styles and basic clothing, but I don't look good in those; I don't know why. Maybe it has something to do with my age. It just seems that unique clothes with elaborate designs suit me better. The moss-green shirt I am wearing is Kolor [a Japanese fashion brand]. The black pants are original Deuxieme Classe [a select shop in Japan]." We ask if her white shoes are Céline, but she laughs and says, "Oh no, they are chef shoes specifically made to be worn in the kitchen." Still, they look great, just like her bentos. When we mention this to Yamamoto, she tells us "If someone told me that they could see a sense of style in a bento box I created, I would be thrilled."

While Chiori Yamamoto and her staff are working hard to keep up with the discerning (and hungry) style maniacs working in the fashion industry, our next contributor Yukako Izumi, deputy editor of *Time Out Tokyo*, keeps her ear to the ground to give both Japanese and foreign readers a sense of where these maniacs go "local" to eat, shop, and go out.

OPPOSITE It's early in the morning in the Chioben kitchen, and Yamamoto and her staff work diligently in silence, making the day's bento. Watching the way they fill each box one after another with rhythmic precision is like observing artists or composers at work. And this artistry is visible in care- fully curated clothing that the team wears.

Yukako Izumi

Deputy editor, *Time Out Tokyo*

"The deeper I go into the backstreets of Tokyo, the more I find unique stores that make me want to know more about them."

—Yukako Izumi, deputy editor, *Time Out Tokyo*

Fashion maniacs are obsessed not only with food but also with finding a so-called local spot—that is, a unique place, preferably in the old (and disappearing) backstreets of "local" Tokyo—that serves up something original, whether it's clothing, music, or experiences. We sit down with Yukako Izumi—who, as deputy editor at *Time Out Tokyo*, has to keep track of the ever-evolving food and fashion scene—to hear about how people in Tokyo are endeavoring to preserve the disappearing "local" feel and culture of the city's neighborhoods and backstreets, while at the same time generating and maintaining the interest of international audiences.

Izumi tells us that the magazine's goal is to be "the ultimate guide for metropolitan residents provided by local experts." To compete with information freely available on the internet, *Time Out*'s diverse editorial staff tries to present what Izumi calls "the various charms of Tokyo from a variety of viewpoints. We can give very specific information that only locals would know, and we don't just emphasize the attractive, standard sightseeing spots that most tourists would wish to visit in Japan. Our intention is to provide content that caters to both visitors to Tokyo and Tokyo residents."

When we ask Izumi what she means by "local," she tells us, "The deeper I go into the backstreets of Tokyo, the more I find unique stores that make me want to know more about them. There are so many 'local' spots in Tokyo [that attract devoted maniac fans]. I think this is one of Tokyo's distinctive characteristics." With Japan's scrap-and-build approach to urban planning and construction, in which old buildings are torn down to make new, more efficient (and more earthquake-proof) buildings, the desire to seek out the older places that retain some of the original character of their local areas is understandable. As Izumi explains, "The cityscape of Tokyo is

OPPOSITE An attractive lineup of sake bottles inside Hasegawa-saketen in Azabu-Juban, a prime example of a "local" spot. Each brand of sake sold here has it's own distinctive and stylish label design.

changing rapidly because large shopping malls are popping up, one after another, and these backstreets and alleyways are disappearing. Against this backdrop, younger fashion maniacs are trying to preserve this local aspect of the existing backstreets in their neighborhoods, and more and more people are taking this on. At the same time, they have a really global outlook. Their enthusiasm for and support of these unique local fashion labels and stores has resulted in a kind of backstreet niche industry of high-style clothing and other merchandise created by and for truly passionate connoisseurs. And the number of such 'local' maniac spots is on the rise, especially in East Tokyo," which has traditionally been more industrialized but is increasingly becoming a hot spot for maniacs to discover new labels.

Shimokitazawa and Koenji are also popular areas among maniacs of all ages. They're known as meccas for vintage clothing enthusiasts, attracting fashion industry types and tourists alike. Izumi tells us why tourists have so easily found these up-and-coming areas and enjoy them so much: "It's easier than ever for people outside of Japan to keep an eye on Tokyo's street scene through Instagram. There is an abundance of secondhand and vintage clothing stores, and also vinyl record stores, in both places. A lot of overseas musicians actually come here to check out the vinyl record stores." What makes these areas uniquely appealing to maniacs looking for vintage music and clothing, Izumi says, is that "generally speaking, these shops selling vintage finds, whether it's clothing or music, have a huge range of genres and everything is kept in really good condition. Vinyl records in particular are

categorized and displayed very neatly, and when tourists see them they are always surprised."

It's not just the selection and presentation that attracts true maniacs, but also the intentional, well-informed curation that these stores offer. "The owners of these stores take their time diligently collecting vinyl records and don't just blindly chase new things. They have the ability to curate the selection. They have their own criteria for categorizing their records and displaying them in an attractive way. I think that Tokyo is *the* city where these sorts of people, and the stores that cater to them, gather together." Izumi gives the award-winning Tsutaya bookstore in Daikanyama as an example. "This store is a favorite of both Japanese people and foreigners. There are a tremendous number of books neatly displayed by category here." The bookstore boasts a huge music section, and there are smaller pop-up shop areas throughout the store specializing in food, homewares, textiles, and other merchandise related to the subjects of the books displayed on nearby shelves.

Izumi also mentions Tokyu Hands, which is a kind of multilevel general store/select shop chain that seems to sell everything you could ever need or want for daily life, hobbies, travel, work, and more—hundreds of things you need and want but didn't know about before you entered the store. The most striking feature of Tokyu Hands, though, is that all of these things are interestingly designed. Even everyday items seem to be something more thanks to their excellent design and quirky presentation. The store is a dream for anyone who loves good design that is sophisticated but playful at the same time.

> **"The influence of Instagram in particular is huge. If you can post great images, this is a time when even small, niche stores in a Tokyo alley can garner a global following."**
>
> —Yukako Izumi, deputy editor, *Time Out Tokyo*

For smaller stores that compete to offer a particular curated selection to their target maniacs, "The influence of Instagram in particular is huge. If you can post great images, this is a time when even small, niche stores in a Tokyo alley can garner a global following."

In the spirit of appreciating small, local stores, we have curated a selection of Tokyo's fashion maniac spots, from well-known, well-established stores to those that are more obscure or "local," as Izumi uses the word. Our selection reflects the places currently influencing street style through their curated selections of clothing, accessories, vintage items, or other offerings. In the listings that follow, you'll find more details about the shops and brands we've featured throughout this book, along with additional selections for eating, drinking, and exploring the music and literary scenes.

The listings are organized by neighborhood to give you an idea of each area's distinctive character. We recommend picking a neighborhood to explore (this is a great way to approach Tokyo both for first-time and frequent visitors). It is easy to get around Tokyo, due to the excellent public transportation, but the distances are vast, and with so much to see and do, it's all too easy to try to pack in too much at once.

In choosing the neighborhoods to feature, we have focused on neighborhoods and districts that have close connections to fashion; other equally interesting neighborhoods and tourist sites not mentioned here have been omitted because these areas and Tokyo's most popular tourist sites have been covered very well already in other guides. We hope that by hearing from the people featured in this book and by exploring the following neighborhoods and local haunts of fashion maniacs—whether in person on a trip to Tokyo or through the websites and Instagram feeds of the stores in question—you'll get a sense of authentic Tokyo style.

Q&A
Takuya Ebe

Editor in chief of *dancyu web*

Takuya Ebe joined the editorial department of one of Tokyo's most influential food magazines, *dancyu*, in 2000. The magazine has a devoted following not only among those in the food industry, but also people in fashion and a range of other culture and creative industries. It is targeted primarily at men, but is also becoming increasingly popular among women. After serving as editor in chief from 2013 to 2017, Ebe now oversees the online food magazine, *dancyu web*, which is fast becoming a popular online destination for Tokyo's most discerning and stylish people looking for food and style inspiration. We sat down with with Ebe to find out more about the ways in which food and fashion trends overlap.

Recently, it seems that there are an increasing number of people who admire the clothing and lifestyles of chefs and celebrity cooks in addition to the food they make. There have even been a number of popular books published in Japan featuring female chefs' clothing.

That's definitely true, especially among young people. There are also an in-creasing number of fashionable chefs focusing not only on great-tasting food, stylish tableware, and so on, but who are also committed to creating a whole worldview with their restaurants. This is evident in the food, the interior décor of the restaurant, the clothes their servers wear, and more.

In the past, it was normal for a success-ful chef to open a second larger restau-rant, compared with their first. But now it seems that chefs want to downsize. They seem to want to focus on their personal vision and to do it in such a way that they can be really hands-on in every aspect of the restaurant's style. I think these chefs have a really good understanding of food and drink, of course, but also of what kind of fashion suits their personal style.

Is there a kind of food or drink that you would say can really express individual style?

Sake. Since sake is produced through-out Japan, I think a person's choice of sake—where the kind of sake they like was brewed—can tell you something about where a person has been, what they have experienced, where they come from, and where they are going. To put it another way, I think a person can express a lot about their individual style and personality through the sake they choose to drink.

Yes, and I think the change began particularly around the turn of the millennium. Before around 2000, I never used to write more than just "sake" or "shochu" (a stronger distilled spirit) when talking about alcohol and food. But now, I have to go into great detail about the taste of each kind of sake, the brands, and so on. I think this is like people's obsession with the methods and details of manufacturing that go into jeans and white T-shirts. In Tokyo, there are so many ideas and information about fashion available that people who take a particular stance like this to differentiate themselves are increasing. But I also think the overwhelming majority of people are simply trying out new trends in food and fashion because they're getting media attention.

Younger sake producers, who tend to have vastly different lifestyles and experiences from their more traditional predecessors, are also transforming sake's image. Whereas the previous generation of brewers might have devoted their working lives to brewing sake exclusively, this new generation seems to come into the trade after living in Tokyo or after working for a few years in another industry. They tend to have more global viewpoints and are also very fashion conscious. I have even noticed recently that label designs on sake bottles have become more stylish, which is perhaps an expression of this wider, more design- and style-oriented experience that young sake brewers bring to producing sake. There are so many foods like this, too, whose provenance, quality and style of preparation, and presentation can express someone's personal history, lifestyle, and fashion sense. But for me, I definitely can sense a person's individual style through sake.

It seems that this emphasis on individual style is making fashion more and more fragmented and differentiated. Do you think something similar is happening with food?

> **"Younger sake producers . . . tend to have more global viewpoints and are also very fashion conscious."**
> —Takuya Ebe

When enjoying food or fashion becomes too trend driven, I think people risk losing their sense of themselves and what they like. If you don't actually like the food at a celebrated restaurant, or if everyone says a new fashion trend is good, but it doesn't work with your own style, you might start to doubt your own taste. That's why I think enjoying food and wearing styles you like is a good way to show your personality. If you focus on what you really love, your sense of style will be obvious.

TOKYO GUIDE ICONS

- ✎ Brand Boutique
- ⚲ Women's
- ⚦ Men's
- ⚓ Vintage
- ◊ Jewelry, Accessories
- 🍴 Restaurant/Café
- ☕ Coffee/Cakes
- 🍷 Alcohol/Bar
- 📖 Books
- ♫ Music
- ⌂ Home
- ✉ Stationery/Products
- 🗋 Gallery/Museum
- ✿ Flowers
- ⚱ Beauty

HARAJUKU & OMOTESANDO

BIG LOVE
♫

Offering a selection of new releases focusing on albums from Europe and America, Big Love is getting a reputation as a spot for that uniquely Japanese tribe of fashion-sensitive music maniacs.

3F-A, 2-31-3 Jingumae,
Shibuya-ku, Tokyo
www.bigloverecords.jp

DEPT @VACANT
⚓ ⚲ ⚦

VACANT
(see page 86)
☕ 🗋 ✎

A combination vintage clothing store, concept store, café, and event gallery space.

1 & 2F 3-20-13 Jingumae,
Shibuya-ku, Tokyo
d-e-p-t.tokyo
www.vacant.vc

EATRIP
THE LITTLE SHOP OF FLOWERS
(see page 208)
🍴 ✿

6-31-10 Jingumae,
Shibuya-ku, Tokyo
restaurant-eatrip.com
www.thelittleshopofflowers.jp

FACETASM JINGUMAE
✎ ⚲ ⚦

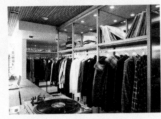

For those looking for the hottest Japanese brands that are also popular overseas, Facetasm should be the first stop. The store is in a renovated Japanese house covered in creeping ivy whose interior has been refurbished in a style that captures the essence of Tokyo street style. And be sure to check out the cool styles put together by Chang (see page 20), a staff member who is well known in Tokyo for her unique approach to styling.

2-31-9 Jingumae,
Shibuya-ku, Tokyo
www.facetasm.jp

FALINE TOKYO
(see page 120)
⚲ ⚦

1-7-5 Jingumae,
Shibuya-ku, Tokyo
www.bambifaline.com

#FFFFFFT SENDAGAYA
⚲ ⚦

A selection of exclusively solid white T-shirts from Japanese and international brands. The potential variations on a basic white T-shirt theme is astounding. Everything looks the same and yet completely different! Open only on Saturdays.

1F 2-3-5 Sendagaya,
Shibuya-ku, Tokyo
www.fffffft.com

FILMELANGE
✎ ⚲ ⚦

A Japanese brand that is popular with people of all ages, FilMelange features casual designs created with quality tailoring and luxury materials.

1F Shuwa Gaien Residence,
2-6-6 Jingumae,
Shibuya-ku, Tokyo
filmelange.com

HABERDASHERY OMOTESANDO
⚲ ⚦

Offering eternally stylish clothes that remain above the vagaries of fashion trends, including major Japanese brands such as ASEED-ONCLOUD.

102 Mahal Omotesando, 5-12-1
Jingumae, Shibuya-ku, Tokyo
www.haberdashery.co.jp

HARAJUKU ROCKET
☕ 🗋

With so many different events going on in gallery that often hosts culinary events, there is always something new to discover. Be sure to check out OMOTESANDO ROCKET (next to Omotesando Hills), too.

6-9-6 Jingumae,
Shibuya-ku, Tokyo
www.rocket-jp.com

KOFFEE MAMEYA
☕

A selection of beans from around the world roasted in different ways. Discover your favorite through a one-on-one consultation, and don't forget to try the coffee while you're there.

4-15-3 Jingumae,
Shibuya-ku, Tokyo
www.koffee-mameya.com

LAMP HARAJUKU
(see page 133)

4-28-15 Jingumae,
Shibuya-ku, Tokyo
www.lamp-harajuku.com

MARTE
(see page 105)

202 Villa Hase, 6-6-11
Jingumae, Shibuya-ku, Tokyo
marte.jp

NUMBER SUGAR

Caramels at Number Sugar are
made without additives for an ex-
ceptional taste, and, with such cute
packaging, they make the perfect
souvenir. Be sure to try caramel-
flavored drinks, too.

1F 5-11-11 Jingumae,
Shibuya-ku, Tokyo
www.numbersugar.jp

OCAILLE
(see page 190)

101 Villa Rosa, 3-31-17
Jingumae, Shibuya-ku, Tokyo
Instagram: @ocaille

OTOE

This is the vintage shop TORO's
second location, focusing on their
original brand, Otoelogy, which fea-
tures "remake" designs crafted from
vintage and secondhand clothing.

2F 2-31-9 Jingumae,
Shibuya-ku, Tokyo
Instagram: @otoelogy

SANTAMONICA OMOTESANDOU
(see page 97)

5-8-5 Jingumae,
Shibuya-ku, Tokyo
Instagram:
@santamonica_omotesandou

THE NORTH FACE 3 (MARCH)

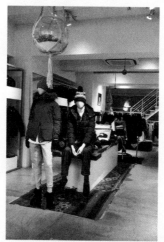

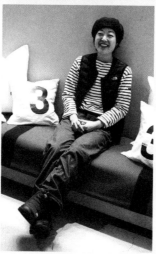

Although the North Face is a well-
known American brand specializing
in durable, comfortable urban
outdoor style, most of the items
featured in this shop are actually
designed in Japan and are limited
editions only available in Japan.
This rarity in their selection attracts
a number of fans of North Face
from overseas.

NA Building, 6-10-8
Jingumae, Shibuya-ku, Tokyo
www.instagram.com/tnf_march

*The North Face 3 (march) store man-
ager, Yuka Nagatsuma, wears urban
outdoor styles. "Women who come
into the shop care not only about the
designs but also their functionality."*

TORO
(see page 89)

1-2-10 Jingumae,
Shibuya-ku, Tokyo
Instagram:
@torovintageclothing

VERMEERIST BEAMS
(see page 127)

B1F International Gallery
BEAMS, 3-25-15 Jingumae,
Shibuya-ku, Tokyo
www.beams.co.jp/vermeerist

AOYAMA, NISHI-AZABU & AZABU-JUBAN

AURALEE

A new Japanese brand that has been getting attention from a wide range of stylish, fashion-sensitive people for its neutral designs, original materials, outstanding comfort and fit, and limited edition pieces. The brand's flagship store is in Minami-Aoyama near the old-fashioned jazz club Blue Note Tokyo.

1F 6-3-2 Minami-Aoyama,
Minato-ku, Tokyo
auralee.jp

BEAUTIFUL PEOPLE

This Japanese brand with a large overseas fan base offers designs that are full of wit. Their skillfully crafted patterns create beautiful silhouettes that must be seen to be believed.

3-16-6 Minami Aoyama,
Minato-ku, Tokyo
beautiful-people.jp

BLOOM & BRANCH AOYAMA
COBI COFFEE AOYAMA
THE BAR BY BRIFT H
(see page 203)

101 Daiichi Kuyou Building,
5-10-5 Minami-Aoyama,
Minato-ku, Tokyo
bloom-branch.jp

BROWN RICE CANTEEN

Located inside Neil's Yard, the natural apothecary from London, this café offers a varied menu of vegetable-rich Japanese dishes.

1F 5-1-8 Jingumae,
Shibuya-ku, Tokyo
www.nealsyard.co.jp/brownrice

EYEVAN 7285 TOKYO

This eyewear brand is getting attention as a favorite among Tokyo's most stylish people. The brand's "Made in Japan" quality and detailing are sure to appeal to anyone looking for outstanding eyewear.

1F 5-16-2 Minami-Aoyama,
Minato-ku, Tokyo
eyevan7285.com

MUVEIL

A collection of Japanese brands whose designs incorporate hand-crafted details such as beading and embroidery.

B1F Chateau Toyo Minami
Aoyama, 5-12-24 Minami-Aoyama,
Minato-ku, Tokyo
www.muveil.com

HASEGAWA SAKETEN
AZABU-JUBAN

For sake aficionados, Hasegawa Saketen in Azabu-Juban is a must visit. The store carries a selection of more than two hundred different types of sake—carefully chosen to suit the time of year—to pair with the season's signature dishes. Chefs from all over the world come here because of this constantly changing selection and its location near some of Tokyo's best restaurants. With its cups and foods that complement the sake, the store is a good introduction to Japanese food culture—and is a reliable place to find souvenirs.

2-3-3 Azabu-Juban,
Minato-ku, Tokyo
www.hasegawasaketen.com

H BEAUTY&YOUTH
PIZZA SLICE
(see page 200)

3-14-17 Minami-Aoyama,
Minato-ku, Tokyo
www.h-beautyandyouth.com

HEIGHTS

Situated in a quiet vintage apartment building, this is a select shop for those in the know. Shopping is done through one-on-one consultations where staff advise on personalized beauty, skincare, and grocery selections to stimulate all five senses.

*Consultations by appointment only (reservations can be made on their website)
www.heights-heights.com*

HIGASHI AOYAMA

This store offers retro modern Japanese-style homewares, interior décor, and other items. Be sure to stop in at the nearby Nezu Art Museum, too.

1F Palace Aoyama, 6-1-6 Minami-Aoyama, Minato-ku, Tokyo
www.higashiaoyama.jp

LAILA VINTAGE

A popular stop for international fashion designers visiting Tokyo, Laila Vintage is the sister store to the concept store Laila Tokio (see page 183).

5-46-2 Jingumae, Shibuya-ku, Tokyo
laila.jp

MEETSCAL STORE AOYAMA

A concept store that celebrates local culture through an abundant collection of one-of-a-kind works by up-and-coming artists.

5-2-15 Minami-Aoyama, Minato-ku, Tokyo
www.meetscal.parco.jp

MINT DESIGNS AOYAMA

Japanese fashion brand whose product designs have been influential and well-received internationally. It's no wonder that the brand counts many artists among its fans.

5-49-5 Jingumae, Shibuya-ku, Tokyo
mint-designs.com

MISS FALINE

(see page 120)

3-6-26 Kita-Aoyama, Minato-ku, Tokyo
www.bambifaline.com

NO.501

Featuring a range of rare natural wines, customers at no.501 take advice from the charming in-house sommelier. Don't forget to try some of her recommendations at the bar inside the store.

1F SEIZAN Gaien, 2-5-4, Jingumae, Shibuya-ku, Tokyo
bottle.tokyo/no501

SAKURAI JAPANESE TEA EXPERIENCE

Experience Japanese hospitality at its best in this unique tea salon. The menu also features Japanese tea blended with herbal teas and alcohol. A good selection of tea leaves are also available as souvenirs.

5F SPIRAL, 5-6-23 Minami-Aoyama, Minato-ku, Tokyo
sakurai-tea.jp

SIRI SIRI

Naho Okamoto, the brand's designer, manages the SIRI SIRI store, which also serves as the brand's showroom. Here you'll find a full range of rings, necklaces, pierced earrings, and bracelets made using traditional Japanese craftsmanship, techniques, and materials, including glass, rattan, acrylic, and more.

2F Kasumicho Building, 2-11-10 Nishi-Azabu, Minato-ku, Tokyo
sirisiri.jp

SUPER A MARKET

(see page 178)

3-18-9 Minami-Aoyama, Minato-ku, Tokyo
www.superamarket.jp

SURR BY LAILA

An affiliate store of Laila Vintage and Laila Tokio (see page 183), SURR by LAILA is known for its vintage clothing for men, including a lineup of rare work and military styles, as well as clothes from major fashion houses. All of the clothes are in excellent condition, so the selection will also appeal to those who do not normally go for vintage. The "Diary" page on their website, written by the store's knowledgeable staff (Japanese only), is a constant source of fashion news and hot conversation topics among people in Tokyo's fashion world, and their fabulous Instagram feed is also well worth a look (@surr_by_laila).

202 3-15-13 Kita-Aoyama, Minato-ku, Tokyo
surr.co.jp

TSUTA COFFEE

Spend a few moments in blissful relaxation drinking coffee at this café while you enjoy the beautiful garden that is lovingly tended by hand.

1F 5-11-20 Minami-Aoyama, Minato-ku, Tokyo
tsutacoffee.html.xdomain.jp

SHIBUYA

COW'N
(see page 192)

42-2 Kamiyamacho,
Shibuya-ku, Tokyo
on.fb.me/1DYXqks

DESPERADO
(see page 174)

1F Shibuya Sakuragaoka
Building, 4-23 Sakuragaoka,
Shibuya-ku, Tokyo
www.desperadoweb.net

DISCO

A popular nail salon creating nail
designs that combine fashion and
art. The owner and nail artist, Nag-
isa Kaneko, her staff, and of course
the customers at DISCO are among
Tokyo's most fashionable people.

3F 1-14-9 Jinnan,
Shibuya-ku, Tokyo
www.disco-tokyo.com

D47

A store by the brand D & DEPART-
MENT centered on the theme of
long-life Japanese design from
designers and craftsman throughout
Japan, and also featuring a gallery
space and restaurant.

8F Shibuya Hirarie,
2-21-1 Shibuya,
Shibuya-ku, Tokyo
www.d-department.com./jp

GEN GEN AN

Try the taste of authentic Japanese
tea while listening to the hip-hop
music playing in this café.

1F 4-8 Udagawacho,
Shibuya-ku, Tokyo
www.gengenan.net

GRAPHPAPER
(see page 150)

The store's tranquil, gallery-like
space holds a surprising trick—some-
thing to look forward to as you
head to the store. They also hold
solo exhibitions of popular ceramics
designers and craftspeople, so be
sure to check their website regularly
to see what's going on.

1A/2D Kari Mansion, 5-36-6
Jingumae, Shibuya-ku, Tokyo
www.graphpaper-tokyo.com

UTRECHT

Next door to the concept store
Graphpaper is this independent
bookstore. Focusing on art, design,
and fashion, Utrecht deals in rare
books and magazines that can't be
found anywhere else.

2C Kari Mansion, 5-36-6
Jingumae, Shibuya-ku, Tokyo
utrecht.jp

HIGH AND SEEK
(see page 197)

*Open to female shoppers only
C-408 Villa Moderna, 1-3-18
Shibuya, Shibuya-ku, Tokyo
highandseek.blogspot.jp

LAILA TOKYO
(see page 183)

2F 1-5-11 Shibuya,
Shibuya-ku, Tokyo
laila-tokio.com

N ID TOKYO

A favorite among fashion lovers
from around the world, this select
shop carries unique, independent
brands from both Japanese and
international designers.

1F 1-3-2 Jinnan
Shibuya-ku, Tokyo
nid-tokyo.com

POSTALCO

Producing everyday items and
leather goods, this brand offers sim-
ple, humorous, and unique designs
for notebooks, pencil cases, wallets,
bags, raingear, and more.

3F Yamaji Building, 1-6-3
Dogenzaka, Shibuya-ku, Tokyo
postalco.net

SISTER
(see page 189)

2F FAKE Building 6-23-12
Jingumae, Shibuya-ku, Tokyo
sister-tokyo.com

ST&DARD MADE.
(see page 195)

1F 1-1-3 Shoto,
Shibuya-ku, Tokyo
standard-made.jp

6/ROKU BEAUTY&YOUTH
SHIBUYA CAT STREET
THE LITTLE SHOP OF FLOWERS

1F 5-17-9 Jingumae,
Shibuya-ku, Tokyo
www.beautyandyouth.jp/6
www.thelittleshopofflowers.jp

7x7

San Francisco is the concept behind
7x7, which is the nickname for the
area of the city where the store is
located. Offering original menswear
brands and hard-to-find items, many
of Tokyo's most fashion-forward
women surreptitiously buy clothes
here for themselves, too.

1F 1-5-11 Shibuya,
Shibuya-ku, Tokyo
seven-by-seven.com

EBISU

ANTIQUES TAMISER

A shop that fashion lovers, art
lovers, antique lovers, equipment
lovers, and so on attend. There is
no doubt that you will admire the
owner's devotion.

3-22-1 Ebisu,
Shibuya-ku, Tokyo
tamiser.com

BRITISH EQUIPMENT
PUBLISHING

This concept store offers a variety
of all things British, from clothes
to homewares, food, and more.
People who like classic rock styles
will be particularly impressed with
the selection here.

1F 3-15-7 Higashi,
Shibuya-ku, Tokyo
www.britishequipmenttrading.com

CONTINUER

A curated collection of eyewear
brands that combines practicality
and style. Don't miss their sister store,
The Parkside Room, in Kichijoji.

1F 2-9-2 Ebisu Minami,
Shibuya-ku, Tokyo
www.continuer.jp

GALLERY DEUX POISSONS
CAFÉ DEUX POISSONS

This gallery space and café fea-
tures contemporary jewelry created
from experimentations with various
materials that go beyond precious
metals and gemstones. A great
place to touch the works of artists
from around the world.

2-3-6 Ebisu,
Shibuya-ku, Tokyo
www.deuxpoissons.com

KIJIMA TAKAYUKI

One of Japan's leading hat brands,
Kijima Takayuki hats are known
for their fashionable and very
wearable designs and are favorites
among both men and women.

1F East Daikanyama,
2-17-4 Ebisu Nishi,
Shibuya-ku, Tokyo
www.kijimatakayuki.com

PETITE ROBE NOIRE
(see page 24)

This modern, elegant space exudes
the style and vision of Petite Robe
Noire designer Yoshiyo Abe. The
brand offers a full range of timeless
costume jewelry and elegant little
black dresses that are sure to
become keepsakes for future gener-
ations. Wedding and engagement
ring orders are also accepted.

#506 5F Ebisu Flower Home,
Kobayashi Building, 3-26-3
Higashi, Shibuya-ku, Tokyo
www.petiterobenoire.com

POST

This bookstore focuses on selling
high-quality titles from a single
publisher at a time. The store also
produces original book displays for
select titles and events.

2-10-3 Ebisu Minami,
Shibuya-ku, Tokyo
post-books.info

SUKIMA

Specializing in shoes and leather
accessories by Hender Scheme, the
up-and-coming Japanese genderless
brand (see page 162), Sukima's
main store is situated in a space
that was a car factory for fifty years.
This heritage is carefully maintained
in order to showcase the brand's
commitment to creating pieces that
endure through the ages by proudly
retaining the oil stains on the walls
and floors created by years of work

by the site's car mechanics. Besides a wide variety of leather shoes, the store offers genderless bags, wallets, and pouches, along with leather home interior items. Also, the store's "Recreation" corner, a gallery space displaying the store's limited edition Hender Scheme pieces, is definitely a must-see!

1F 2-17-20 Ebisu,
Shibuya-ku, Tokyo
henderscheme.com

YAECA

A favorite brand among female chefs, YAECA offers simple, everyday clothing made with high-quality materials and a commitment to excellent manufacturing and tailoring.

1F 2-20-15, Ebisu Minami,
Shibuya-ku, Tokyo
www.yaeca.com

MARKETS

Earth Day Market

If you're looking for a farmers' market in Tokyo, this is the one to go to. Held in two locations, one in Yoyogi Park and Inokashira Park, the market also features live music.
www.earthdaymarket.com

Oedo Antique Market

A veritable city of antiques held at both the Tokyo International Forum (in Yurakucho near Ginza) and Yoyogi Park. A favorite among Tokyo fashion insiders.
www.antique-market.jp

Farmers' Market @UNU

Held on weekends in front of United Nations University in Aoyama, Farmers' Market @ UNU offers fresh fruits and vegetables directly from the farms. We also recommend the lunch plates at each stall.
farmersmarkets.jp

YOYOGI

LE CABARET

A casual French bistro serving dinner and wine in a relaxed atmosphere.

Motoyoyogi Leaf #1F Motoyoyo-gicho, Shibuya-ku, Tokyo
restaurant-lecabaret.com

365 JOURS

Delicious bread and baked goods made with care from natural, fresh, locally sourced ingredients.

1-6-12 Tomigaya,
Shibuya-ku, Tokyo
www.365jours.jp
facebook: @365joursTokyo

CRISTIANO'S

Rustic Portuguese soul food served with a selection of wines from around the world.

1-51-10 Tomigaya,
Shibuya-ku, Tokyo
www.cristianos.jp

MAISON CINQUANTE CINQ

A cozy spot for dinner serving French food and rare organic wines from around the world.

2F 3F, 3-5-1 Nishihara,
Shibuya-ku, Tokyo
facebook: @maisoncinquantecinq

PATH

This is the place to enjoy French food served Tokyo-style from breakfast to dinner (though we recommend making a reservation for dinner). Their bread, baked fresh on site, and patisseries are available for take-out.

1F 1-44-2 Tomigaya
Shibuya-ku, Tokyo
www.instagram.com/
path_restaurant

ROUNDABOUT

Specializing in everyday basics.

B1 3-7-12 Uehara,
Shibuya-ku, Tokyo
roundabout.to

SIEBEN

A unique collection of vintage interior décor, homewares, and furniture.

Type7Bldg. 10-6 Motoyoyogicho,
Shibuya-ku, Tokyo
www.type-seven.com/sieben

THE MB

An eclectic selection of vintage and new pieces for men and women.

1F-A Biena-okudo, 2-43-6
Uehara, Shibuya-ku, Tokyo
www.the-mb.net

DAIKANYAMA

BOUTIQUE JEANNE VALET
(see page 98)

13-6 Daikanyamacho,
Shibuya-ku, Tokyo
www.jeannevalet-altosca.com

DAIKANYAMA T-SITE

Books, DVD, and CD rentals, restaurants, cafés and more are housed within this attractive "community space." The main draw here is the Tsutaya bookstore, offering a wide range of books from all over the world. Stylish people gather here to check out the latest fashions in clothes, interiors, lifestyle, and more.

16-15 Sarugakucho,
Shibuya-ku, Tokyo
real.tsite.jp/daikanyama

DESCENTE BLANC

From the Japanese sports and outdoor brand DESCENTE comes a store packed with sports gear featuring high functionality and excellent style.

C Building CUBE Daikanyama,
19-4 Sarugakucho,
Shibuya-ku, Tokyo
www.descenteblanc.com

EVA
(see page 102)

1B Avenue Side Daikanyama, 2-1
Sarugakucho, Shibuya-ku, Tokyo
evavintagetokyo.com

GARDEN HOUSE CRAFTS

The perfect spot for lunch (they close at 8:00 P.M.), this café/restaurant offers a delicious deli menu, freshly baked bread, and a selection of cakes and desserts, all prepared using seasonal ingredients.

Log Road Daikanyama,
13-1 Daikanyamacho,
Shibuya-ku, Tokyo
gardenhouse-crafts.jp

HAUNT

Located behind Daikanyama Tsutaya bookstore, this select shop features a wide selection of denim clothing from Red Card (see page 237), a Japanese denim brand with a good reputation both throughout Japan and internationally.

16-1 Enrakucho,
Shibuya-ku, Tokyo
haunt-tokyo.com

OKURA

Discover sophisticated Japanese fashion items including indigo-dyed pants and dresses. The store's charming interior is designed to look like the inside of a Japanese house.

20-11 Sarugakucho,
Shibuya,ku, Tokyo
www.hrm.co.jp/okura

VINI VINI

The way that the selection captures the style essence of each era presented is second to none, making Vini vini a go-to source for representatives from overseas fashion house brands looking for vintage. VINIVINI LUXE nearby provides even more finds in one location.

2-11 Sarugakucho,
Shibuya-ku, Tokyo
vinivini.buyshop.jp

NAKAMEGURO

DEPT TOKYO
(see page 84)

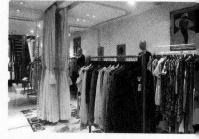

1-13-12 Aobadai,
Meguro-ku, Tokyo
www.d-e-p-t.tokyo

DIGAWEL

A Japanese brand with a quintessential street style feel, DIGAWEL is popular among charismatic men and also women who like gender-neutral styles.

1F Ishizaki-Adachi Building
2-30-7 Kamimeguro,
Meguro-ku, Tokyo
www.digawel.com

JANTIQUES
(see page 92)

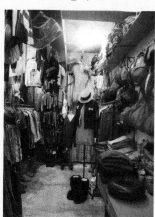

2-25-13 Kamimeguro,
Meguro-ku, Tokyo

ROOTS TO BRANCHES

A curated selection of the basic necessities—tableware and home utensils, clothing, and shelter—to enrich everyday life. The store features brands such as FUMIKA_ UCHIDA (see page 57), jonnlynx (see page 152), and others and has a loyal fan base among Tokyo's fashionable women.

2F Asahibashi Building, 1-16-7 Aobadai, Meguro-ku, Tokyo *roots-to-branches.jp*

YAECA APARTMENT STORE

Although there is no obvious sign outside, this store has a regular stream of stylish customers. The space and presentation is wonderful and is worth seeking out as a destination in its own right (see pages 213 and 232).

2B Riviera 1-21-22 Higashiyama, Meguro-ku, Tokyo *www.yaeca.com*

WALTZ

For those looking for refuge from the digital age, or just a great spot to observe Tokyo's coolest street

styles, waltz is a must-see. Located on a quiet street in Nakameguro, waltz is an analogue concept store that aims to be a haven for those looking for respite from the digital music age. waltz owner Taro Tsunoda worked for Amazon Japan for years. But faced with the increasing popularity of live-streaming and digital music played on smartphones, Tsunoda decided to go independent and focus on analogue-based music. The store's mission is to create new value for classic analogue music formats.

Since opening its doors in August 2015, waltz has earned a reputation among music lovers worldwide. Devoted customers and those who are visiting for the first time, curious to see the famous collection, come to waltz as much for the experience as for the classic vinyl albums and cassettes artfully displayed throughout the shop. waltz carries cassette tapes and players, vinyl records, old books and magazines, and VHS tapes and players, attracting a diverse and discerning clientele of music subculture lovers from all over the world.

4-15-5 Nakameguro, Meguro-ku, Tokyo *waltz-store.co.jp*

SHIMOKITAZAWA

ANTIQUE YAMAMOTO SHOTEN

Here you can find furniture and tableware that seems to come straight from an old Japanese movie. Each piece has been carefully restored so quality is guaranteed.

5-6-3 Kitazawa, Setagaya-ku, Tokyo *www.antique-yamamoto.co.jp/*

B&B

This is a bookstore where you can drink beer. They have an active event calendar, so it's best to check out their website to see what's on before you head over.

2-12-4 Kitazawa, Setagaya-ku, Tokyo *bookandbeer.com*

CITY COUNTRY CITY

A record store and café that's frequented by musicians and fashion designers alike, this is the spot to get insider information on Tokyo's music scene.

4F Hosozawa Building, 2-12-13, Kitazawa, Setagaya-ku, Tokyo *city-country-city.com*

FLOWER BAR GARDENA

Why not decorate the place you're staying with some of the (reasonably priced) flowers lined up in front of this store? Later, in the evening, this flower shop transforms into a bar with a fantastic atmosphere.

2-34-6 Kitazawa, Setagaya-ku, Tokyo *Twitter: @simokitagardena*

FILM
♨ ♟ ♦

This shop boasts an amazing selection of high-quality men's and women's vintage clothing from around the world located in the heart of one of Tokyo's best areas for vintage shopping.

2-28-4 Daizawa,
Setagaya-ku, Tokyo
film-web.tumblr.com

FOG LINEN
✐ ♟ ⌂

This Japanese linen brand is gaining popularity in the US. The store offers a stylish display of their original items, which are perfect for a variety of uses and interior settings.

1F 5-35-1 Daita,
Setagaya-ku, Tokyo
www.foglinenwork.com

HAIGHT & ASHBURY
♨ ♟ ♦

This long-established vintage store has been in business for more than twenty years, and their selection only gets better with age. Anyone coming here, regardless of age, style preference, and so on, is sure, to enjoy it.

2F 2-37-2 Kitazawa,
Setagaya-ku, Tokyo
haightandashbury.com

HIGH AND LOW
✐ ♟ ♦

A fantastic selection of good quality vintage, whether the piece is a famous brand or not. Be sure to take a look at their original "remake" pieces, too, designed and created out of vintage materials.

2-29-9 Daizawa,
Setagaya-ku, Tokyo
www.highandlow.jp

JET SET TOKYO
♫

Another Tokyo music maniac spot, packed with new releases across genres and a great source of insider information on music trends.

201 Yanagawa Building, 2-33-12
Kitazawa, Setagaya-ku, Tokyo
www.jetsetrecords.net

MEADOW BY FLAMINGO SHIMOKITAZAWA
♨ ♟ ♦

Rich earth tones coat the walls of this vintage shop, setting the scene for the quintessentially Tokyo-style vintage selection here. If you can't make it to the shop, check out their Instagram to see this distinctive approach to vintage.

Shimokitazawa COO Building A,
2-26-14 Kitazawa,
Setagaya-ku, Tokyo
Instagram: @meadow_by_flamingo

MÉL
♨ ♟ ♦

With a focus on mainly French vintage clothing from the 1830s to the early 1900s, the selection here hits the mark for those who love Victorian styles.

2F 2-26-7 Kitazawa,
Setagaya-ku TOKYO
mel-antique.tumblr.com

NEW YORK JOE EXCHANGE
♨ ♟ ♦

New York Joe Exchange's location in what was once a public bathhouse is a charming backdrop for their vintage selection. (The store's name is an Anglicized pun on *nyuyokujo*, a Japanese term for "bathhouse.")

3-26-4 Kitazawa,
Setagaya-ku, Tokyo
newyorkjoeexchange.com

VELVET
♨ ♟

Created by a former fashion magazine editor, Velvet offers a sophisticated selection of vintage pieces in a stylish setting. The store focuses on men's clothing, but counts many women among its clientele, too.

1F Suzuran Building 3-26-3,
Kitazawa, Setagaya-ku, Tokyo
velvet.pw

KOENJI

KITAKORE BUILDING HAYATOCHIRI
✐ ♨ ♟ ♦

This spot is for those who want to know more about Tokyo's underground scene. The chaotic state of everything here will no doubt overwhelm even the most intrepid visitors.

3-4-11 Koenji Kita,
Suginami-ku, Tokyo
hayatochiri.thebase.in

GARTER
♟

A creative space that exhibits the work of up-and-coming designers and artists. We are always amazed by the global approach the gallery takes to the art it displays.

3-4-13 Koenji Kita,
Suginami-ku, Tokyo
Instagram: @gartertokyo

SMALL CHANGE
♨ ♟ ♦

Full of vintage bought in the US and UK, this store is brimming with dresses and accessories for those with an active party lifestyle.

1&2 F 3-45-16 Koenji Minami,
Suginami-ku, Tokyo
www.smallchange.jp

SOKKYOU
♨ ♟ ♦

There is no sign indicating the location of this shop in a one-room back alley apartment, but that doesn't stop vintage maniacs from gathering here to pore over the selection.

3-59-14 Koenji Minami,
Suginami-ku, Tokyo
www.sokkyou.net/blog

HACHIMAKURA

This unique paper and vintage store is a treasure trove of inspiration and ideas. They sell mainly wrapping paper made from old paper and vintage picture postcards. It's a moving experience to feel the fine textures that have been created over the years.

3-59-4 Koenji Minami,
Suginami-ku, Tokyo
hachimakura.com

DEALERSHIP

Offering American vintage glassware from the 1940s to the 1980s, their Fire King collection is a masterpiece!

3-45-18 Koenji Minami,
Suginami-ku, Tokyo
www.dealer-ship.com

ANTIQUE BOOKS SANKAKUYAMA

This spot will be a hit among people who like Japanese music, animation, design, and fashion from the 1970s to the nineties.

3-44-24 Koenji Kita,
Suginami-ku, Tokyo
Twitter: @sankakuyama_b

R-ZA DOKUSHOKAN

House rules at this café and reading space dictate no talking with friends or on the phone. But there are ways around this rule if you stay and find you can't resist. Figuring them out is part of the fun of coming here and makes the place really popular.

3-57-6 Koenji Minami,
Suginami-ku, Tokyo
r-books.jugem.jp

TATOUAGE BY ZOOL

A long-established fixture of Koenji's vintage scene, with a number of locations throughout the area. They carry women's clothing dating from around one hundred years ago to the nineties.

1F 3-45-1 Koenji Minami,
Suginami-ku, Tokyo
zool.jp

SHINJUKU

APARTMENT HOTEL SHINJUKU

A unique, retro hotel situated in a residential area slightly away from the center of Shinjuku. Staying here is like visiting the studio of a young artist.

4-4-10 Shinjuku,
Shinjuku-ku, Tokyo
ap-shinjuku.com

BEAMS JAPAN

A select shop from Beams that showcases the charms of various regions of Japan through fashion, art, food, folk crafts and more. If you are looking for souvenirs, go here first.

3-32-6 Shinjuku,
Shinjuku-ku, Tokyo
www.beams.co.jp/beamsjapan

KEISUKE KANDA SHINJUKU

Experience a little of Tokyo's *kawaii* style and culture at the home of this irresistibly stylish Japanese brand.

3F Hokuto Daiichi Building,
2-14-3 Yoyogi, Shibuya-ku, Tokyo
www.keisukekanda.com

THE FOUR-EYED

Located in a spot known for its nightlife, this concept store is exciting from the moment you walk in and is the perfect place to see Japanese millennial street styles.

1F Paredoru Kabukicho, 2-8-2
Kabukicho, Shinjuku-ku, Tokyo
Instagram: @the_foureyed

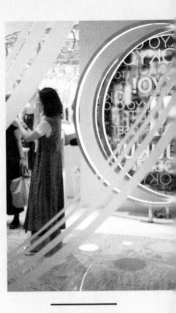

TOKYO KAIHOKU

(see page 186)

2F Isetan Shinjuku Store Main Building, 3-14-1 Shinjuku,
Shinjuku-ku, Tokyo
www.isetan.co.jp

JAPANESE DENIM

Denim is absolutely essential as a fashion item. During the nineties in Japan, it was cool to wear Levi's vintage jeans, especially among men, who continue to frequent vintage stores in Harajuku and Shibuya in search of the perfect jeans, paying prices that rival those of high-end designer brands with the rarest of vintage jeans fetching upwards of 1 million yen ($10,000).

Once women began following this trend for men's jeans, more and more Japanese denim manufacturers started developing techniques for making distressed or vintage-looking jeans, and a number of brands in Japan and around the world began offering new styles and types of jeans. One of these was the skinny jean, which first caught on in America in the early 2000s but soon became popular among women in Japan because they showed off the beautiful silhouette of their legs. Skinny jeans firmly established denim as a key part of any fashionable Tokyo woman's style. This demand prompted manufacturers to further refine their production techniques, making Japanese denim sought after worldwide.

Now, it's widely accepted in Japan that brands who create jeans also shape the course of fashion. While Japanese brands that originated with denim, such as

45rpm and Edwin, enjoy a devoted following overseas, there are also many other denim brands in Tokyo. Among these, RED CARD is attracting a lot of attention among stylish women in Tokyo.

The denim label RED CARD specializes in jeans for women that are created, from the beginning, with real women's bodies in mind. RED CARD's stylish accessibility—in keeping with the ethos of the concept stores, such as Haunt, that carry their clothes—is the result of brand director Yuji Honzawa's long stints at two of the major denim labels in Japan, Edwin and Levi's, where he worked for ten and six years respectively. After consulting for denim direction in many Japanese apparel companies, such as Uniqlo, Honzawa used his expertise to create the ultimate jeans, establishing RED CARD in 2009.

"It may surprise you to learn," he says when we ask him about his influences, "that when I was at university I majored in mechanics. So, looking at jeans as industrial products was how I began. I studied every aspect of denim—materials, accessories, methods, and machines—because I wanted to know everything about Levi's, the original maker of jeans. And I think Red Card jeans reflect all of that. Stitches, tags, patterns . . . I can go on forever. Basically, they are jeans created by a middle-aged jeans fanatic," he says, laughing.

The brand is popular among Tokyo's most stylish women because of the denim's quality, vintage-feel and the flattering, comfortable fit. As for sources of new design inspiration, Honzawa tells us: "The streets of Tokyo are the best place to look at fashion. No other city in the world has so many fashion boutiques and so many people dressed in such a wide range of fashionable styles." Honzawa also

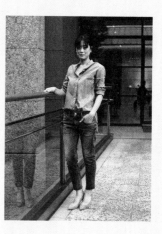

takes inspiration from the women he dresses, too: "When I look at people on the streets and in vintage shops, I can grasp what kind of jeans women want and what kind of jeans I want to make next."

redcard.tokyo

GINZA

AKOMEYA TOKYO
🍴 🏠 ✉

Focusing on rice dishes, Akomeya Tokyo serves a range of Japanese dishes. The taste of the restaurant's steamed rice is unforgettable.

2-2-6 Ginza, Chuo-ku, Tokyo
www.akomeya.jp

GINZA WEST
🍴

This famous Ginza café is known for its influence on Japanese tea ceremony culture. The sheer abundance of delicious food, with each dish lovingly prepared and elegantly presented, is absolutely amazing.

7-3-6 Ginza, Chuo-ku, Tokyo
www.ginza-west.co.jp

HIGASHIYA
🍵

Savor the taste of delicious Japanese cakes and sweets perfectly paired with tea and served in a modern setting that also respects tradition. The tearoom is a great place for people-watching in Ginza, too.

2F Pola Ginza Building, 1-7-7 Ginza, Chuo-ku, Tokyo
www.higashiya.com

MINDBENDERS & CLASSICS
🎩 👤 ♦

A vintage clothing store for those in the know, located in an old multipurpose building. The selection focuses on old-fashioned French everyday clothes and work clothes. The walls are also packed with art pieces and paintings with a high level of artistic value.

6F Nakadori Building, 2-6-8 Kyobashi, Chuo-ku, Tokyo
mindbendersandclassics.com

PORTER CLASSIC GINZA
PC KENDO PC SASHIKO
🏷 ♦

This brand, created and developed by the Yoshidas, a father and son team, has become tremendously popular in the world of men's fashion in Japan. The brand's designs are made with traditional craftsmanship and have been getting attention from clothing lovers all over the world.

2F 5-1 GINZA FIVE, Ginza, Chuo-ku, Tokyo
porterclassic.com

EAST TOKYO

ANATOMICA
🏷 👤 ♦

The store's somewhat isolated location makes this a destination in its own right, but browsing the selection here is well worth the trek. When you're done shopping, head upstairs to the second floor for delicious, rare wines and brasserie-style dishes at Fujimaru Asakusabashi.

Full of original pieces that capture the essence of both Paris and Tokyo, Anatomica clothes are based on classic designs, with particular attention paid to elegant silhouettes, quality materials, and the highest levels of craftsmanship. Although it caters to men more than women, women who like boyish French styles are among the brand's hardcore fans.

S Building, 2-27-19 Higashi Nihonbashi, Chuo-ku, Tokyo
anatomica.jp

FUJIMARU ASAKUSABASHI
🍴 🍷

This wine shop and diner frequented by Tokyo gourmands serves a selection of wines from around the world. Be sure to also try their own original wine produced in house.

S Building, 2F 2-27-19, Higashi Nihonbashi, Chuo-ku, Tokyo
www.papilles.net

KAKIMORI
INKSTAND BY KAKIMORI
✉

Custom order original note cards, stationery, and ink in your favorite shapes and colors, or pick up gifts and souvenirs from the wide range of paper goods on offer here.

4-20-12 Kuramae, Taito-ku, Tokyo
www.kakimori.com

NAKATASHOTEN AMEYOKO
♦

Hugely popular among men, this is the go-to spot for military styles. Stylish women are also often spotted here, too, and we recommend the "boy-size" flight jacket they sometimes carry.

6-4-10 Ueno, Taito-ku, Tokyo
www.nakatashoten.com

TOKYOBIKE RENTAL YANAKA
🏠

A bicycle brand with an ever-expanding global presence and loyal fan base. At this specialist rental location, you can rent a Tokyobike and explore East Tokyo in style.

4-2-39 Yanaka, Taito-ku Tokyo
tokyobike.com

Shoichi Aoki, *STREET* magazine
www.street-eo.com

Hiroshi Ashida,
Vanitas (magazine)
adachipress.jp/vanitas
kotobatofuku
(concept store in Kyoto)
kotobatofuku.tumblr.com

Adrian Hogan, illustrator
www.adrianhogan.com

Hanami Isogimi, *The Senken*
thesenken.com

Misha Janette,
Tokyo Fashion Diaries
mishajanette.com
www.tokyofashiondiaries.com

Ayana Miyamoto
Instagram: @catserval

Rei Shito
STYLE from TOKYO
reishito.com
Instagram: @reishito

Scott Schuman, *The Sartorialist*
www.thesartorialist.com
Instagram: @thesartorialist

Kumiko Takano,
ACROSS, PARCO Co. Ltd.
www.web-across.com

Shen Tanaka, *HINT/OF/ COLOR*
www.shentanaka.com
Instagram: @shen_tanaka

Hitomi Nomura, *MARTE*
Instagram: @hitominomura

Yuki Fujisawa
yuki-fujisawa.com

Ebony Bizys,
Hello Sandwich
hellosandwich.blogspot.jp

Time Out Tokyo
www.timeout.jp/tokyo

Akiko Aoki, AKIKOAOKI
www.akikoaoki.com

Olympia Le-Tan
www.olympialetan.com

Riona Nakagome, model
Instagram: @riona__n

Kako Osada, foodremedies
foodremedies.info

Chiori Yamamoto, Chioben
Instagram: @chiobento

Takyua Ebe,
dancyu web
www.president.co.jp/dan

Akane Sasaki,
fashion publicist
madder-madder.com

Hirofumi Kurino,
United Arrows
www.united-arrows.co.jp

Masami Sato, Anatomica
Instagram: @anatomica_tokyo

TOKYO BRANDS WE RECOMMEND

AETA aeta.website
AKIRA NAKA
 akiranaka.com
BED j.w. FORD
 bedjudewillford.com
BODCO zozo.jp/brand/ bodco
CHACOLI chacoli.jp
CINOH cinoh.jp
COMOLI comoli.jp
DOUBLET doublet-jp.com
FACETASM www.facetasm.jp
FUMIKA_UCHIDA
 fumika-uchida.com
HATORA hatroid.com
ITHELICY ithelicy.com
JONNLYNX jonnlynx.jp
LOKITHO lokitho.com
MAIKO TAKEDA
 maikotakeda.com
MEGANE AND ME
 www.meganeandme.com
MOTHER
 motherdenim.com
NAIFE naife.tokyo
Noriko Nakazato
 orikonakazato.com
SEMOH semoh. byhiroyukiueyama.com
SINA SUIEN sina1986.com
SULVAM sulvam.com
TAN
 tantantantan.com
YUIMA NAKAZATO
 yuimanakazato.com
VTOPIA
 www.vtopia.com
WRITTENAFTERWARDS
 writtenafterwards. com/home

Heartfelt thanks to everyone whose talent and support made this possible: To each of our amazing contributors for sharing your style and insights with us and with our readers, thank you. Laura Dozier, our editor, for her perceptive guidance, creative suggestions and openness to new ideas, and, of course, for her patience. Eric Himmel, for the inspiration (and his enthusiasm) for this book. Sebit Min, for coming to see us in Tokyo and for her design, which captures the spirit of Tokyo style so well. Meredith Clark and the entire team at Abrams for all their hard work and support. And a very special thanks to Tomoko Kataoka for her insight, advice, and support at every stage, and to Naoki Watanabe for bringing street styles past and present to life with his illustrations. Thank you all.

Editor:
Laura Dozier

Designer:
Sebit Min

Production Manager:
Katie Gaffney

Library of Congress
Control Number: 2017949740

ISBN: 978-1-4197-2905-8
eISBN: 978-1-68335-232-7

Original Text © 2018
Yoko Yagi/Paper Crane Editions

Photography © 2018
Tohru Yuasa
Page 115: Images courtesy
of Ebony Bizys
Illustrations © 2018
Naoki Watanabe

Editorial Consultant:
Tomoko Kataoka

Producer:
Erica Williams,
Paper Crane Editions

Translations:
Plus Miracle, Tokyo

Special Thanks to
Arisa Nakagoe,
Mayu Tominaga,
Ayumi Yasui,
and Saori Yokoyama

Cover © 2018 Abrams

Abrams Image books are available at special discounts when purchased in quantity for premiums and promotions as well as fundraising or educational use. Special editions can also be created to specification. For details, contact specialsales@abramsbooks.com or the address below.

ABRAMS The Art of Books

195 Broadway
New York, NY 10007
abramsbooks.com